W9-CMC-897

KENYA

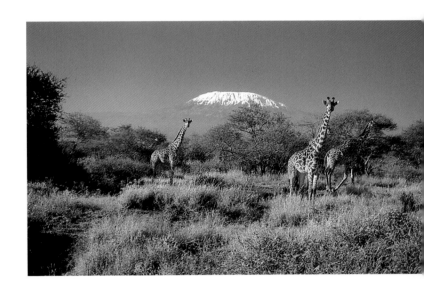

SMITHMARK

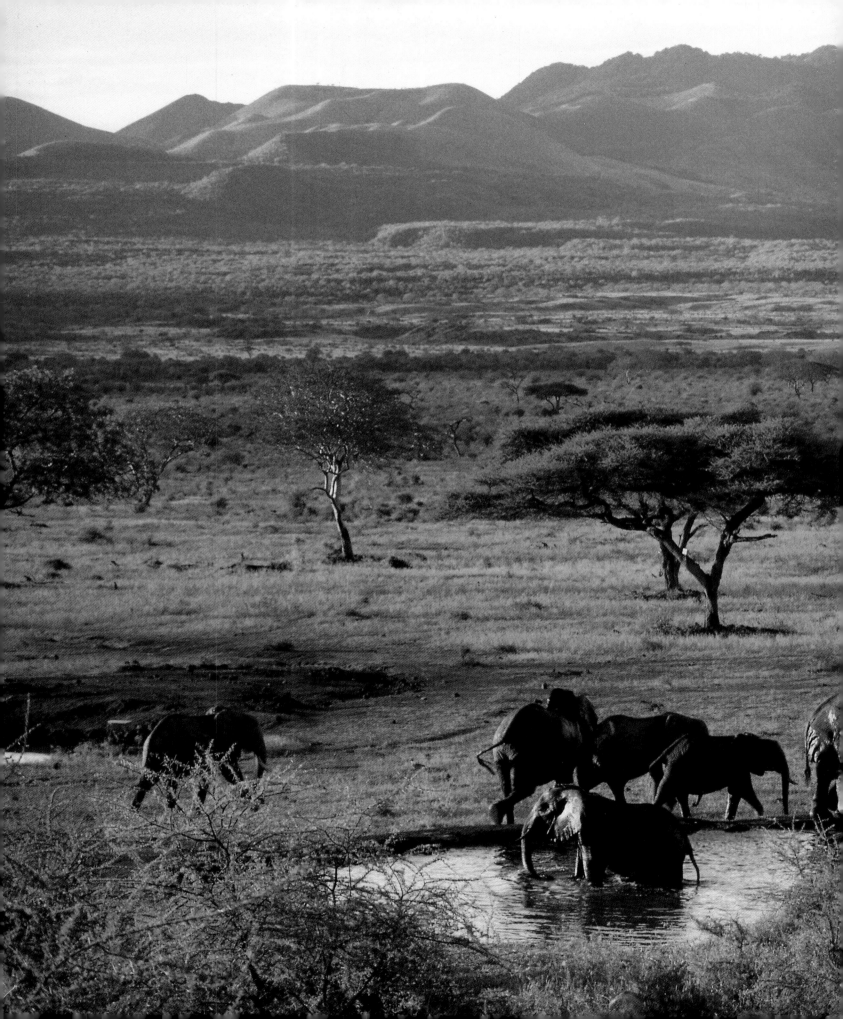

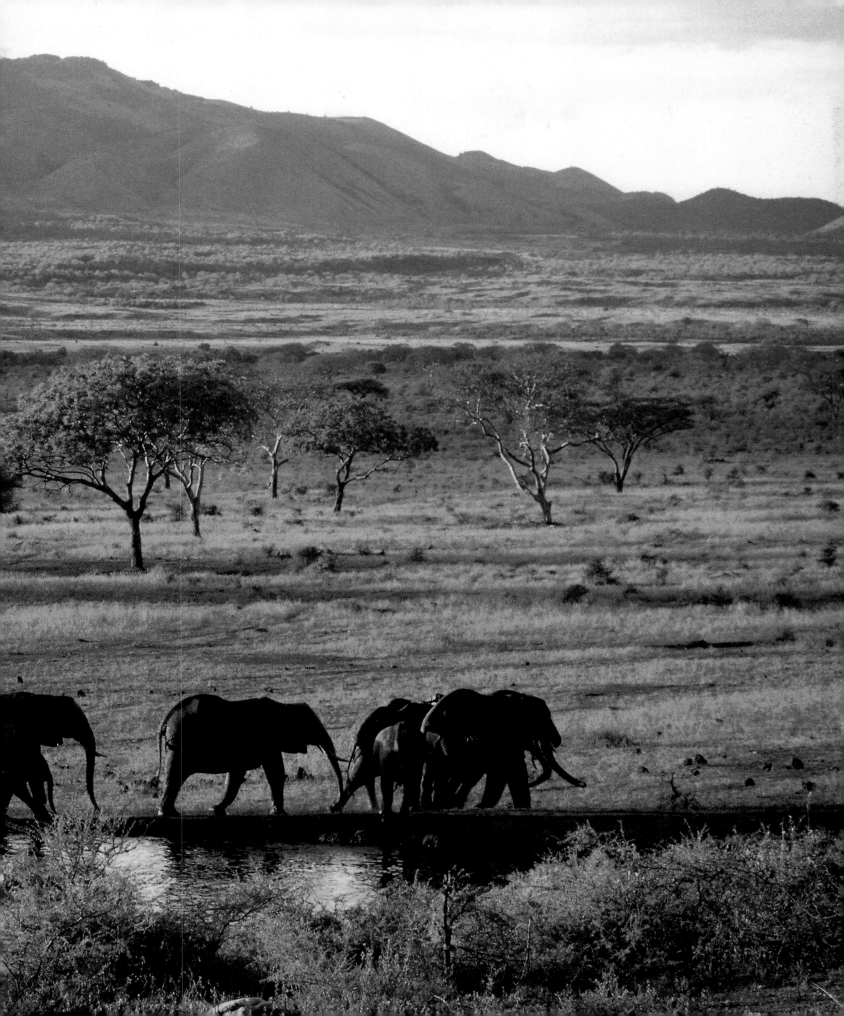

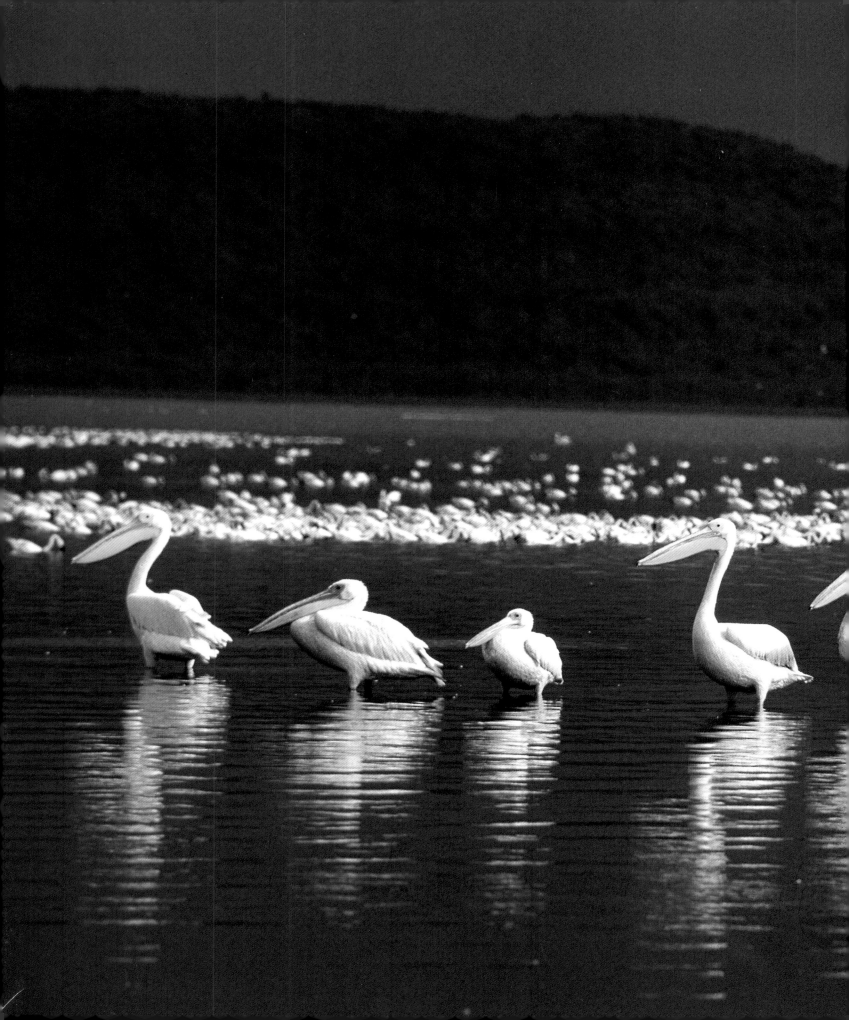

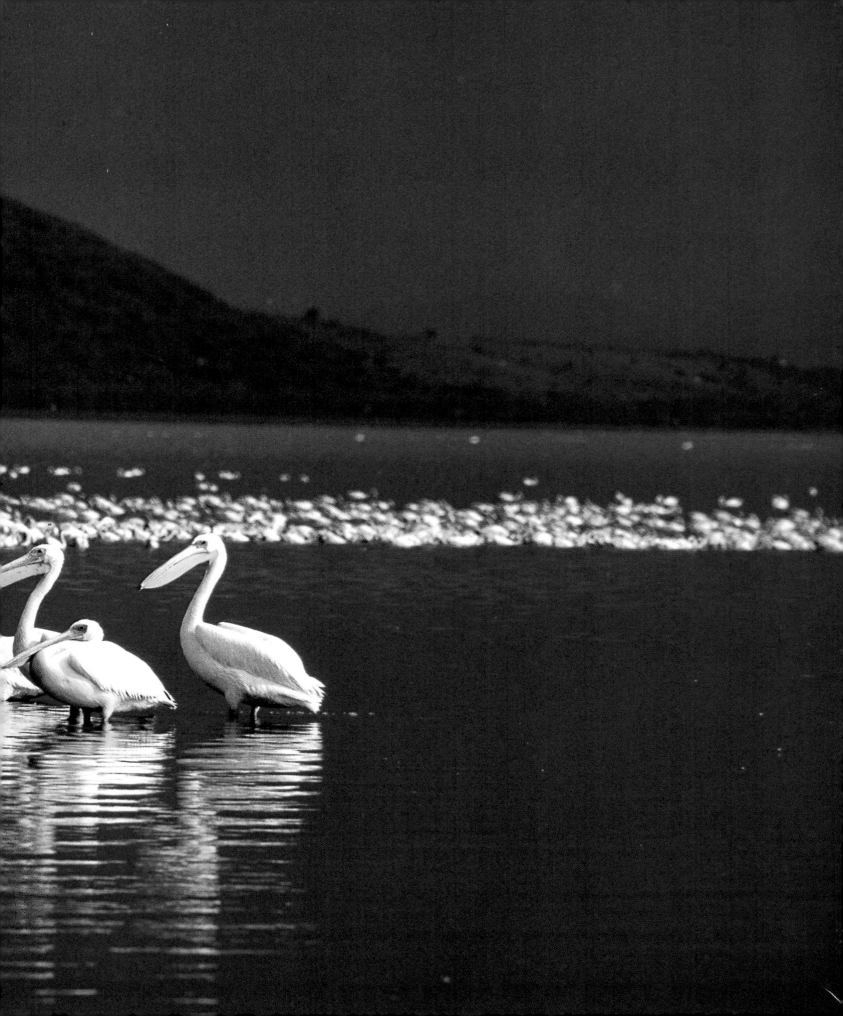

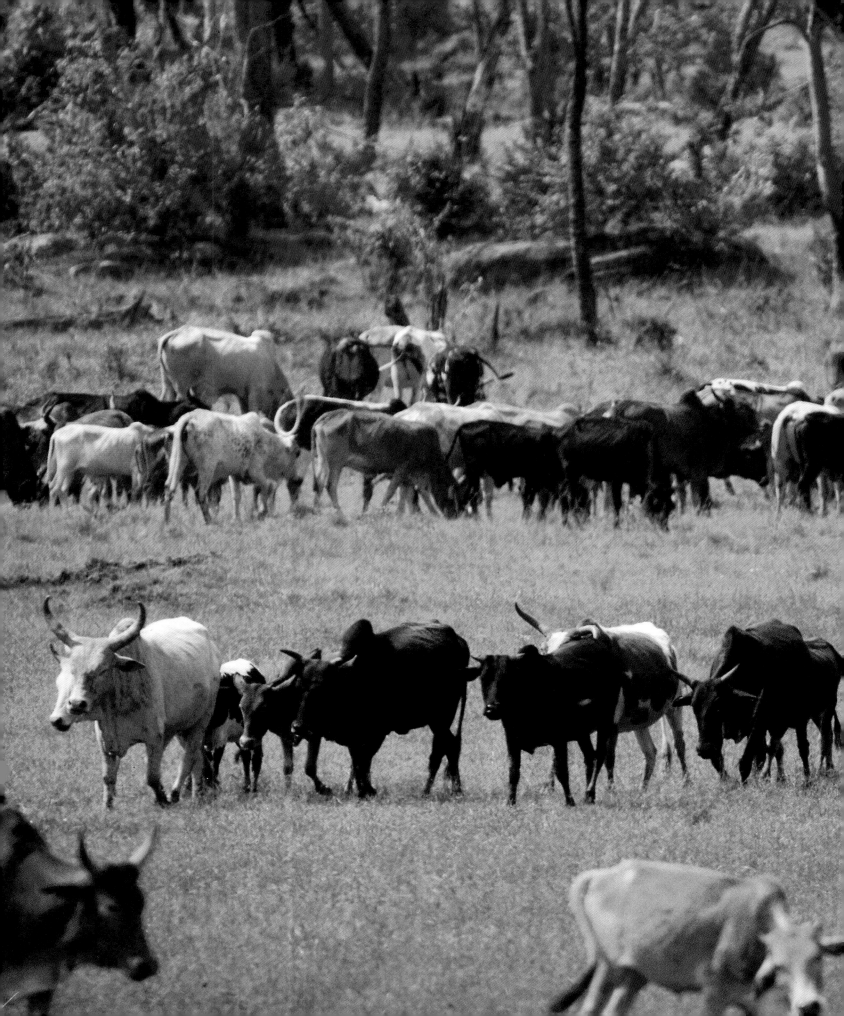

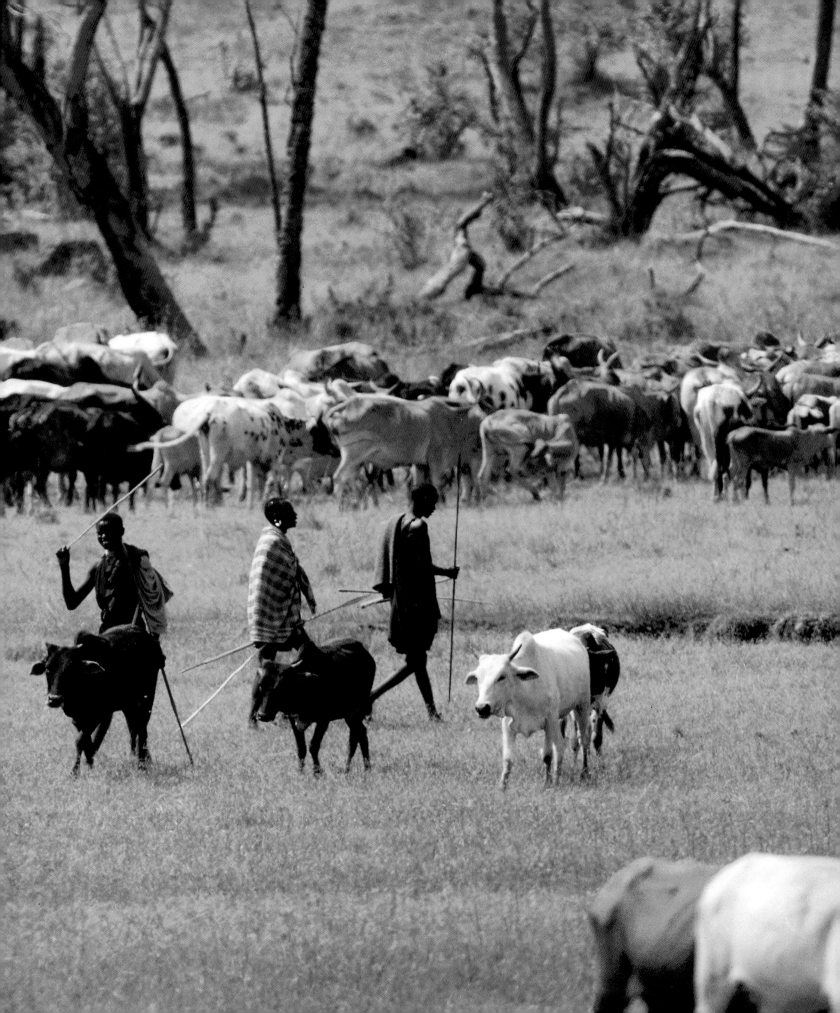

Text by
Alberto Salza

Graphic design
Anna Galliani

Map
Giancarlo Gellona

Contents

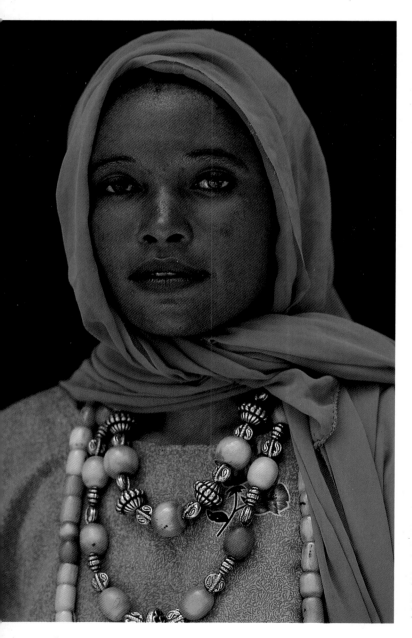

1 *A group of giraffes wanders in search of food amid the tall grasses of the savanna; rising majestically in the background is the snow-capped peak of Kilimanjaro.*

2-3 *The elephant (Loxodonta africana) symbolizes Africa much more than the lion. It represents the vastness of this continent, its strength, its very special kind of beauty and its resistance to the severest living conditions. In the savanna, nursery herds of females and calves led by a senior female travel many kilometres from one water pool to another, from one source of food to the next. If man interferes with their movements, elephants start to destroy the environment in which they live, and eventually die.*

4-5 *Not only delightful to look at, pelicans (Pelecanus onocrotalus) and pink flamingoes (Phoeniconaias minor) are also capable of surviving in one of the most hostile places on Earth: the alkaline lakes of the Great Rift Valley which divides Eastern Africa in two, passing through Kenya. Abounding in the sodium-rich waters of Lake Nakuru - a national park near the town of the same name - are special algae, shrimps and tiny fish that provide the flamingoes with nourishment. The pelicans instead have more substantial dietary demands, met by fish that themselves feed on small aquatic creatures.*

6-7 *The semi-arid plateaux of Kenya are shared by wild animals and the Masai ("those who speak the Maa language"), with their humped zebu. Their herds are all that the Masai live on. The mainstays of their diet are milk and blood obtained by painlessly letting the blood of their healthiest, sturdiest animals.*

8 *Portrayed in the face of this Malindi woman is a blend of anthropological elements: Arab, Somali, Ethiopian, negro. Since time immemorial the coast of Malindi, on the Indian Ocean, has been a place where trade routes converge. Biological and cultural elements of local peoples and visitors to these parts have mingled to produce distinctive physical characteristics and the very special Swahili culture of Kenya. Her necklace too reflects these continuous additions to the melting pot: strung next to amber from Ogaden are silver from the East and glass beads brought from Venice by Arab merchants.*

9 *The strength and agility of the Masai warrior are expressed in dance: great leaps made with both feet together. The dancer tries to fly upwards to Nkai ("God": the Masai believe in one god only); his performance is also intended to impress the girls who in contrast are not allowed to lift their feet from the ground, the place which symbolizes fertility.*

This edition published in 1996 by
SMITHMARK Publishers, a division of U.S.
Media Holdings Inc., 16 East 32nd Street,
New York, NY 10016.

SMITHMARK books are available for bulk
purchase for sales promotion and premium use.
For details write or call the manager of special
sales, SMITHMARK Publishers, 16 East 32nd
Street, New York, NY 10016; (212) 532-6600.

First published by Edizioni White Star.
Title of the original edition: Kenya,
la magica suggestione dell'Africa.
© World copyright 1993 by Edizioni White Star.
Via Candido Sassone 24, 13100 Vercelli, Italy.

ISBN 0-8317-4330-1

Printed in Singapore by Tien Wah Press.

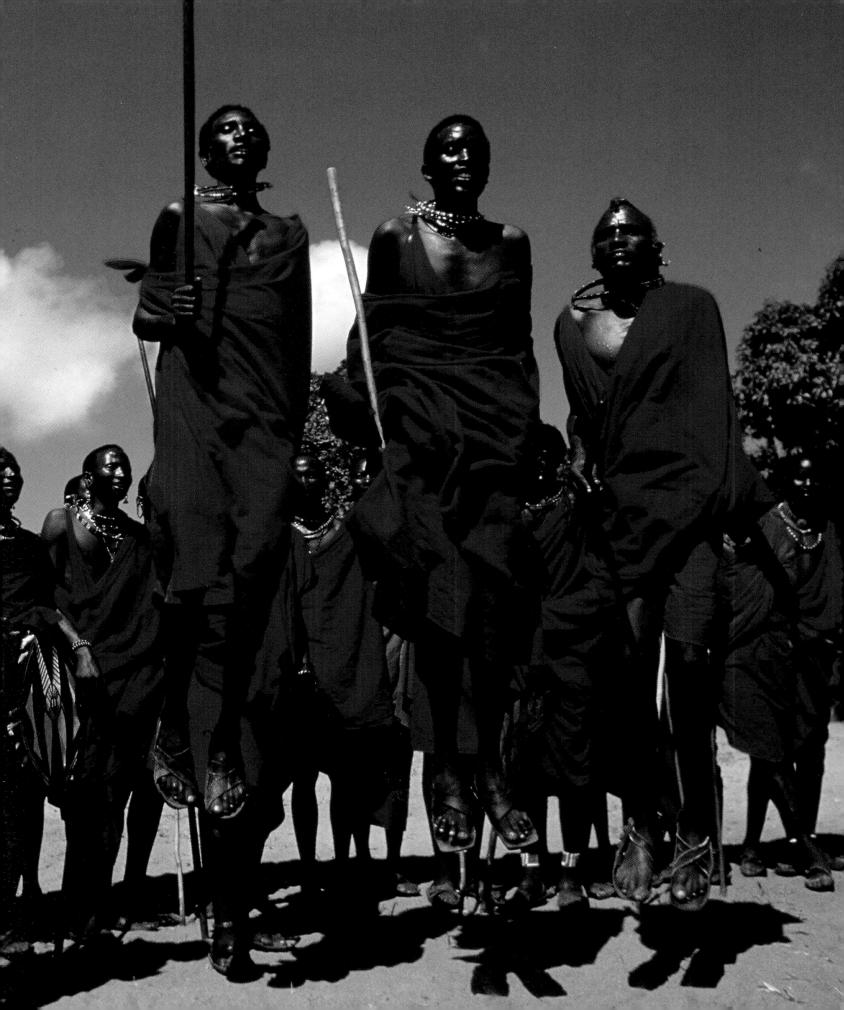

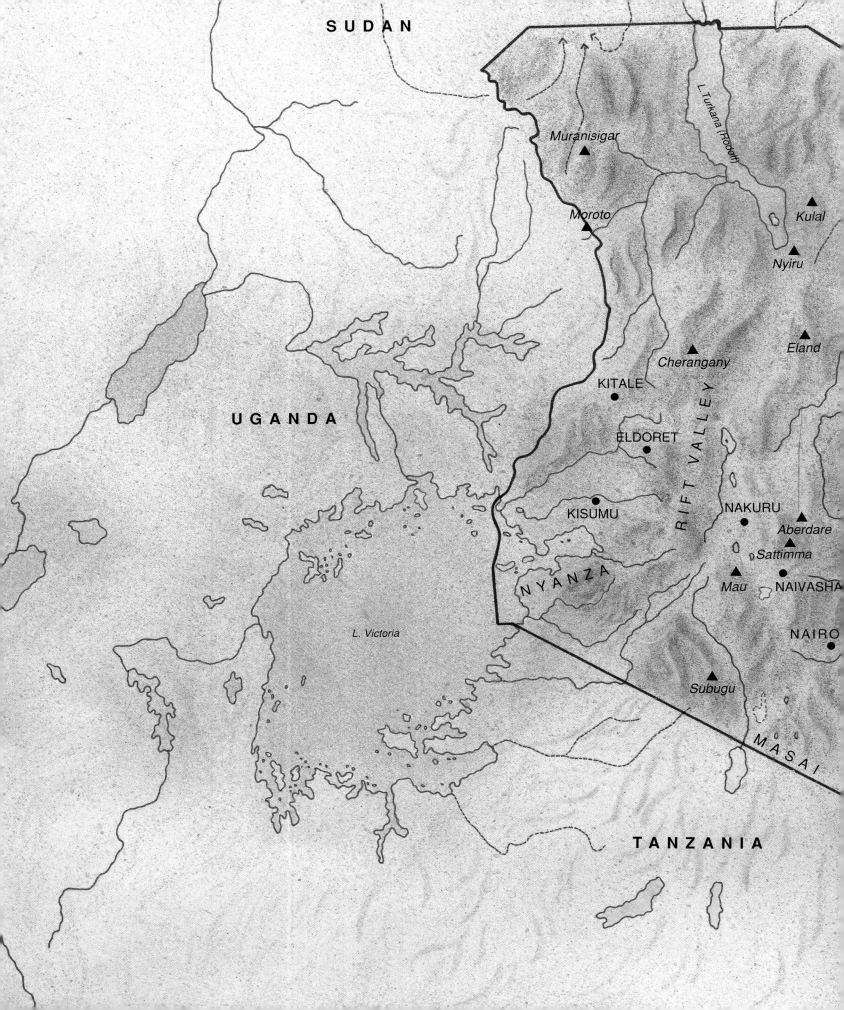

SUDAN

Muranisigar ▲

▲ *Kulal*

Moroto ▲

▲ *Nyiru*

L Turkana (Roboiri)

▲ *Eland*

▲ *Cherangany*

KITALE
●

UGANDA

ELDORET
●

KISUMU
●

NAKURU
●

▲ *Aberdare*

▲ *Sattimma*

RIFT VALLEY

N Y A N Z A

▲ *Mau*

● NAIVASHA

NAIRO

L. Victoria

▲ *Subugu*

M A S A I

T A N Z A N I A

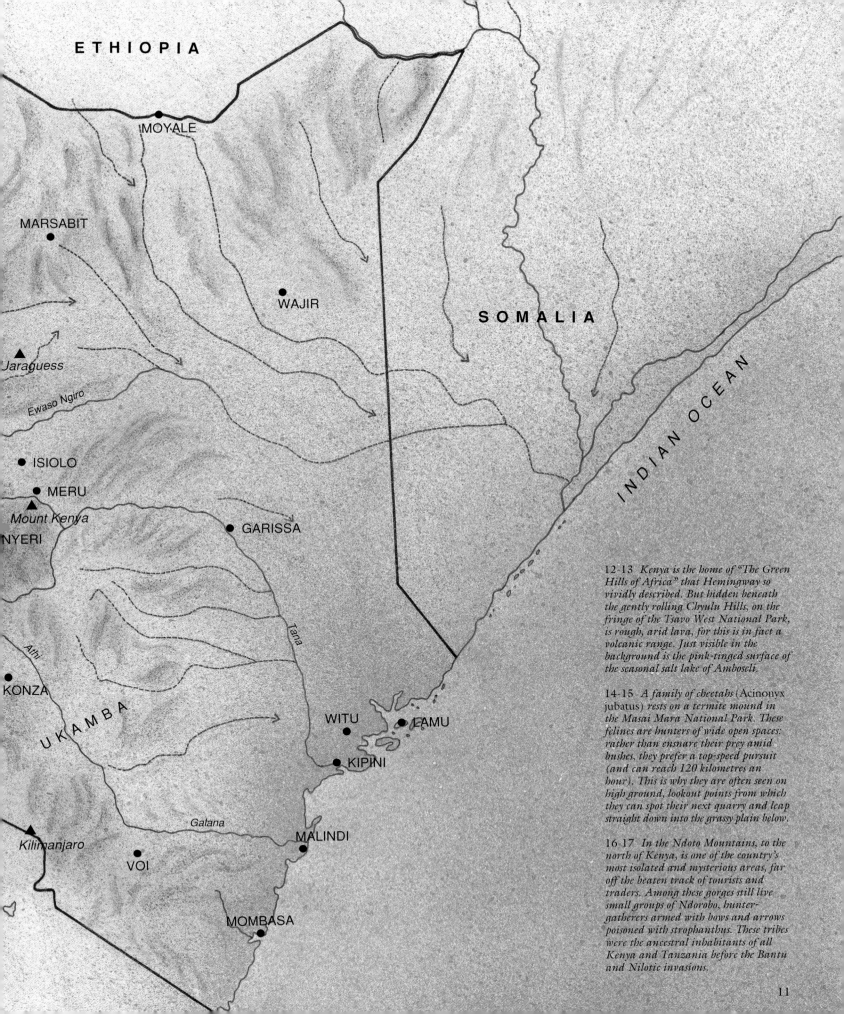

ETHIOPIA

MOYALE

MARSABIT

WAJIR

SOMALIA

▲ *Jaraguess*

Ewaso Ngiro

● ISIOLO

● MERU

▲ *Mount Kenya*

NYERI

GARISSA

INDIAN OCEAN

● KONZA

U K A M B A

Tana

Athi

WITU

LAMU

KIPINI

Galana

▲ *Kilimanjaro*

MALINDI

VOI

MOMBASA

12-13 Kenya is the home of "The Green Hills of Africa" that Hemingway so vividly described. But hidden beneath the gently rolling Chyulu Hills, on the fringe of the Tsavo West National Park, is rough, arid lava, for this is in fact a volcanic range. Just visible in the background is the pink-tinged surface of the seasonal salt lake of Amboseli.

14-15 A family of cheetahs (Acinonyx jubatus) rests on a termite mound in the Masai Mara National Park. These felines are hunters of wide open spaces: rather than ensnare their prey amid bushes, they prefer a top-speed pursuit (and can reach 120 kilometres an hour). This is why they are often seen on high ground, lookout points from which they can spot their next quarry and leap straight down into the grassy plain below.

16-17 In the Ndoto Mountains, to the north of Kenya, is one of the country's most isolated and mysterious areas, far off the beaten track of tourists and traders. Among these gorges still live small groups of Ndorobo, hunter-gatherers armed with bows and arrows poisoned with strophanthus. These tribes were the ancestral inhabitants of all Kenya and Tanzania before the Bantu and Nilotic invasions.

11

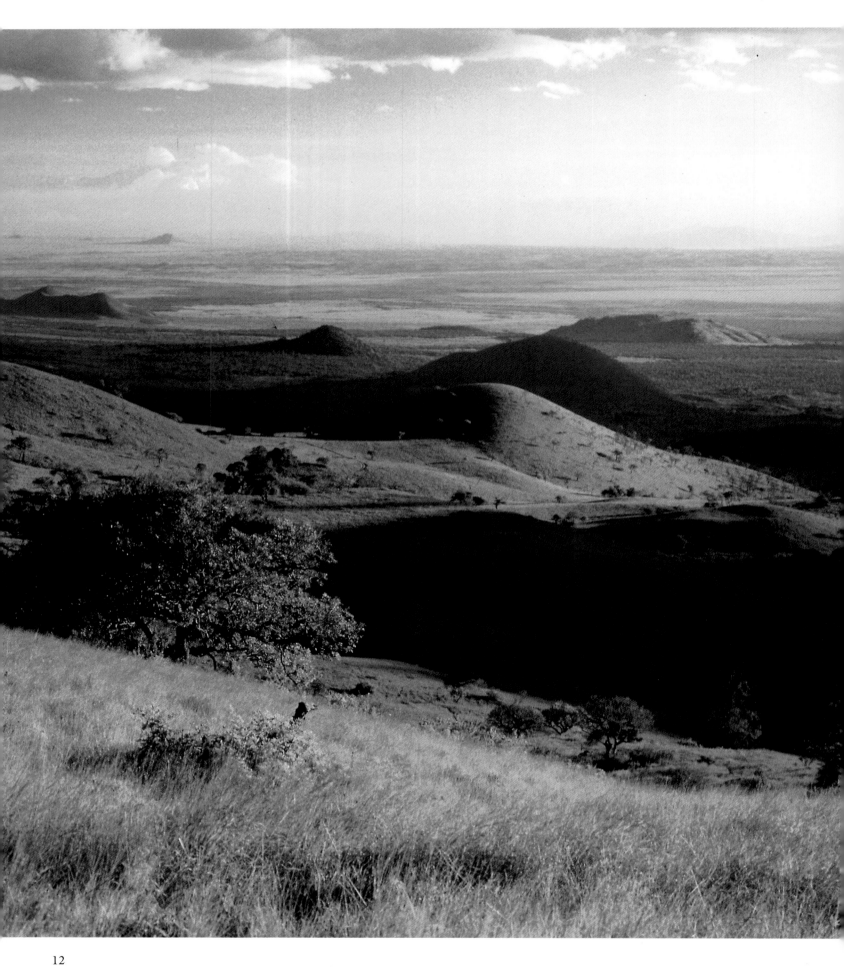

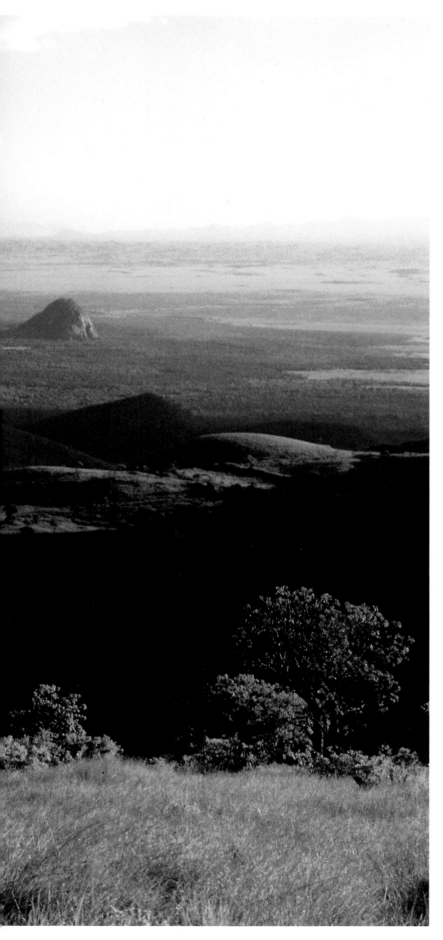

Introduction

"See Mt. Kenya over there?" asked Labria as, by my side, he tugged the halter of a slavering dromedary. Labria is a Samburu, cousins of the Masai. His home is Northern Kenya: uninviting, semi-desert thornbush country. For many years he has been my guide on treks to places forsaken by God and man (even today, with hordes of tourists inundating Kenya). He also tries to teach me how to survive around these parts: not always an easy task (teaching me something, I mean). But there is one thing I have learnt: trust nothing and nobody. "There's no mountain over there - I replied - and even if there were one, it's not Mt. Kenya. It's well over a hundred miles from here, to the south. Even a Samburu can't see that far". Labria wouldn't admit defeat: "An eye can split stones", he said. He is always talking in proverbs. It drives me mad, and he knows it. "And every feline thinks he's king of the jungle", I quipped unkindly.

By now the dromedary was protesting vociferously at the firm hand on the halter. Labria set off at his usual breakneck speed, turning his back on the misty topic of our conversation. "It is Mt. Kenya", he insisted, "Once I even saw the sun reflecting on those sheets of metal your people left up on the top there. You white men are incredible: what need was there to make the peak of a mountain shine? As we say: don't ask a hunter for butter". I let the subject drop: there was no point in turning the knife in the wound. I did not even try to explain that the reflection was made by the eternal snows: in his drought-ridden surroundings Labria could have no conception of such a thing and assumed it to be metal roofing, the only shiny surface known in the Samburu universe. "There is nothing to equal buttocks", I remarked cheerfully. "True, replied Labria, "and words don't fill your feeding bowl. You should know that: you write and talk an awful lot.... Come on". And we set off at the double, as though bound for the peak of Mt. Kenya.

Kenya is an intriguing, many-faceted country. It reminds me of the monster created by Baron Frankenstein. Like that creature, it is beautiful, lovable and yet awesome. And its various pieces often seem to have been assembled in a hurry. The joins between assorted landscapes, divergent ethnic groups and seemingly irreconcilable ways of life stand out like scars, visible from afar. In a matter of miles you see deserts turn into mountain forests where orchids grow; you meet half-naked nomadic herdsmen leaning against a hi-tech 4-wheel-drive; you witness the spectacle of wild animals of every species in their natural habitat while you sit sipping gin & tonic. You might even test your wits - and knowledge of proverbs - against a Samburu camel driver. Kenya is like the gnu - part-antelope, part-horse - which looks as though it was created from the leftovers of Darwin's evolution. The gnu may be called the "clown of the bush" (because of the curious way in which it leaps) but it is a handsome animal provided you ignore its horse's tail, handlebar-shaped horns, squashed face, short mane and skin that looks almost blue (God must have run out of the colours that provide other creatures of the bush with such excellent camouflage). Life can't be easy for the gnu... Continuing in the footstops of Frankenstein, let us return to our own creature, Kenya, and see how it can be

attributed to human form. Its head is Mount Kenya, not because this mountain reaches great heights but because Jomo Kenyatta - the father of modern, independent Kenya and its first President - spent his childhood years on its slopes (he was not taken in by its shining snow...). It is an extinct volcano of outstanding beauty where weird forms of vegetation grow amid rocky outcrops of basaltic lavas. A missionary who came from Piedmont climbed Mt. Kenya endless times. It was a great sorrow to him when, well on in years, he was prohibited by his doctor from doing so again. "I feel I'm practically dead already", he told me, standing by the only productive lemon-tree in the entire immense territory of northern Kenya. Strangely enough, the 'Watu wa Mongu' - "men of God" of the Kikuyu tribe - have always prayed with their arms held high and their face turned towards the peak of this mountain, known as 'Mwene-Nyaga', the home of God.

At the opposite end to the head we find the feet. Kenya's feet are counted in millions of millions and come in many forms: with five toes, padded, hoofed, with three large claws, with retractile claws, keg-shaped (hardly a scientific term but it gives a good idea of what the foot of an elephant or hippopotamus looks like), huge or tiny, scaled or hairy. Right at the bottom end of the country, far away from Mt. Kenya, is where we encounter Kenya's wildlife. Lions, leopards, hyenas, elephants, giraffes, antelopes and gazelles, buffalo, snakes, mongoose, baboons and monkeys: the hills, grasslands, forests and deserts of Kenya are all that remains of Noah's Ark after its timbers disintegrated and turned to dust. Visitors who come to witness this great spectacle spend 90% of their time gaping in wonder at the 'big five' which - in the first few decades of this century - the big game hunters set their sights on. Having survived the risk of extinction, the lion, leopard, buffalo, elephant and rhinoceros have earned the right to a protected life in Kenya's bush country. Let us try to leave them undisturbed while we look more closely at the extraordinary variety of wildlife that has chosen for its habitat the thorns, grass, dust and skies of Africa's great natural parklands (it might take a little more than the 10% of the time we have left).

Our creature has exceptional legs. I have spent many months of many years roaming with nomads behind zebus, goats, sheep and dromedaries. When people ask how many miles I have travelled with them, I say: "Every single one". Otherwise I would not be here to tell the tale. The nomadic tribes of Kenya - among them Masai, Samburu, Turkana, Rendille, Borana, Gabbra, Nderobo - scrape a livelihood driving their herds along "nightmarish trails, of the sort one presumes exist on the moon" (as Rimbaud, a man who knew a thing or two about roaming in Africa, once wrote in a letter). These nomads deserve our greatest respect. At peace with the world and with themselves they move from place to place, coping with drought and famine, erratic rains and dry grass, accompanied by their beautiful womenfolk and their offspring, the tiniest ones bouncing to and fro on their mothers' backs. In their way of life we catch a fleeting glimpse of our own lost freedom. Living in a hut under a roof of cattle dung may not be pleasant but once our legs get moving in the direction of some unknown hill, we realize that the human race is no more than a two-legged species of frightened apes and sitting does not come naturally to our anatomy. Around these parts men's bodies have instead been fine-tuned by almost five

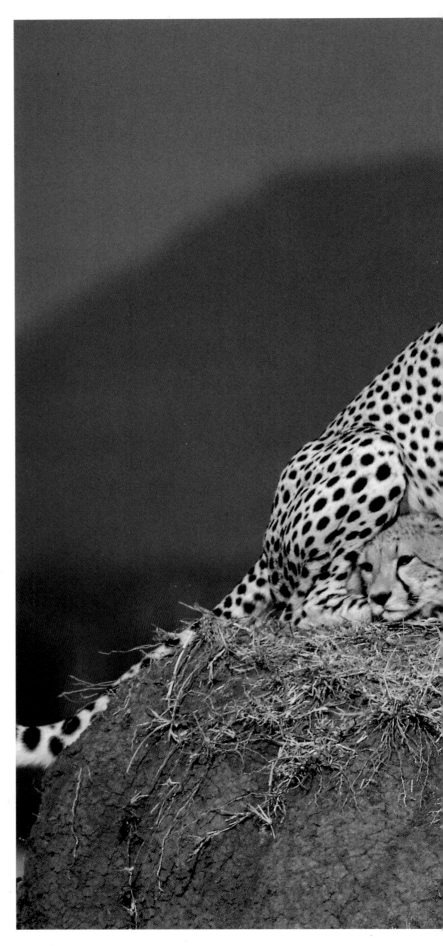

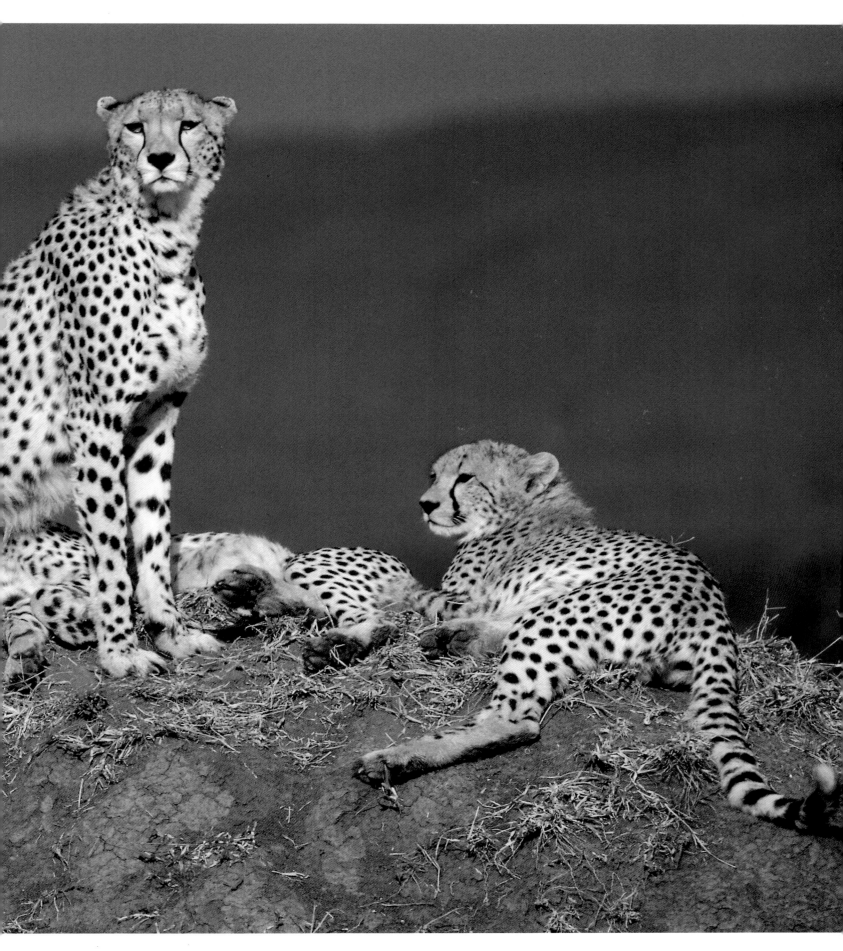

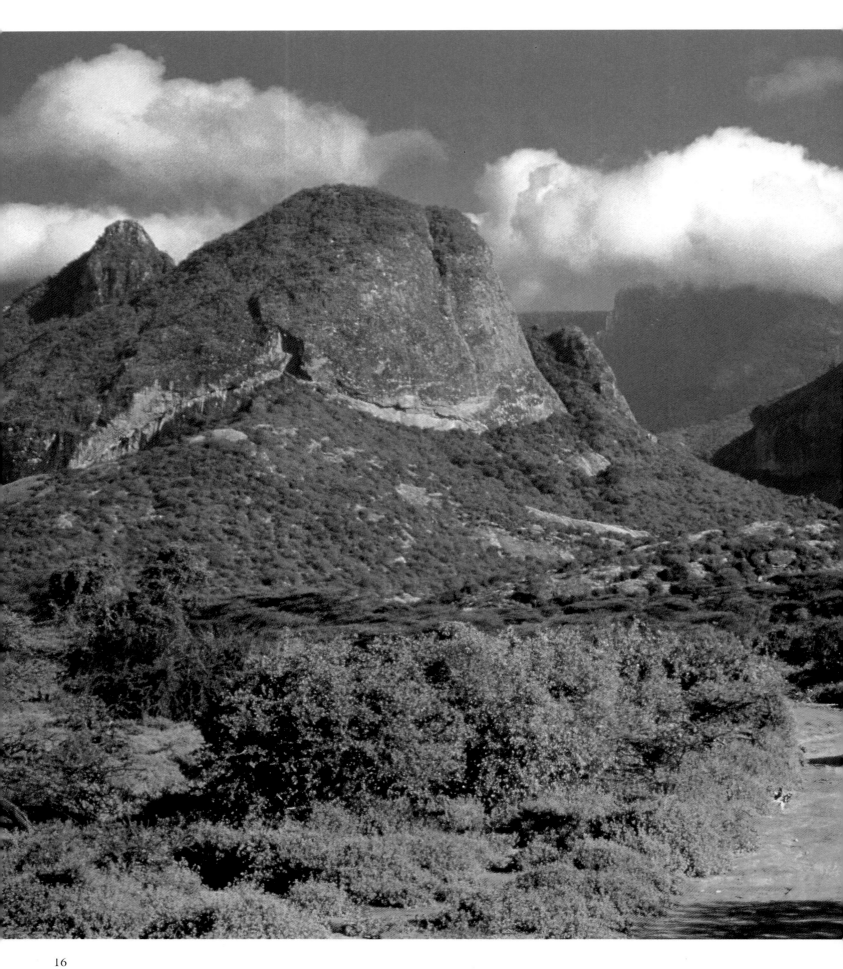

million years of cross-country trekking. In present-day Kenya the territories where a nomadic existence is still possible are shrinking fast (about as fast as man's ideas). There is literally no longer room for these peoples. All we can do is immobilize them, on a few square centimetres of film. No longer do the Masai and Turkana think that by taking their photo, we steal their soul (if they ever did believe this). They have seen enough of us to know we don't give a damn about their soul (or our own). In the early days, when we camped for the night (no tent, just a blanket thrown on the ground), sunset was a precious time for me and I savoured it minute by minute. My Turkana companions were instead fidgety, ill-at-ease. "A bad time, this", said Lepulei, who has been my guide among the stones of Lake Turkana for over twenty years. "Snakes come out at sunset", he went on, "Come away, it's nearly night". For nomads, in Kenya as elsewhere, the hours of sunset - fearsome as they may have seemed - are now over. Darkness has descended. Down in the very depths of our creature there is turmoil, for here we find the still active bowels of the great East African Rift. The valley formed by this huge fault starts in Jordan and continues southward along the Red Sea and through Ethiopia to reach Kenya and Tanzania; it then divides into several branches, reaching Mozambique on one side and Botswana on the other. Some twenty million years of earthquakes and eruptions have created havoc with the earth's crust, and there is surely more to come.

At the geological speed of an inch or so a year, Eastern Africa is heading towards the ocean. Sooner or later it will follow Madagascar's example and become an island. Meanwhile the Rift system has created mountains like Kenya and Kilimanjaro and a myriad of smaller volcanoes scattered along the valley floor and rims. Its depressions have resulted in lakes and without their alkaline waters Kenya would have been a very different place. Lakes Nakuru, Bogoria, Baringo and the immense Victoria (an indirect product of the Rift, even if not part of the system) - to mention only those in Kenyan territory - provide a wetland habitat where millions of flamingoes and other acquatic birds reproduce, a wildlife oasis in an otherwise extremely hostile environment. But the most outstanding product of the Rift was our own species: mankind. Five million years ago the Rift system caused this part of Kenya to become arid. Here the great rain forest which covered the whole of Africa withered and died. The area became savanna, as it remains today, and the monkeys who had lived in the trees of the forest had difficulty surviving. But for one family of bipedal apes, this changed habitat meant the start of a new process of evolution. These hominids, our ancestors, were simply apes who had 'found their feet': the first - and only - primates to adopt an erect posture. They had to contend with a mosaic environment (around Maralal you can travel from forest to desert in the space of a few miles, with all the intermediate shades of savanna in-between) and continuous ecological disasters (erupting volcanoes, storms, floods, drought). Their incredible ability to adapt to these conditions led their anatomical and behavioural characteristics to evolve with amazing speed. From erect posture (a direct consequence of the Rift) the evolutionary process of this species culminated in the spectacular development of the brain. In this part of Africa, almost three million years ago, Homo habilis - a species that already had similarities with modern man - began simple

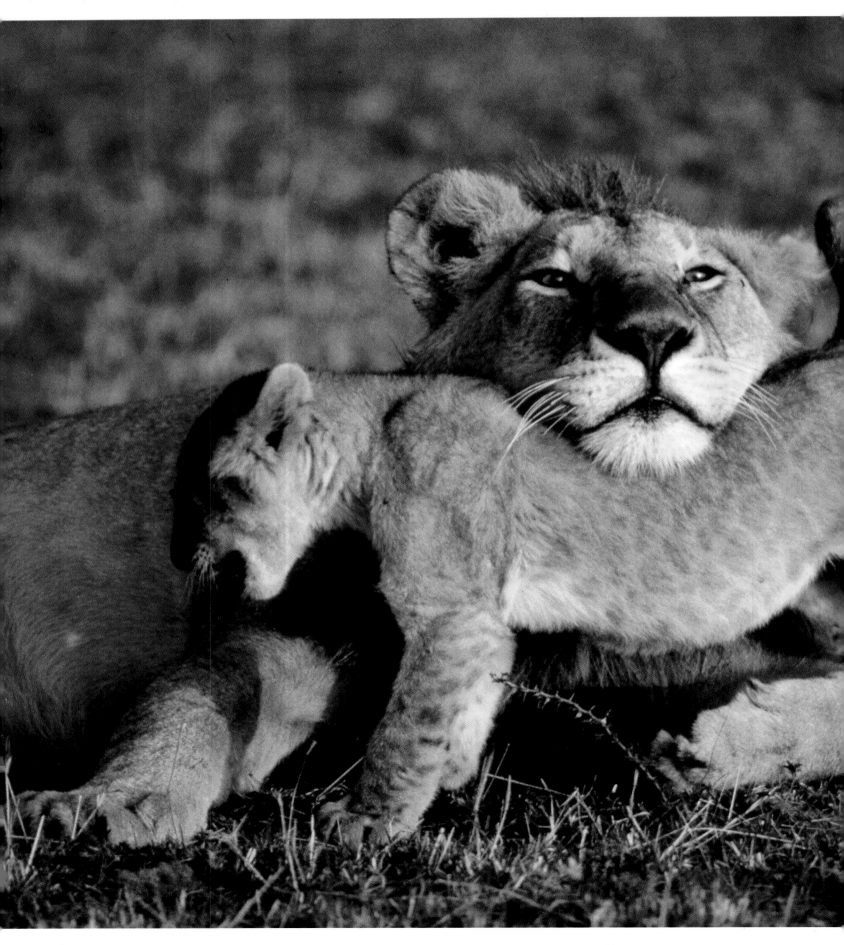

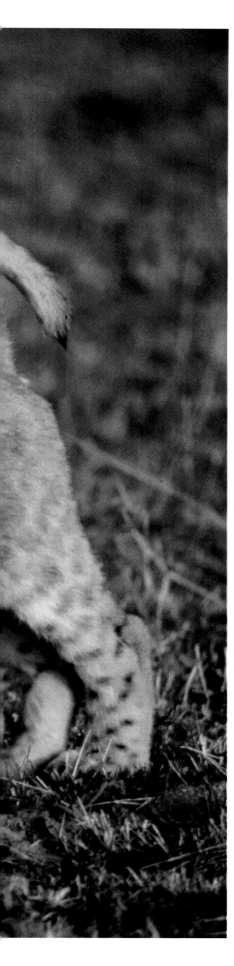

18-19 *Lionesses are very affectionate with their cubs, except at mealtimes when each looks after their own interests. The death rate among lion cubs is actually very high, exceeding 50%. Disease and accidents are the main causes but often the males devour the young male cubs to eliminate potential mating rivals. But were this not to happen, lions - who have no natural enemies - would upset the equilibrium between predators and prey that allows both to survive.*

20-21 *Masai girls are celebrated for their ornate and highly imaginative beadwork. The beads used to be made of glass; now, unfortunately, they are plastic. Beads and necklaces are prized possessions, handed down from mother to daughter; young warriors instead like to give new ones to the girls they fall in love with. Both males and females of the Masai people have their ears pierced when very young. The hole is then gradually enlarged until it is big enough to take even a Coca Cola can.*

22-23 *South of Mombasa the coast of Kenya overlooks the coral barrier of the Indian Ocean. Diani Beach is the archetypal "tropical paradise", with shimmering white sand and coconut palm trees. Like the wildlife in the national parks, these shores are now a resource of fundamental economic importance for Kenya.*

24-25 *Situated some seventy kilometres north of Nairobi, Lake Naivasha is the only freshwater lake of the Great Rift Valley (the waters of all the others are alkaline). Luxuriant vegetation therefore grows on its banks, which are only about thirty kilometres south of the Equator.*

26-27 *Soaring 5,895 metres above sea level is Africa's highest mountain, Kilimanjaro, a huge inactive volcano which came into existence five million years ago on the Tanzania/Kenya border. Its glaciated summit presides over the plains of southern Kenya.*

experiments that eventually changed the world. Striking stones against lumps of basaltic rock, he obtained splinters which he then used to cut things with; the remaining piece of rock served to crush bones, roots and the like. Our forefathers thus 'invented' technology and with it, the ability to control their natural environment. And this extraordinary revolution started right here, close to Mt.Kenya. While in Europe we were still a family of clueless apes, here real men were walking the Earth.

If your curiosity gets the better of you, take a trip to Lake Turkana, the place I love best in all Kenya and regard as our Creature's sexual organs (in purely procreative terms). It is a nightmarish place, a desert of black rocks and baking-hot stones, with a climate to match: the occasional stunted thornbush reminds us that a few drops of rain do fall once in a while. Its only inhabitants are scattered groups of nomads who survive thanks to misplaced obstinacy and an amazing sense of self-importance. The Turkana nomads regarded me as serving no purpose in their life and environment and they put me through endless "tests" (in medieval times they would have been called "ordeals") before I was accepted as a kind of human being. One day I was washing off dust and dried sweat on the shore of the lake. Its jade green water looks deceptively refreshing but it contains so much sodium that it's like drinking lye, a horrible taste, but when you are parched and have no choice... Lepukei watched me washing. "You can rub as hard as you like", he said "but you'll never become as black as me". An original catch-phrase for a washing-powder commercial, perhaps... My tongue was so dry I could not reply. But nothing I could have said would have dampened his self-esteem.

Fossils found along the banks of Lake Turkana prove that hominids existed in this area at every stage along the evolutionary path, from the very oldest Australopithecus right down to Homo sapiens who, had he had the good sense implicit in his pretentious Latin name, would have kept well away from this part of the world. And yet we can trace our very origins, as human beings, to Koobi Fora, on the eastern side of the lake. The site itself may not make a great impact but a real traveller can see more than meets the eye. "True", Labria would say, "and legs - not tongues - are made for walking with". It was on the Aberdare mountains that I came across the arms of Kenya. They belong to a strong woodcutter. Here it is chilly in August and the forest is shrouded in mist. Sleeping in the open can be bitterly cold, however unlikely this may seem in a tropical climate. In Kenya it's wise always to have a sweater with you, just in case. At dawn, numb with cold, I was immensely cheered to see smoke rising from a wood cabin of the sort you normally find in the Rockies (unexpected sights are the norm here). In the cabin was the previously mentioned woodcutter who hastened to offer me the boiling-hot tea which was - I imagine - his entire breakfast. He was a Kikuyu, a member of the ethnic group of agriculturalists once dominated by the Masai; the Kikuyu tribe - now the most numerous in Kenya - organized the Mau Mau Rebellion and fought British colonialism. The woodcutter, who still felled trees with a chopper (I have yet to understand why saws are still not widely used in Africa), was a huge fellow with a docile air. I had finished drinking and was about to return to the damp

forest when he caught me by the arm. "You know how to write", he said, irresistibly appealingly. "Could you stay a moment and explain to me what a semicolon is? It's something that's been on my mind since I was a child". It took me several hours and any intruder would have witnessed a unique scene: a jittery anthropologist, weary after a night sleeping rough, and the gentle, black giant, his head swaying to and fro to keep up with the verbal acrobatics I used to explain the semicolon. Maybe Kenya itself can be summed up with a semicolon: breathing space between a splendid pre-historic era and an uncertain future. I left without asking his name (an aggressive habit typical of Westerners) and the woodcutter raised his long, gnarled arm to bid me farewell. Framed between the sky and treetops, his hand looked enormous. All these splendid limbs are obviously attached to a core, the well-built torso of our Creature Kenya.

Here spectacle ends and structural pragmatism begins, evident in the thousands of towns and villages scattered, with varying density, the length and breadth of the country. Kenya's infrastructure offers more than mere survival: you can eat, drink, sleep and even get from place to place with the ubiquitous 'matutu' (bus services run often with ancient, clapped-out Land Rovers and vans). You may reach your destination with a few more grey hairs but if you want to understand how Kenya works, it is a not-to-be-missed experience. This is what I call everyday Africa, far from the magical world of wild animals and proud, next-to-naked nomadic herdsmen, and well hidden from the view of tourist villages and safari lodges. This Africa produces what it can, in the face of environmental conditions that often verge on the impossible. It is a big, black torso, rippling with muscles and dripping with sweat: a land with the least fertile soil and the highest birthrate, which deserves to be seen first-hand and pondered upon.

Kenya needs more hands to increase its output, even if this means encroaching on the shrinking territory of nomads and animals. These people may be imprisoned in metal shacks and dressed in Europe's surplus stock, but they too have a voice that needs to be heard. Nairobi is the heart of this torso. For Westerners the heart is practically a synonym of goodness. One could hardly describe Nairobi - or Mombasa, Kenya's other big city - as having a warm heart. And yet all Kenya's people seem inevitably to pass this way, through the hub of the country's pulsating arteries. Nairobi is both beautiful and hellish. It was established in the midst of the flat, barren savanna to supply water to the railway linking Mombasa to Uganda (in the Masai language Nairobi means simply "fresh water"). Since then it has attracted many thirsty souls. On the smart hills of Muthaiga (where, until independence, only whites could live) are handsome villas, their gardens ablaze with flowers. In the poor suburb of Kariobangi you will find the real urban Africa, an impossible place to understand and to live in, for us as well as its inhabitants. In the River Road area, only a stone's throw from the Hilton, you risk being robbed by gangs of street urchins: once a shout and a shilling was enough to send them scampering; today hunger has armed them with knives.

Partly due to its climate Mombasa is "softer" but it is still a port, with all this implies (much the same could be said of the "station" side of Nairobi). The curse of urbanization in

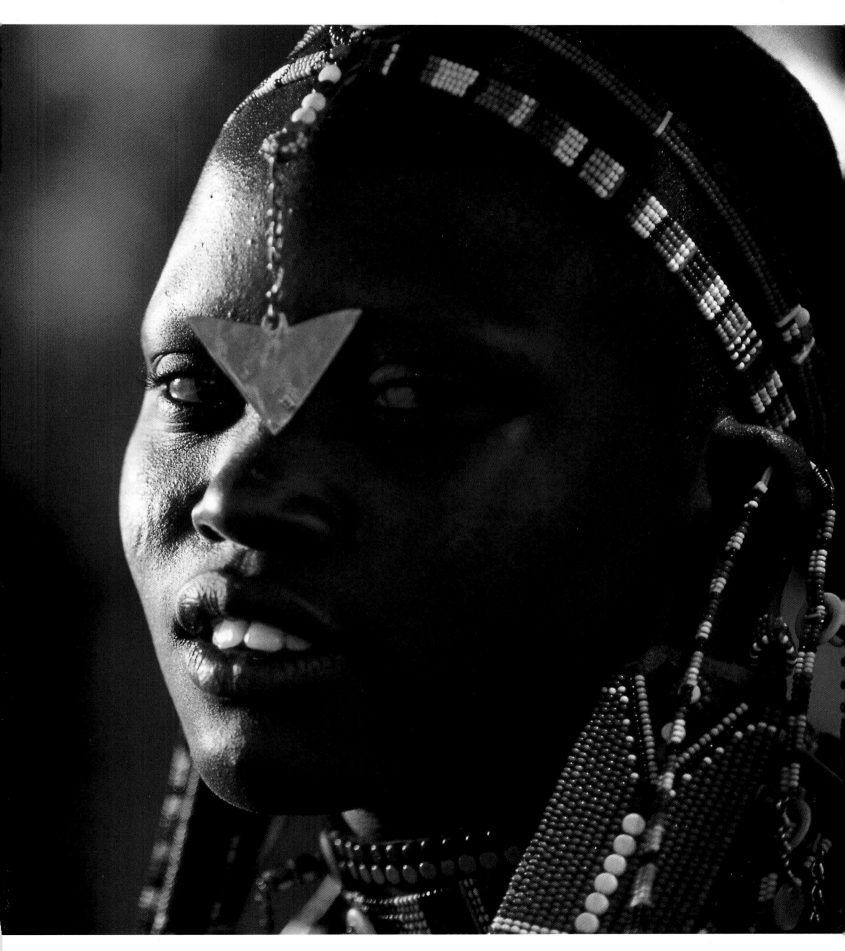

the Third World is that it immediately creates a fourth world, populated by a new underprivileged class. These people used to live on the land, safe within the fold of extended families which are Kenya's mutual aid system. Now, far from the gentleness of the tribal world, they can no longer rely on their own hands earning them a livelihood. Nairobi and Mombasi are hypertrophied hearts which can do no more than keep on pumping, wearily; here pity has become a luxury that only we outsiders can afford.

Kenya has a mouth, from which come sweet breath and melodious words. It is the shore of the Indian Ocean, a tropical paradise with palm trees and white sands. But these beaches have never attracted the black natives of Kenya. The sea has nothing to offer herdsmen and agriculturalists. Navigation is difficult and calls for complex techniques and know-how. The coasts of Africa are often insalubrious places where malaria-carrying mosquitoes thrive. Inland is a barren, uninviting territory known here as the 'nyka', inhabited in the daylight hours by beautiful women who, after dark, turn into hyenas. This is how the plateau-dwellers regarded the tourist paradise. Now, of course, things are much changed. Hotels and villages, built along the coastal strip, prosper; mosquitoes still buzz (but repellents soon put paid to them). In the 'nyka', with its coconut trees and mangos, the women are as beautiful as before but hyenas are no longer seen. For many centuries this part of Kenya has been home to the Swahili (Arabic for "people of the beach"): a mixed race descended from natives and Arab and Omani sailors who came here to explore and trade. The Swahili civilization dates back about a thousand years and reached a notable degree of development. The ruins of its cities lie hidden amid mangrove swamps, especially on the many islands dotting the ocean between the coast and the stupendous coral reefs. When I can take no more of Lake Turkana's gruelling climate or of the Samburus' cultural desert, dust, thorns, robbers and drought, I hop on a clapped-out DC 3 (that's right: the "flying coffin" Dakota of World War Two) and go to Lamu Island. Here I shut myself away in an old Swahili house overlooking a small garden with papaya trees. At sunset I stroll around the little town, on the very edge of the island. At this hour of the day the whole population throngs, the narrow streets previously occupied solely by donkeys. The men wear white robes and the women long black dresses, with veils that leave uncovered only dark eyes with long lashes. I talk to all and sundry, doing my best not to mangle 'kiswahili safi', the "pure language" which spread from here to the whole of Eastern Africa as the lingua franca of trade. After a week in Lamu I am back in the realm of spoken language which is, after all, where we rightly belong. "What's the place where millions of people die?", I heard Labria asking. Caught up in the myth of Frankenstein in Kenya, I had missed something. The dromedary was now a long way off. Labria did not wait for my answer. "Bed", he said. "And if you don't hurry, the heat will kill us". I got up without a word, but hid the knife in my bag. That night, after hours and hours of stones and proverbs, Kenya would have had her monster. "'Melama iltuli o enkop', buttocks and ground are not far apart", I threatened. And off I went, in search of the real Kenya.

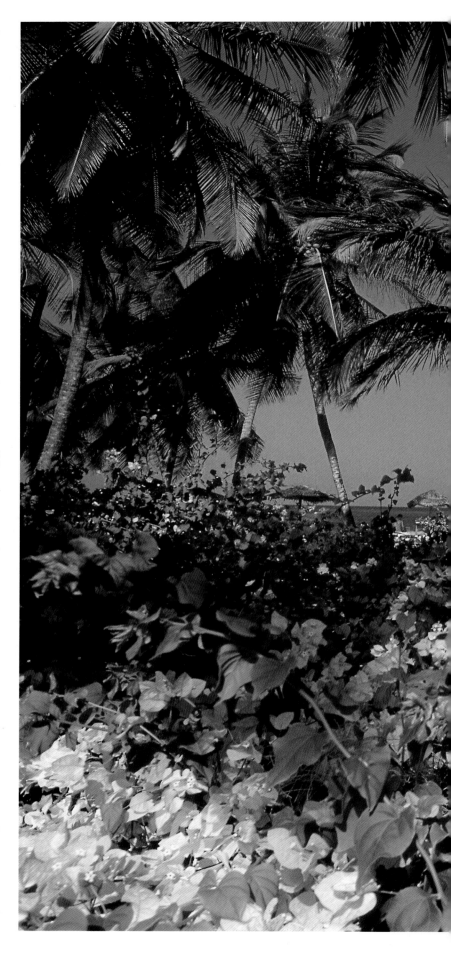

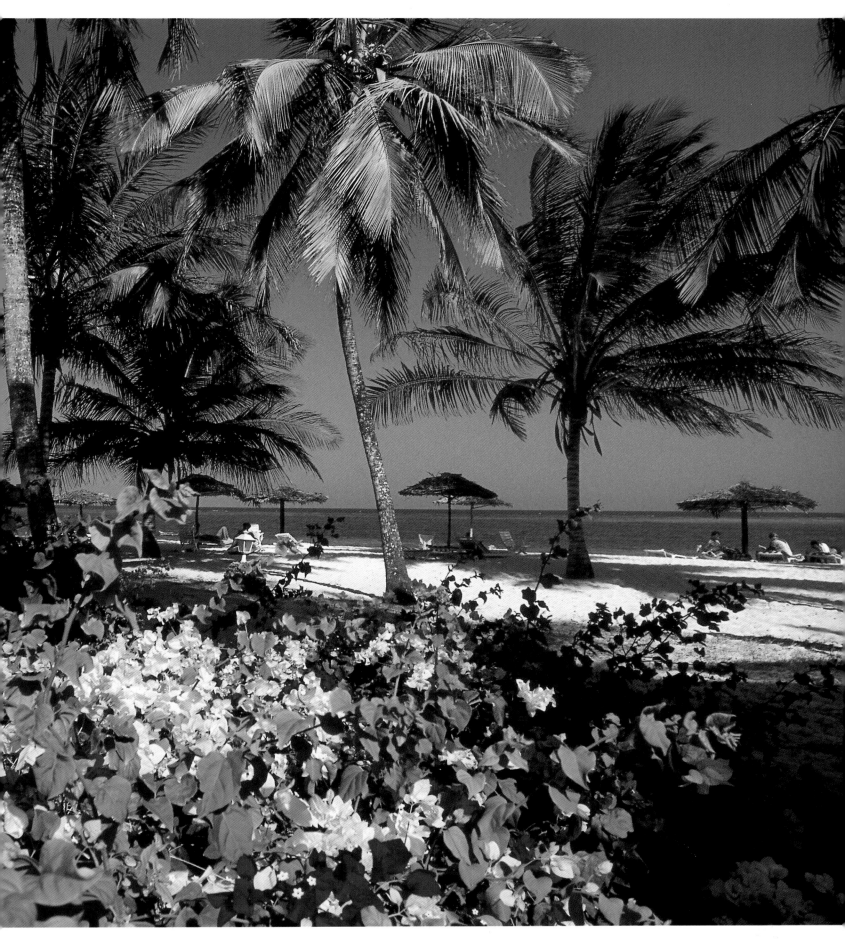

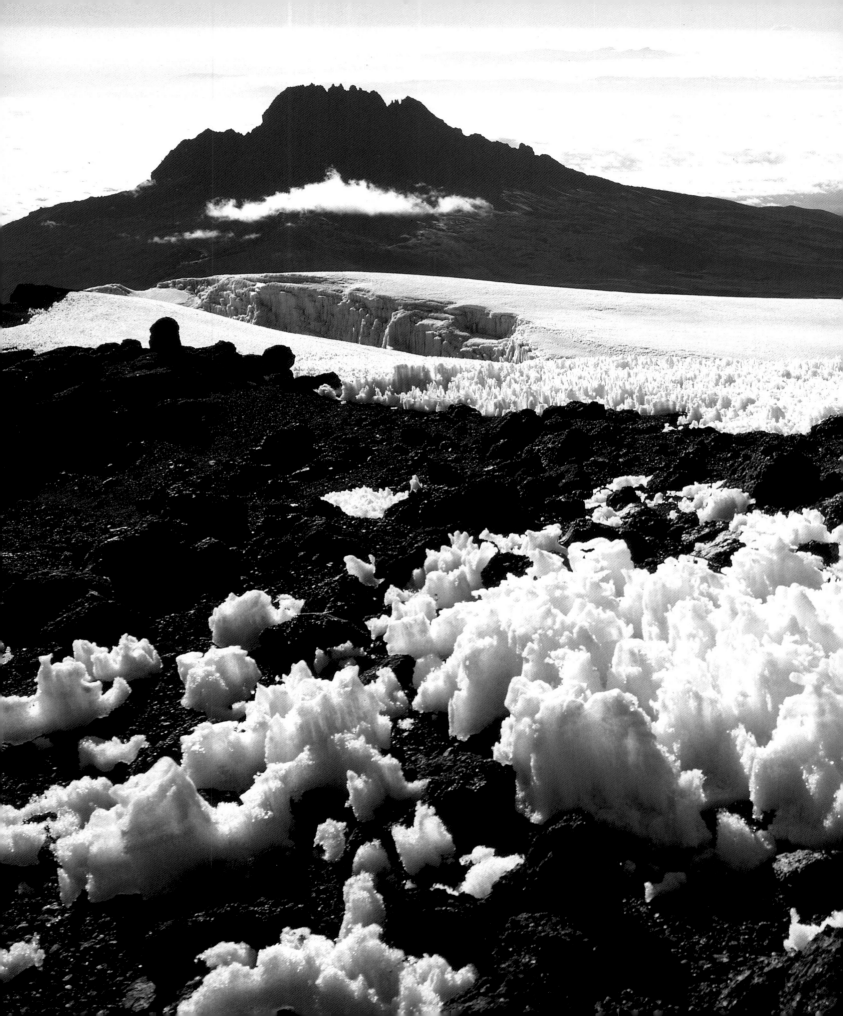

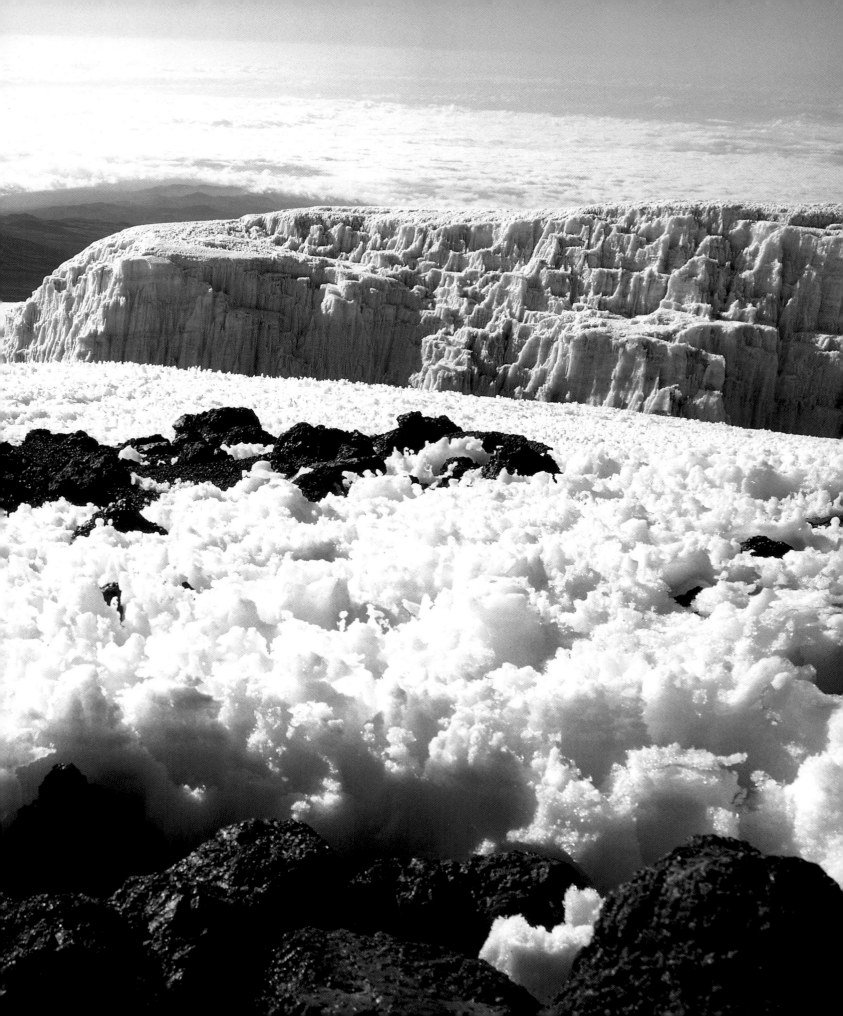

Heirs of Eden

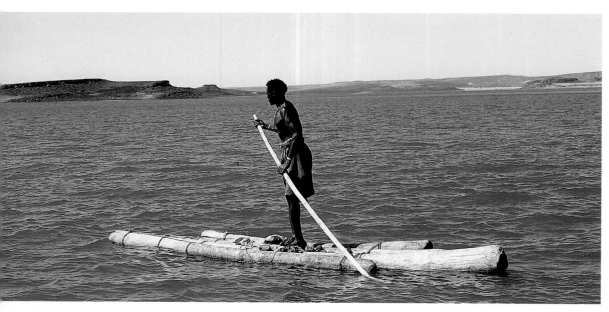

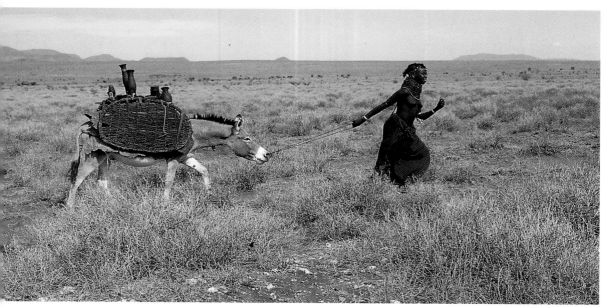

28 top *An El Molo fisherman sails over the waters of Lake Turkana in his dugout canoe, made from the trunk of a palm tree. In the early '70s this tiny tribe of fishermen comprised of only ninety individuals and was close to extinction. Today the El Molo number about 500 and together they share the harsh realities of life on Lake Turkana, in northern Kenya, with 30,000 crocodiles.*

28 bottom *A Turkana girl has a hard time convincing her pack-donkey to cross the stony wastes around Lake Turkana. Herders with numerous goats and few cows, the Turkana manage to survive - though not without difficulty - by using every single resource, no matter how small, that their natural environment offers.*

29 *Young Turkana girls cover themselves with red ochre and goat fat, partly as beauty treatment, partly to protect against sun, wind and insects. Piercing of ear-lobes and lower lips is common practice, and rings, lip plugs and other adornments are worn from earliest infancy. Their braided hair too, on heads shaved punk-style, is matted with ochre and topped with an ostrich feather to complete the decorative effect. The bead necklaces they wear are less elaborate than those of Masai women but have the same "embellishing" function.*

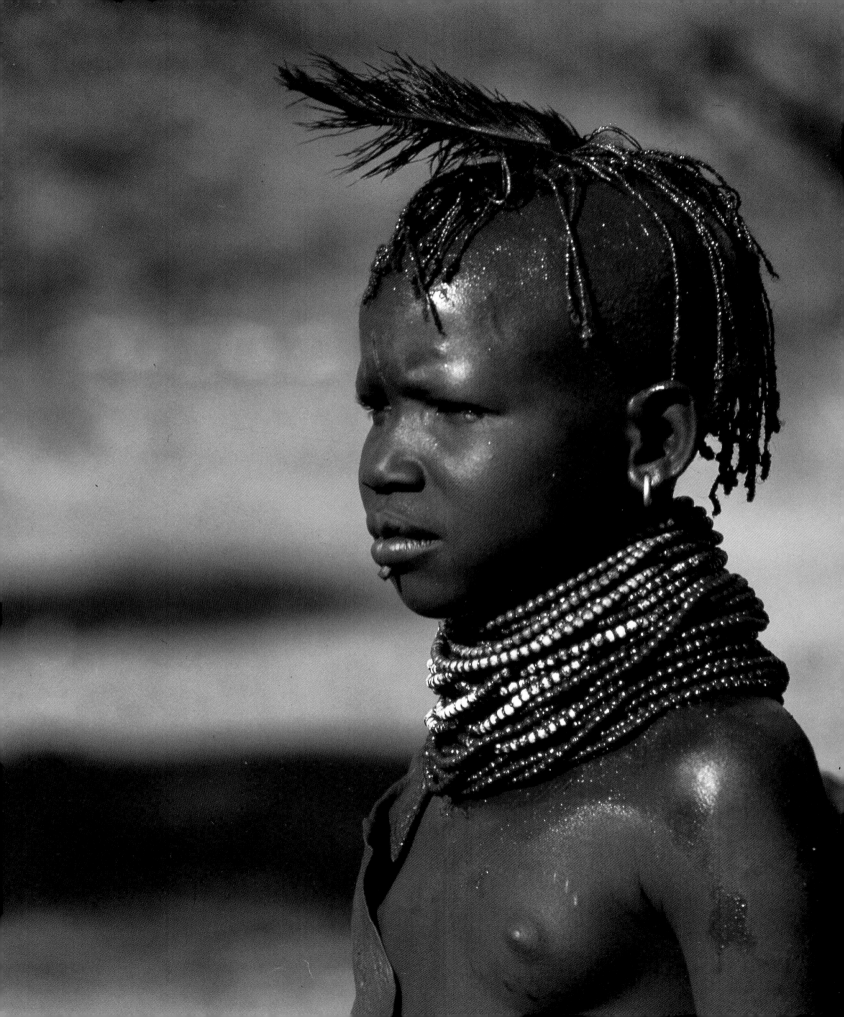

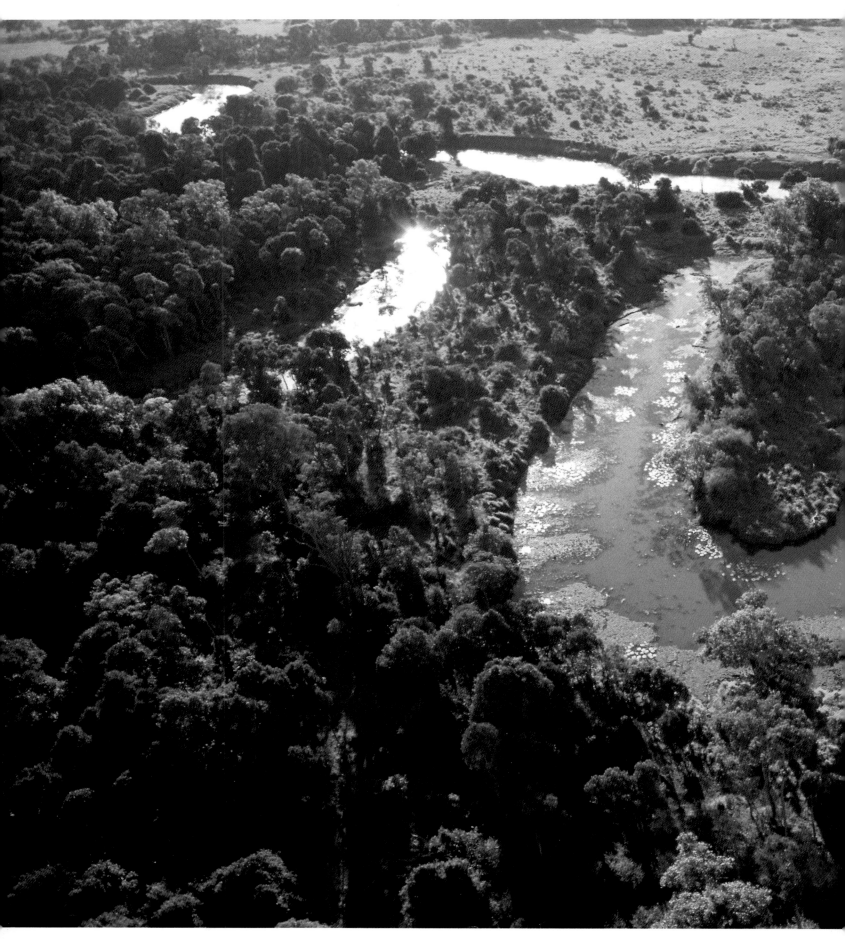

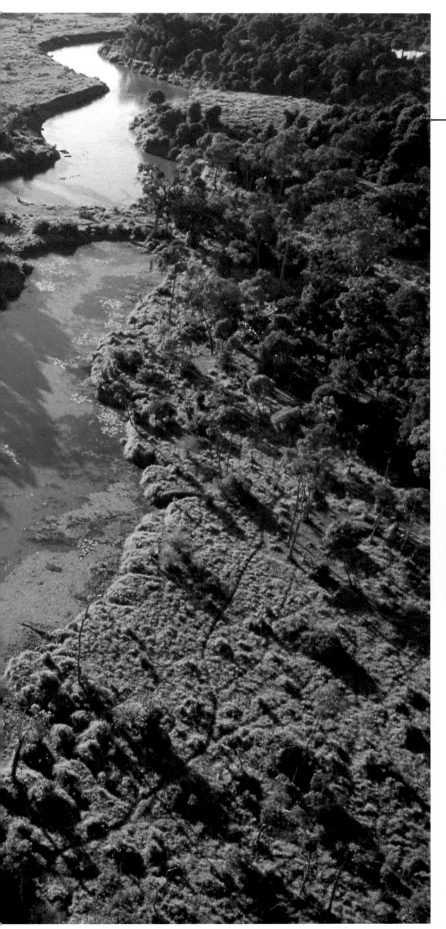

Water, precious source of life

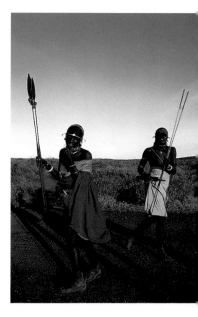

30 *Rainfall is erratic in the savanna and permanent rivers are rare: one of the few is the Mara, in the park of the same name on the border with Tanzania. The meandering course of the river digs a winding bed which, every now and then, widens to form small, halfmoon-shaped lakes that disappear in the dry season.*

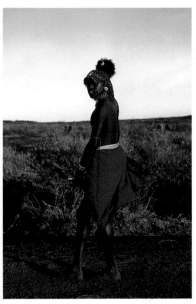

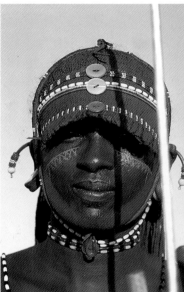

31 *The Samburu are close relations of the better known Masai. At the turn of the century the Samburu were simply a clan of Maa-speakers. Later, they became geographically isolated, for reasons attributable to the environment and to the arrival of British settlers in Kenya; cut off from their Masai cousins, they maintained traditional customs in their original form.*

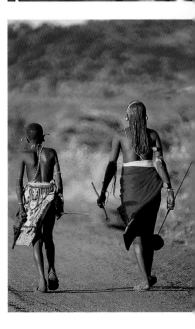

32 For visitors the savanna may have surprises in store: amid acacia woodlands north-east of Mombasa is a place called Mzima Springs. These natural springs are home to hippos and crocodiles and there is a special underwater observation point from which these creatures can be watched. Seeing a hippo waddle along, nibbling at bits picked up from the floor of a pool of clear spring water, is hardly an everyday occurrence!

33 Young Masai warriors have a very discerning concept of beauty, seemingly in contrast with the hard life they have to lead; they spend hours dressing their hair and deciding on colour combinations and ornaments. Before white men and mirrors arrived, the Moran adorned each other with make-up and ornate attire, a practice which helped strengthen bonds among peers. Nowadays the Moran dress up only to dance for tourists, sometimes in places far from the savanna, such as the beach at Malindi.

34-35 The Ewaso Ngiro widens as it crosses the plains of the Shaba nature reserve, not far from Isiolo. This vast, arid and harsh region has practically always been uninhabited.

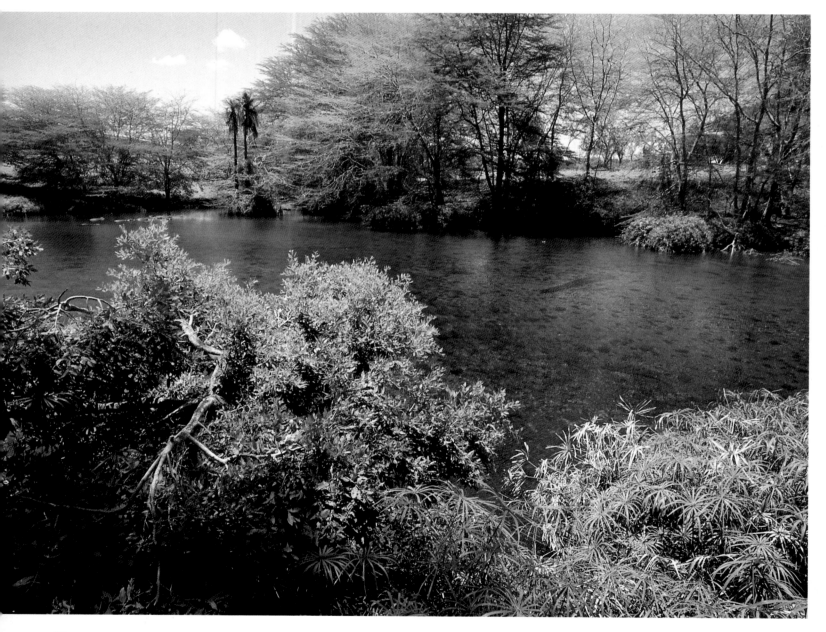

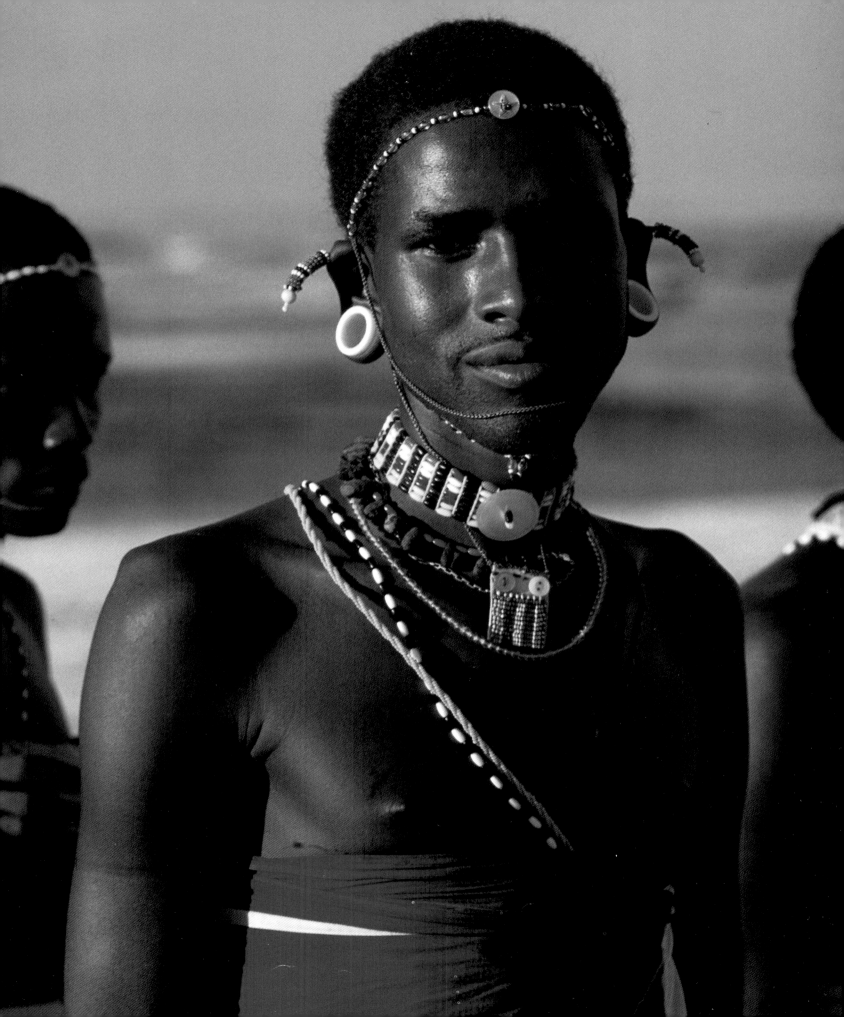

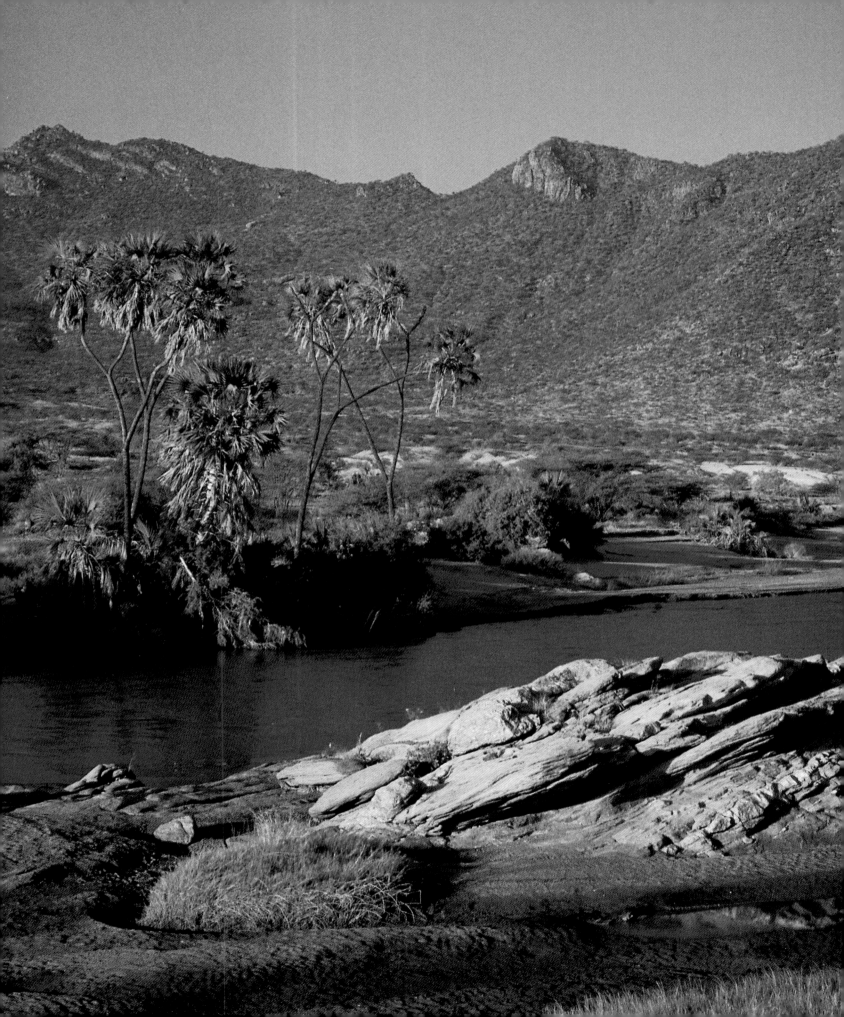

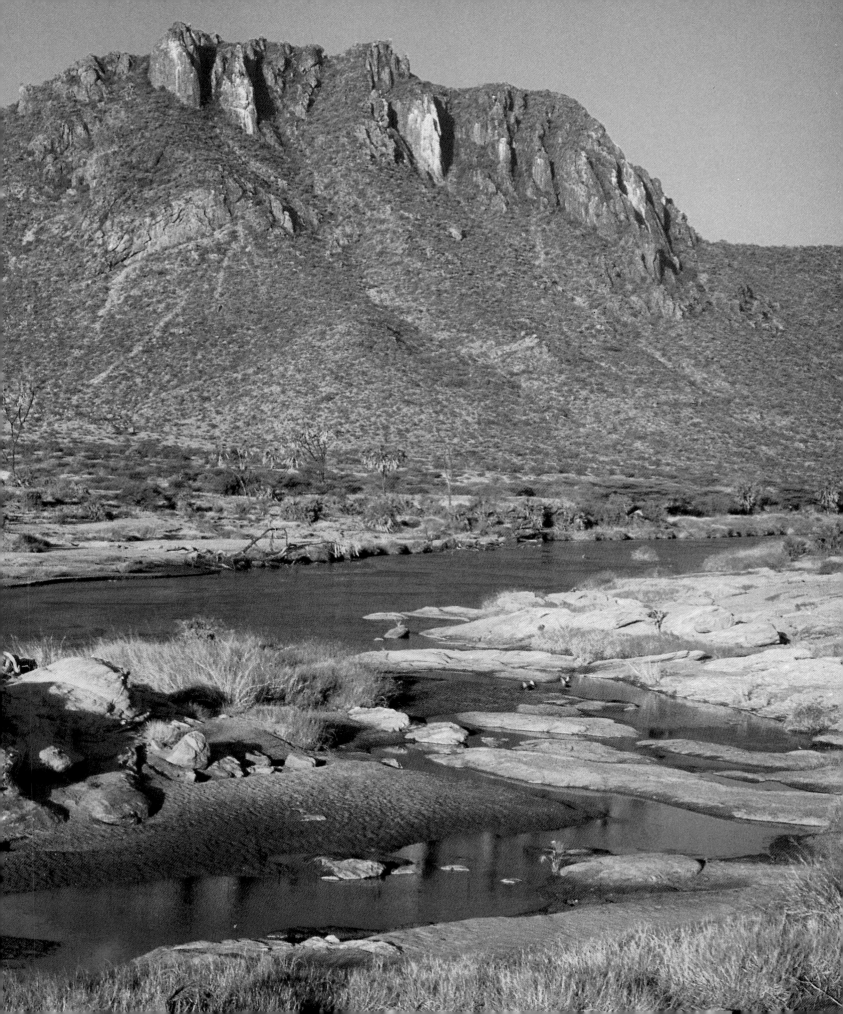

36-37 *The plains of the Masai Mara park, on the border with Tanzania, are typical of the savanna: tall grass stretches as far as the eye can see, a swaying sea interrupted only by the occasional 'umbrella tree' acacia or twisted ficus (on the right). Here rain comes rarely, and goodness knows when.* But when it does come, it is nothing short of a deluge. The months when it is most likely to rain are March and April but violent storms - with thunder, lightning and cascading water - can strike at any time. As soon as the thunder clouds roll away, out comes the burning sun of the savanna again.

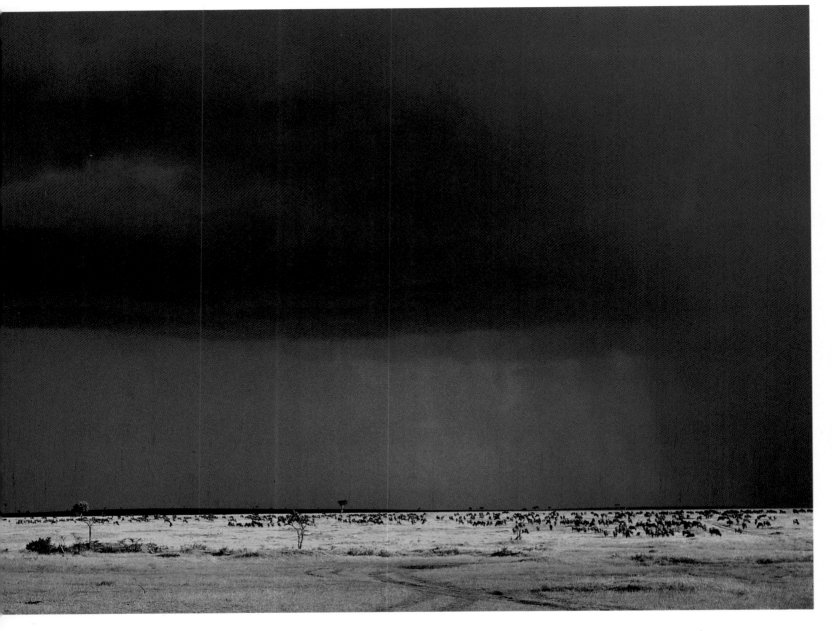

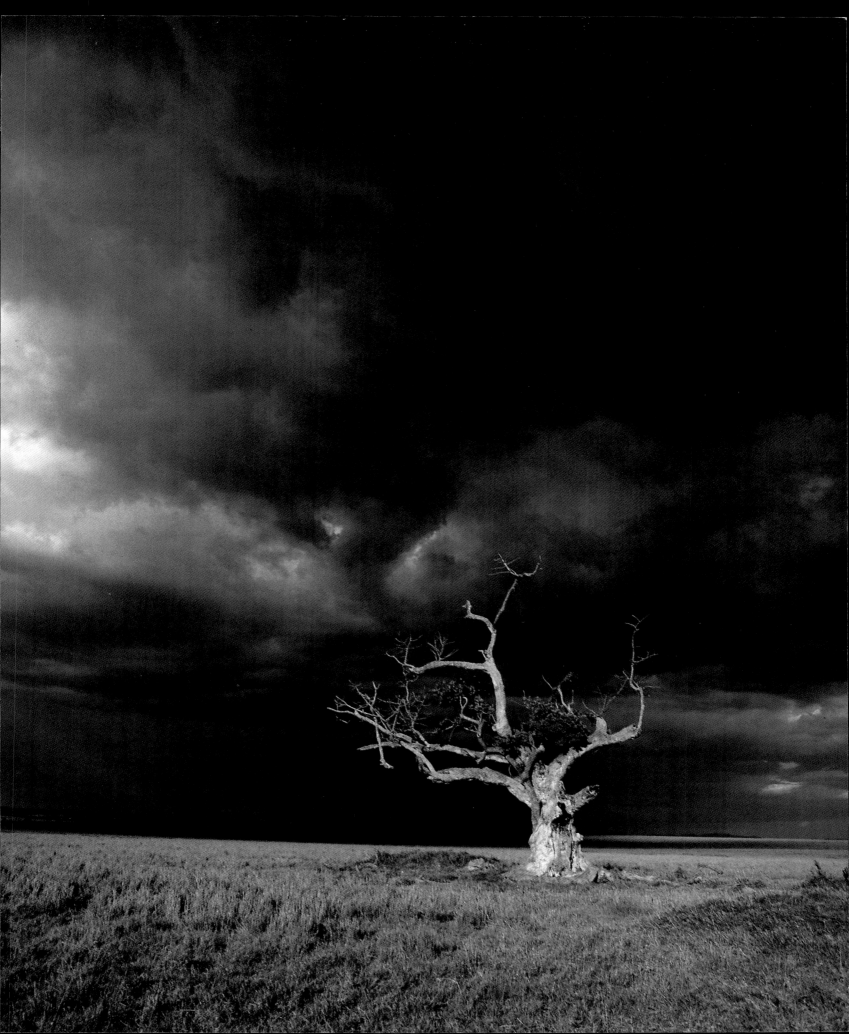

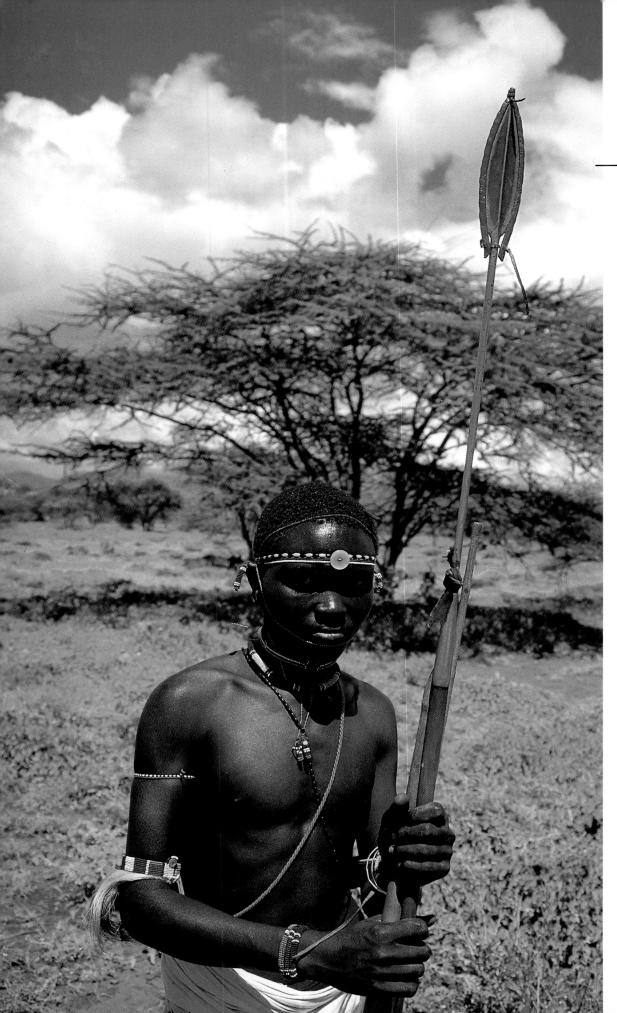

The language of painted bodies

38-39 *Red seems to be the favourite colour of young Samburu, perhaps because of its association with blood. Among these herdsmen, letting their animals' blood and drinking it is common practice: it is a system that allows them to obtain a high level of protein from their livestock without doing them any damage. Meat is eaten by the Samburu on ceremonial occasions only: they do not kill their "capital". Young men (on the left)* still sport their tribe's traditional weapon: a long foliate-headed spear, its cutting-edge protected by a leather strap as a sign of peaceful intentions. *The girls (on the right)* no longer wear skirts made from soft goatskin, dyed with ochre and decorated with beads; poor-quality red material, bought cheaply at local markets, is now used to make them instead. Their breasts too, once adorned with just beads, are now prudishly covered by cotton tops.

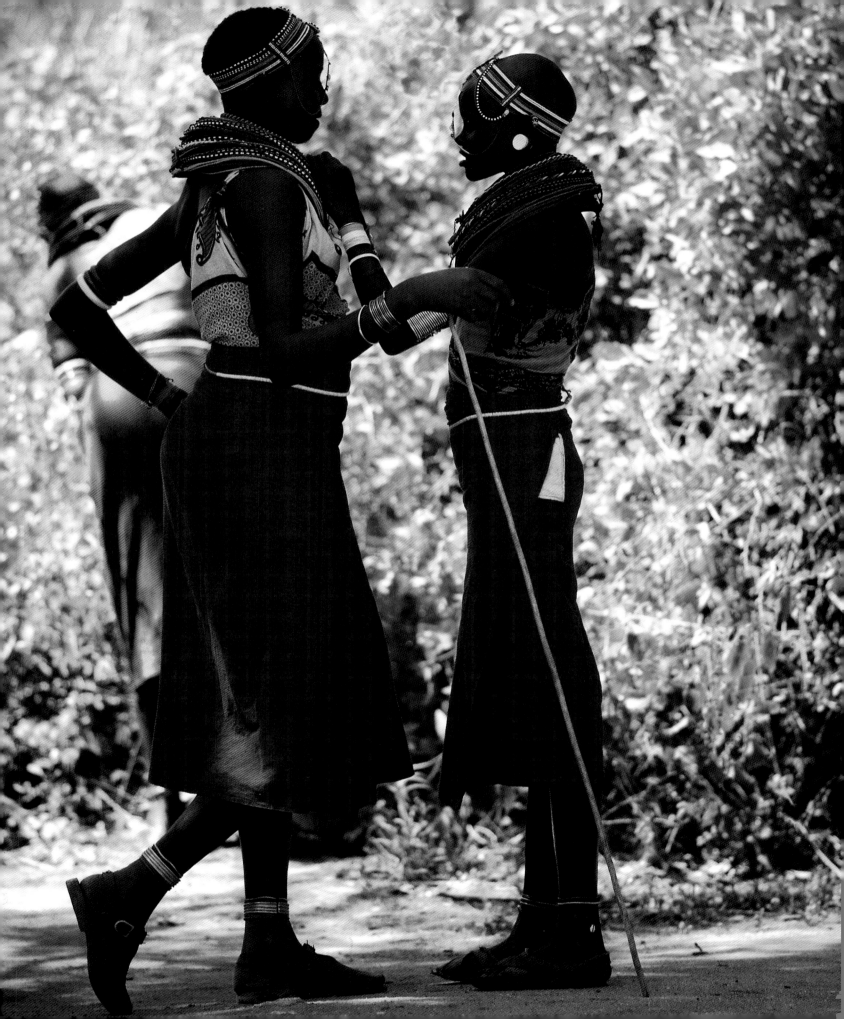

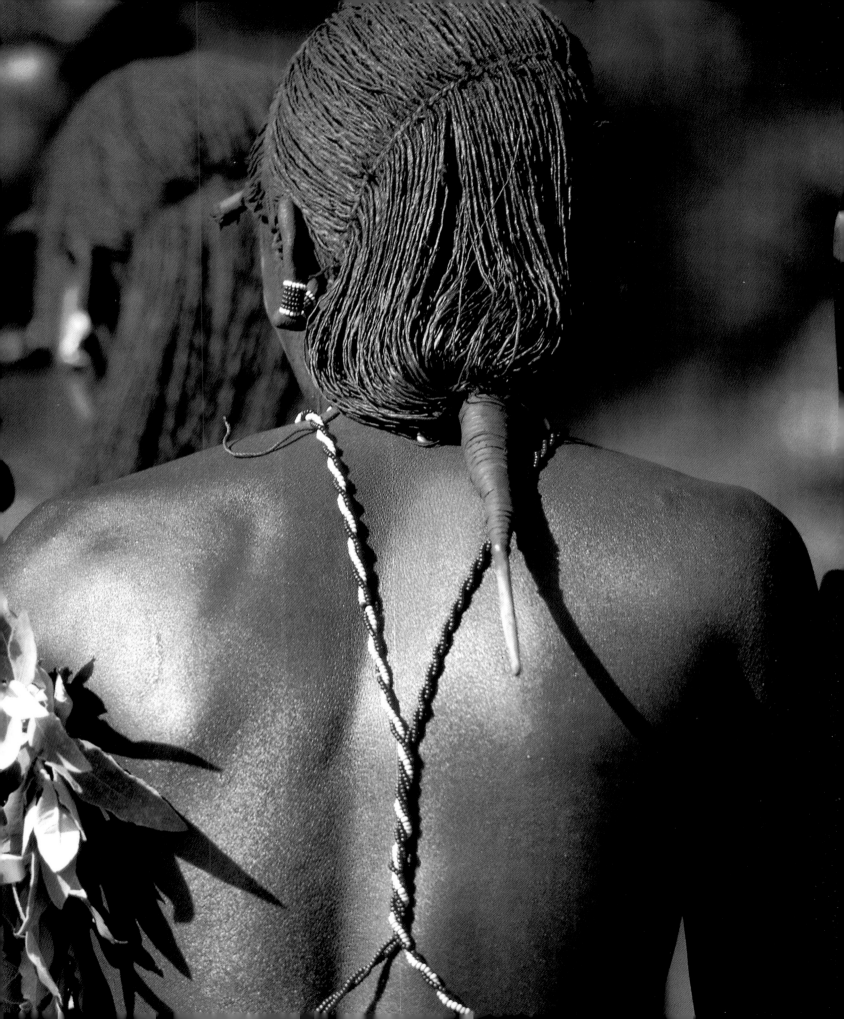

40-41 *Masai warriors take great care of their hair. The elaborate braiding is matted with ochre and goat fat, another reference to blood and animal life, for the Masai live in complete symbiosis with their livestock. In a certain way their hairstyles resemble manes, with downward-pointing horns sticking out of them. With such an ornate hairdo, two pairs of hands are needed to obtain the desired effect. And to ensure it remains unspoilt when sleeping, these warriors rest their heads on wooden neck stools.*

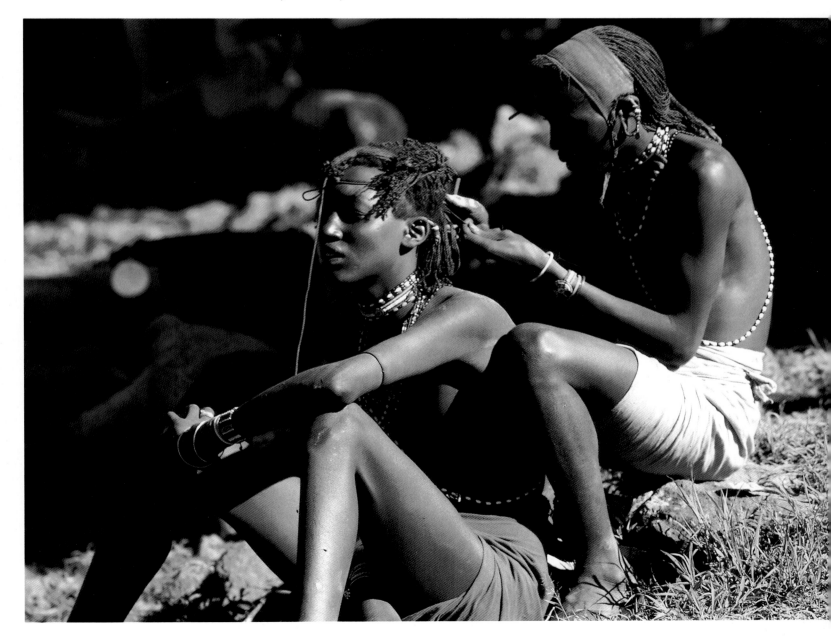

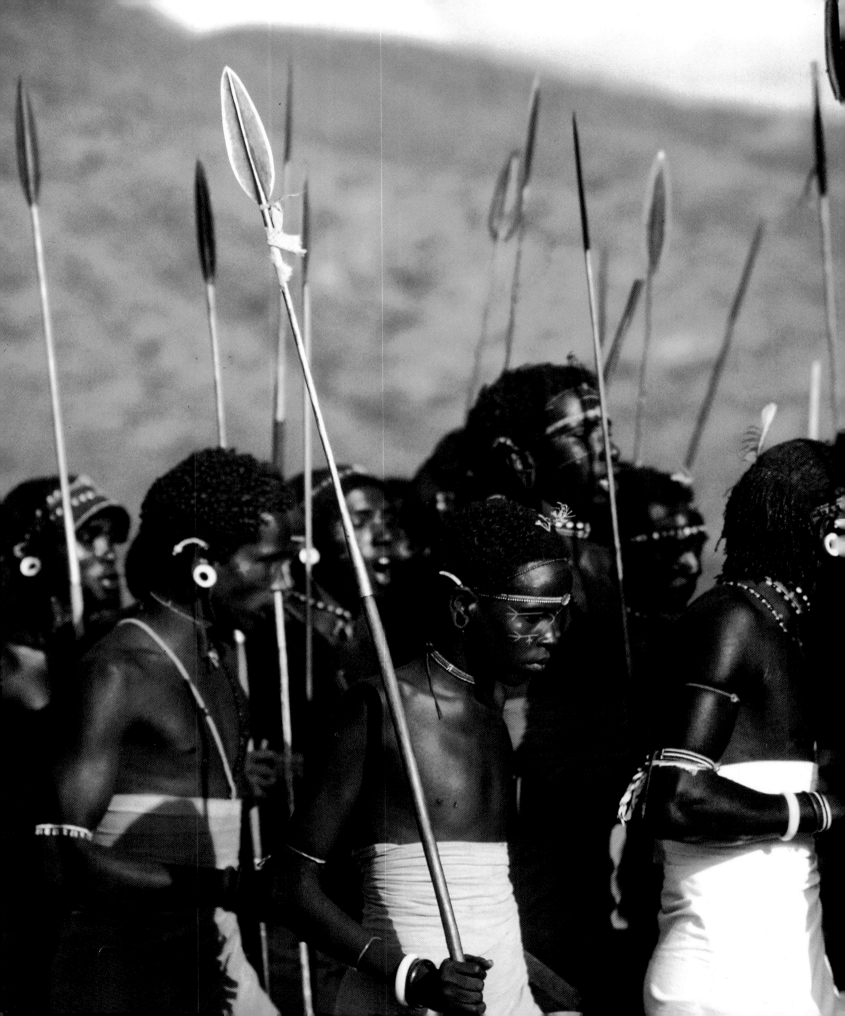

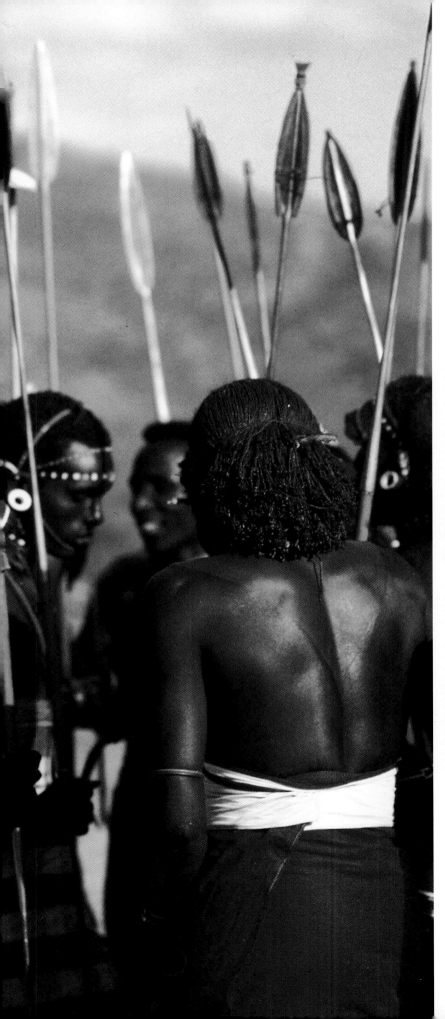

42 *The tribal dances performed by young Samburu on Loroki Plateau are a means of cultivating group cohesion. In a society of herdsmen like the Samburu, based on clan membership passed down from father to son, there is a tendency for small family units to break away and form settlements scattered over a wide area. Communal spirit is therefore re-established in horizontal segments formed of age sets; these impose strong bonds of mutual aid and brotherhood on individuals from different families.*

43 *The physical appearance of this Masai woman is not simply a question of personal aesthetic taste: the type of ornaments she wears and her shaved head indicate her status, that of a married woman.*

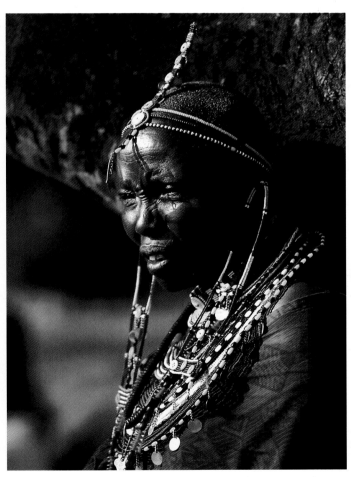

44-45 *In the north of Kenya live many pastoralist tribes of considerable ethnological and human interest (among them Samburu, Turkana, Rendille, Gabbra, Borana, El Molo, Ndorobo and Pokot); a ubiquitous feature of the scenery in this part of the country are thorny acacias, here contributing to the spectacle of a beautiful sunset.*

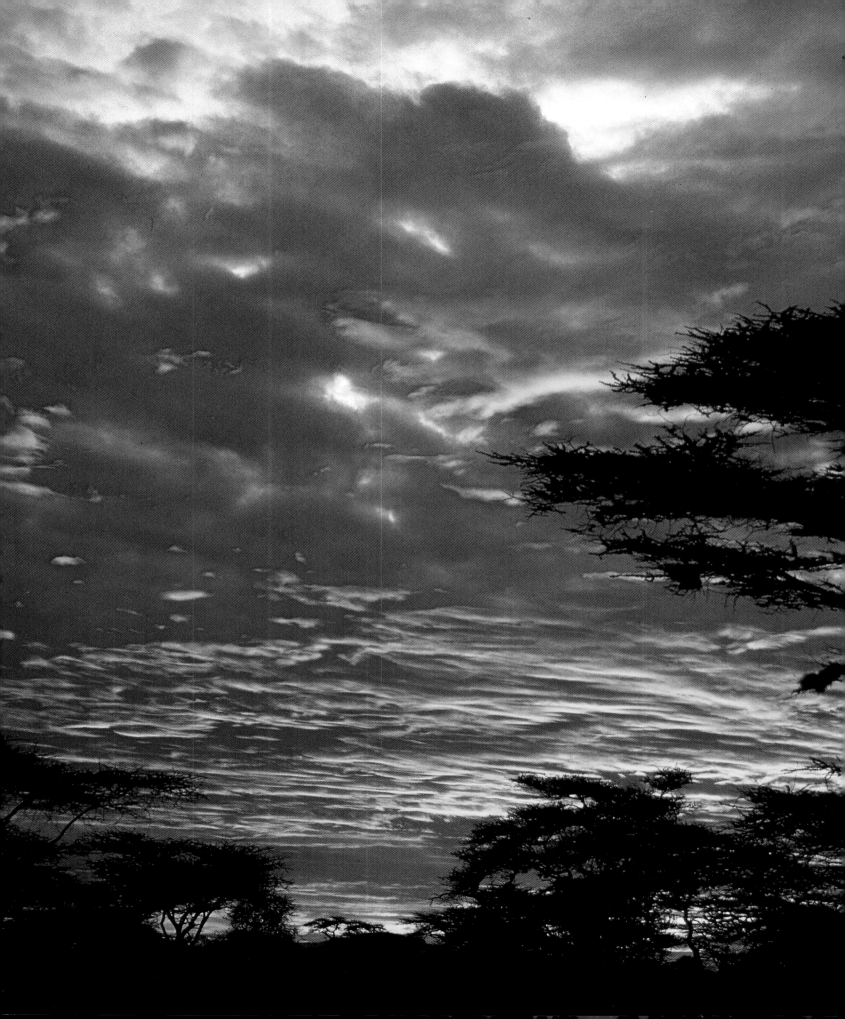

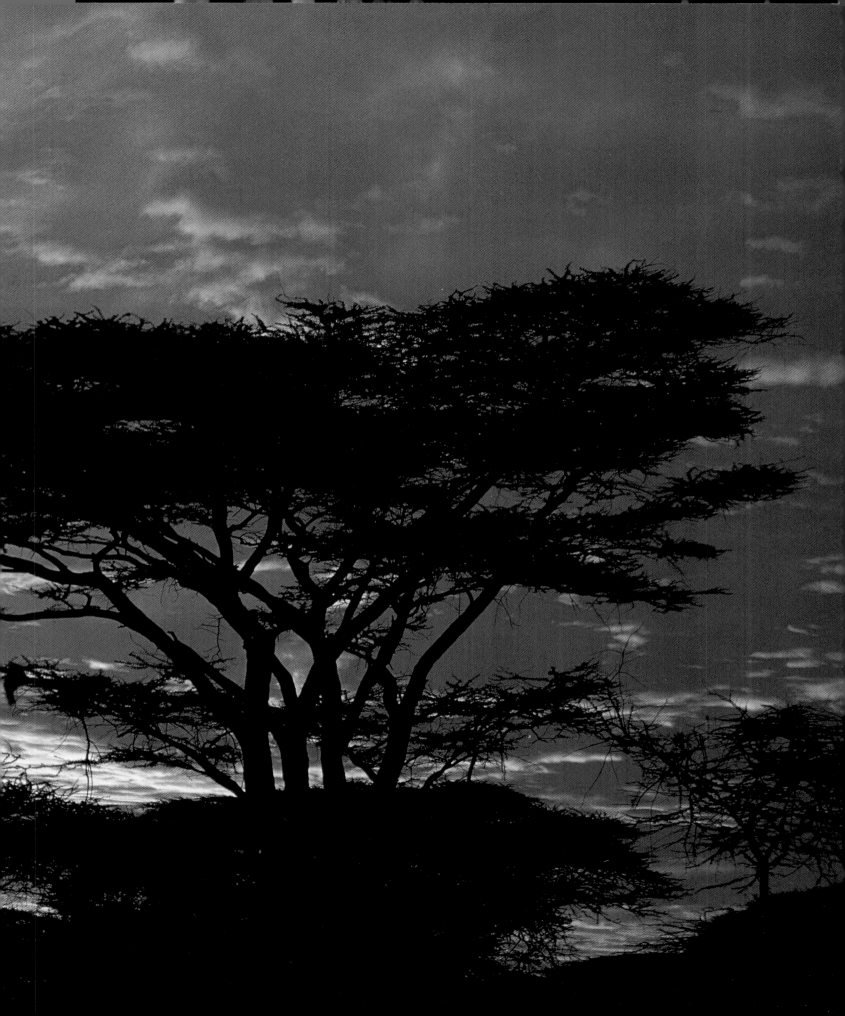

Peoples of the lakes

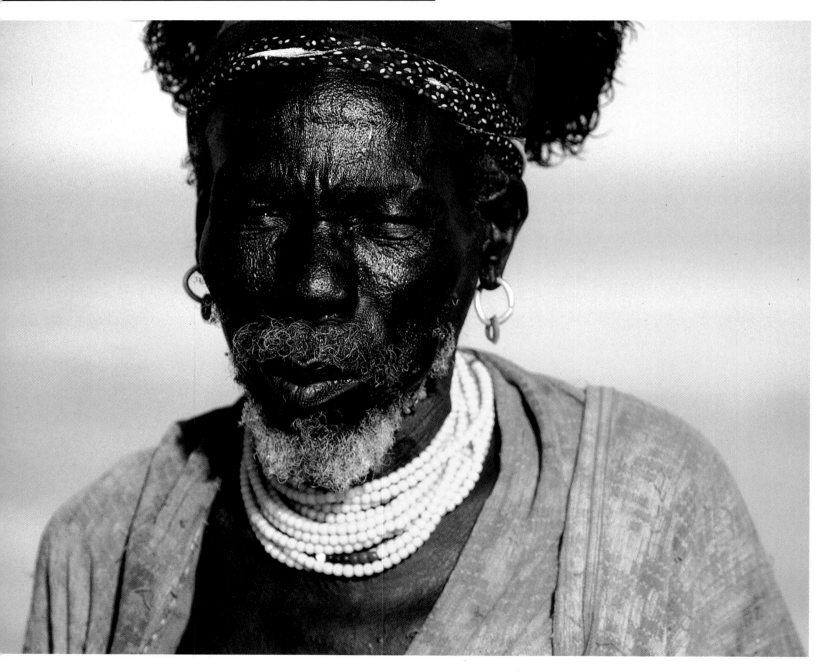

46 In Turkana tribes the term "elder" is used for all married men; but as the "price of a bride" - the dowry a man has to pay to take a wife - is very high, it follows that a man does not become a husband and father until a certain age.

47 A herd of dromedaries led by Rendille herdsmen drink on the shores of Lake Turkana. To survive in this hostile setting they have to keep constantly on the move and search for new resources, which basically means fresh pasture and water.

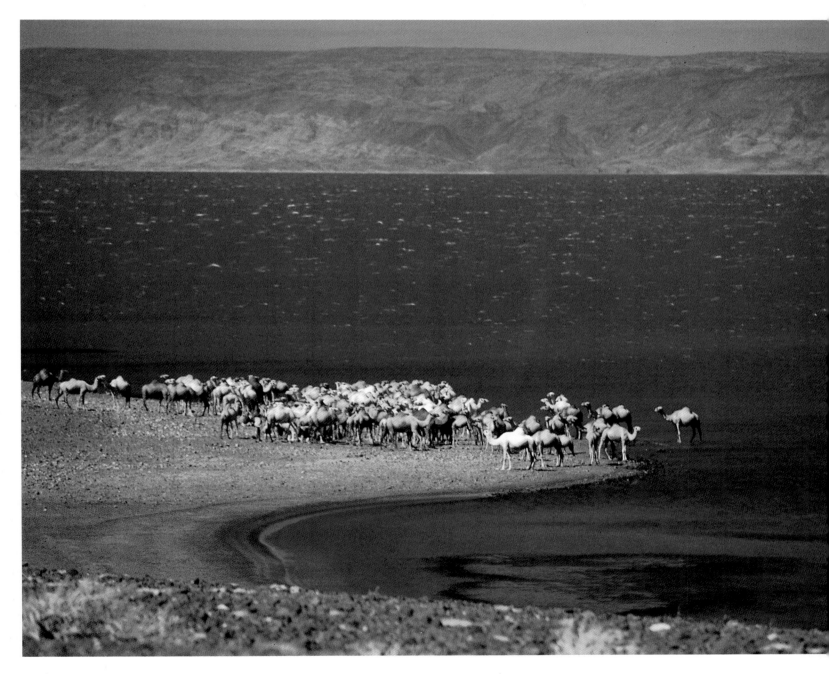

48-49 *On Lake Baringo, at the centre of the Great Rift Valley, Njemps fishermen still use boats made from reeds which they row with simple wooden paddles: a scene not unlike one that could have been seen along the banks of the Nile eight thousand years ago. In this respect the Njemps remain faithful to their Nilotic origins (also evident in the Mongolian fold beneath their eyes).*

50-51 *At Von Honel bay, in the extreme south of Lake Turkana, one can see - in the foreground - the volcanic mud that solidified to form the Abili Agituk; in the top right is the perfect crater of Nabuyatem ("Elephant's belly" in Turkana); the mountains all around are those of South Island and the Loriu plateau which forms the western bank of the bay.*

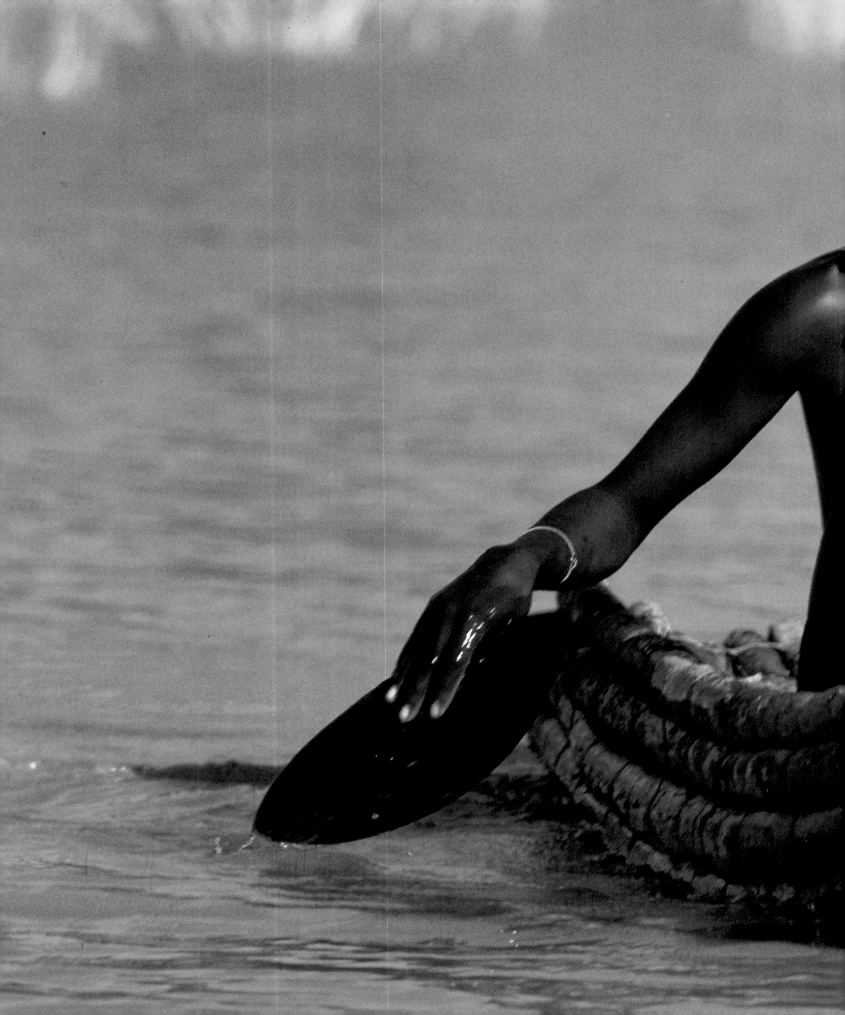

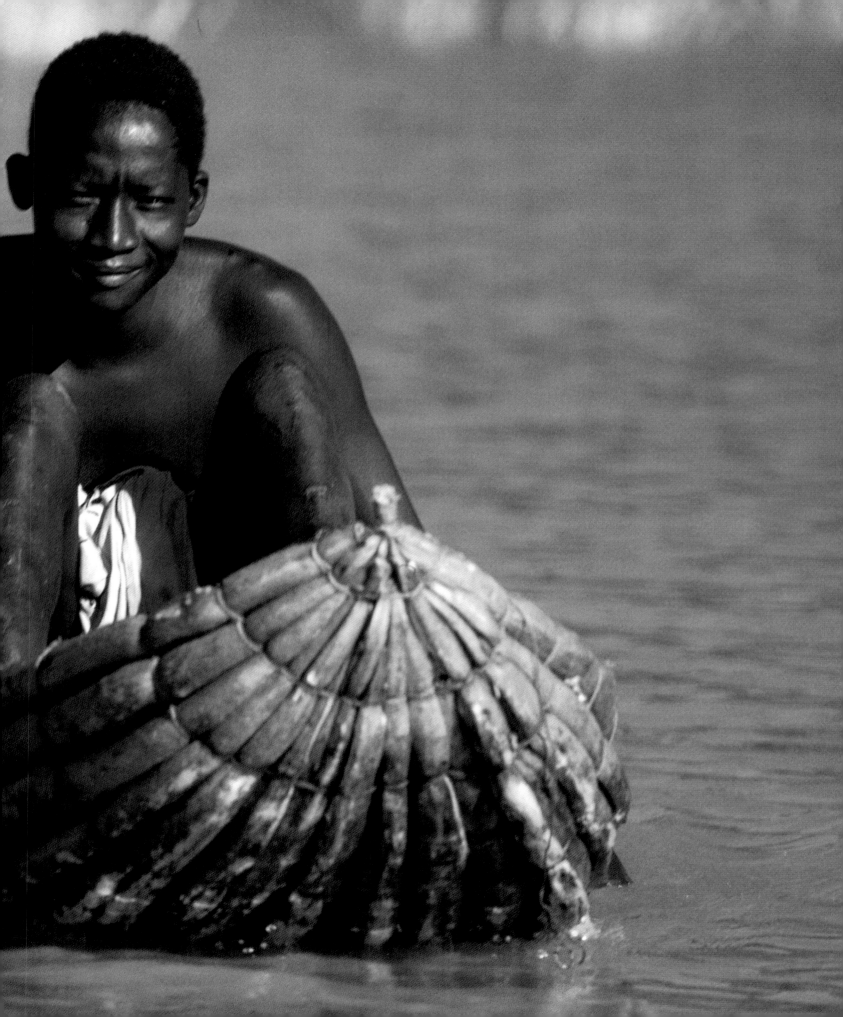

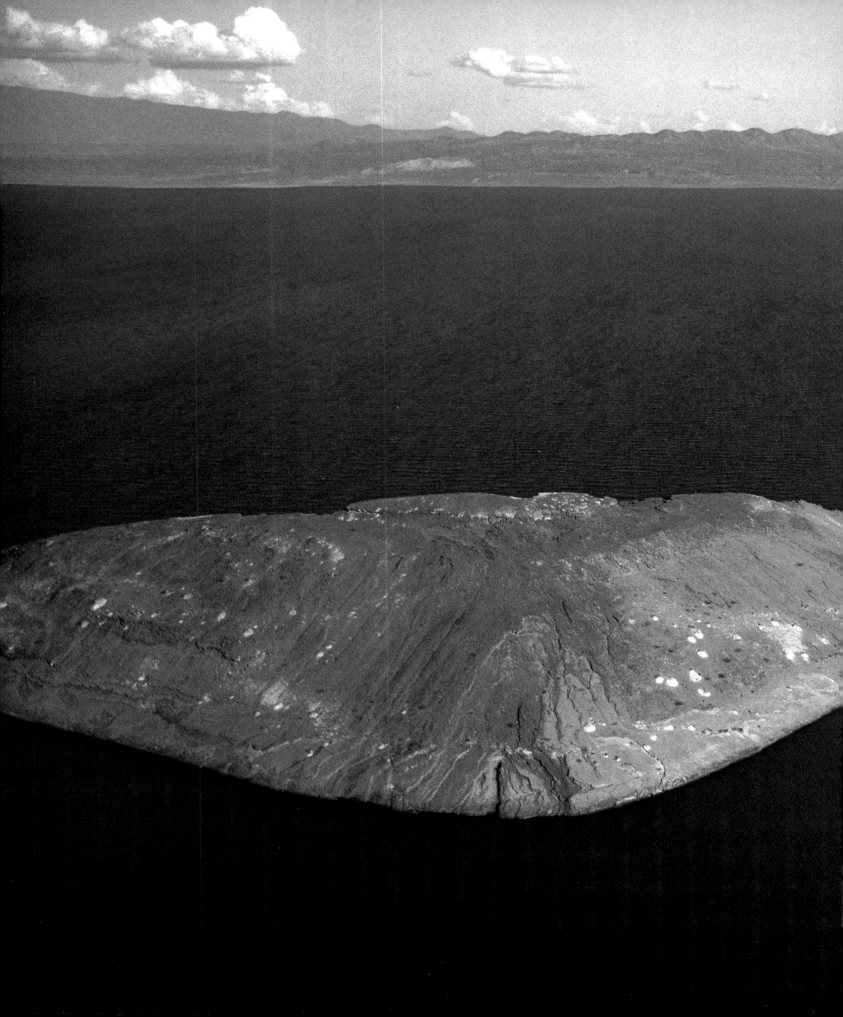

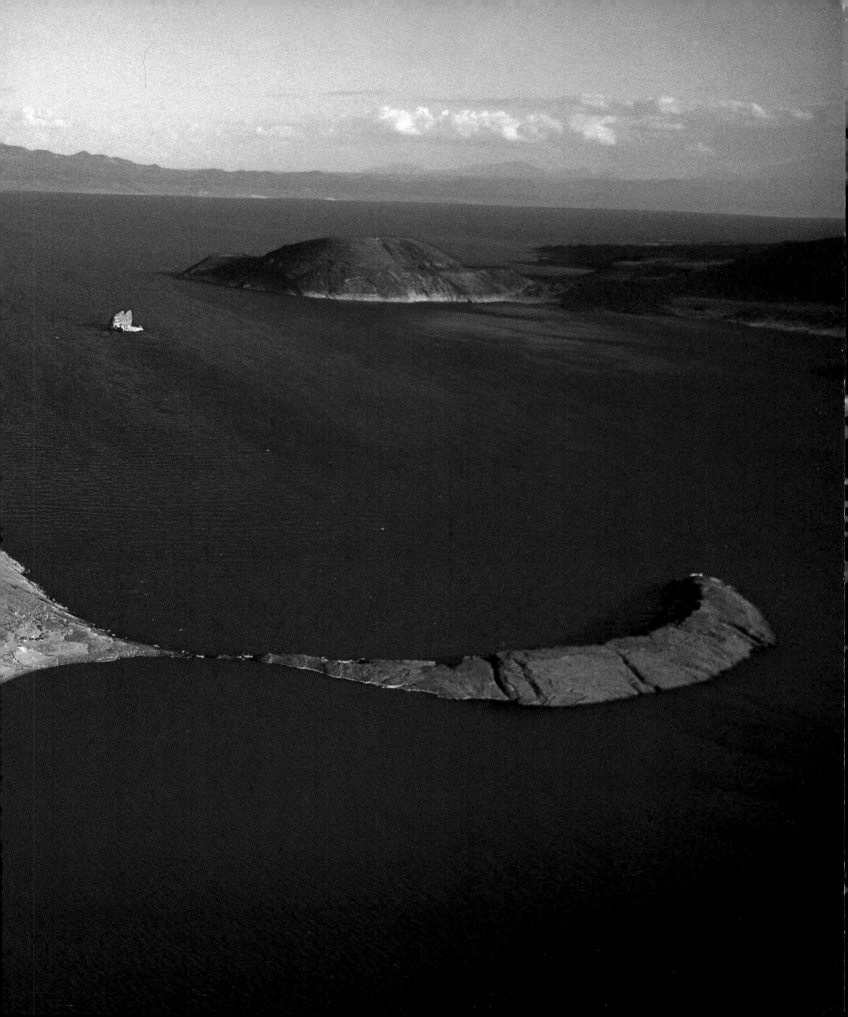

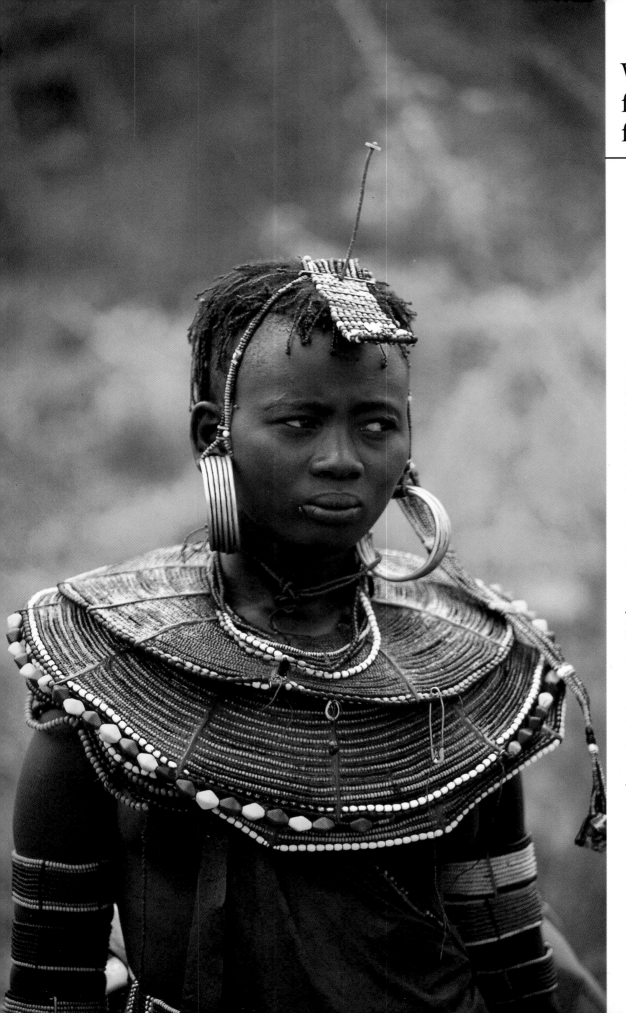

Women between frivolities and fatigue

52 The regions around Lake Baringo are inhabited by the Kalenjin, in recent years world-renowned for their successes as long-distance runners. They are divided into a number of groups. One such group are the Pokot, famous for the hairstyles and bead necklaces of their womenfolk, like the girl pictured here. Maybe it is the chromatic monotony of the savanna that helps stimulate this explosion of colours. An important point to note is that a baby being fed at the breast is always in contact with these beads: in such a barren environment, the mother's necklaces become a visual super-stimulus, essential for the well-balanced development of the child.

53 The area where the Turkana live may be a hostile semi-desert but they too get pleasure out of body decoration and adornment with "cosmetics", beads, pendants or a pair of ostrich feathers, worn by men and women alike with equal ostentation.

54-55 A Gabbra caravan travels along a track that goes from the Chalbi desert to Lake Turkana, in northern Kenya. Muslims of Ethiopian origin, this people is constantly on the move in search of pasture. On its back each dromedary carries what amounts to the home and household belongings of one family. When a stopping-place is found, the bent poles are used to form a half-dome structure that is quickly covered with skins and mats; the rest of the household goods are contained in two baskets. The job of building the makeshift hut is left to the women.

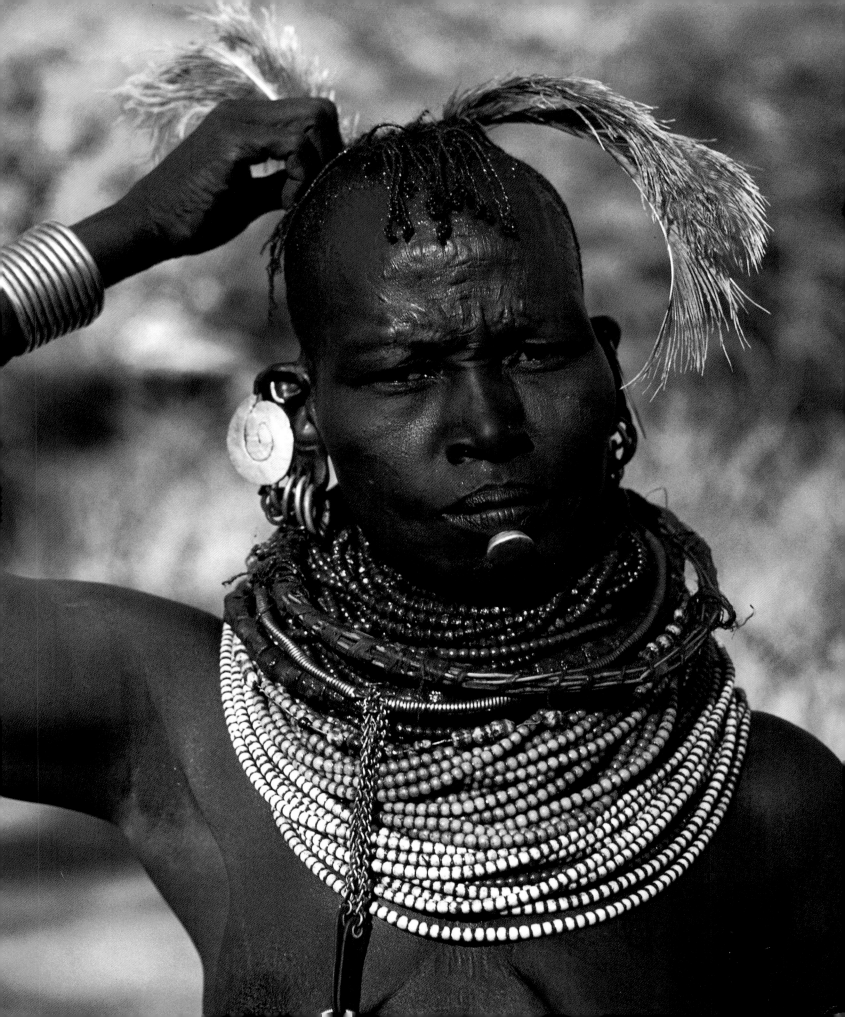

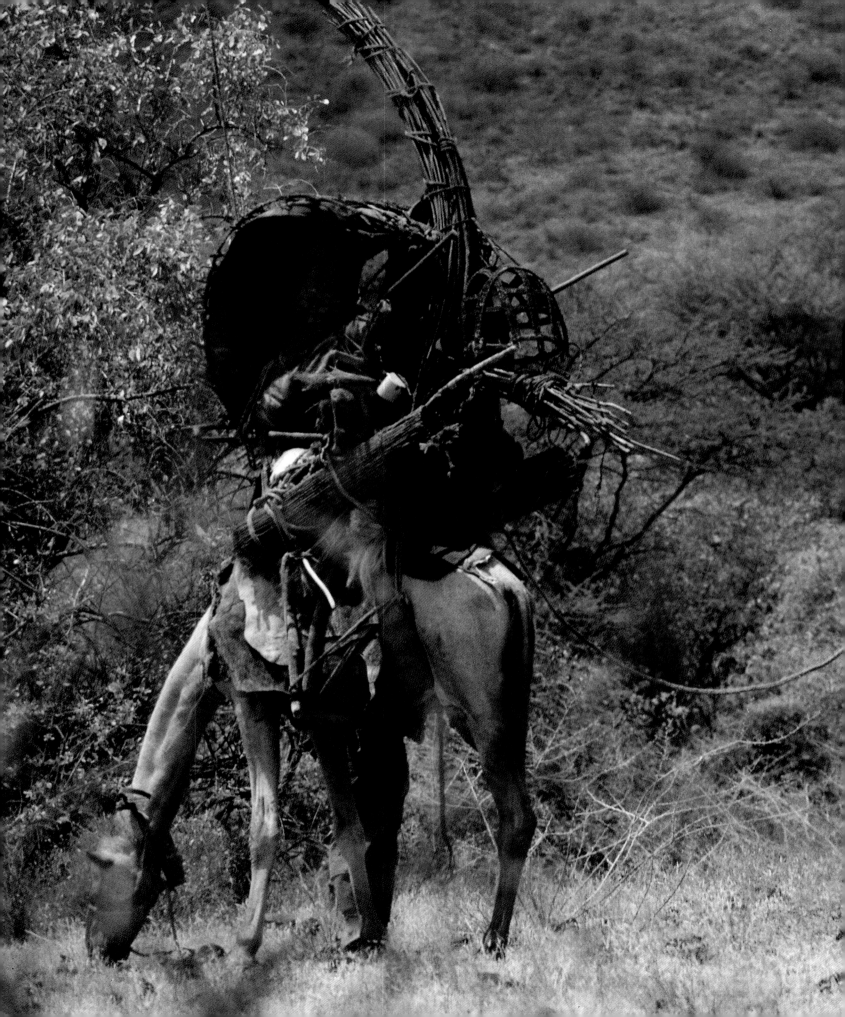

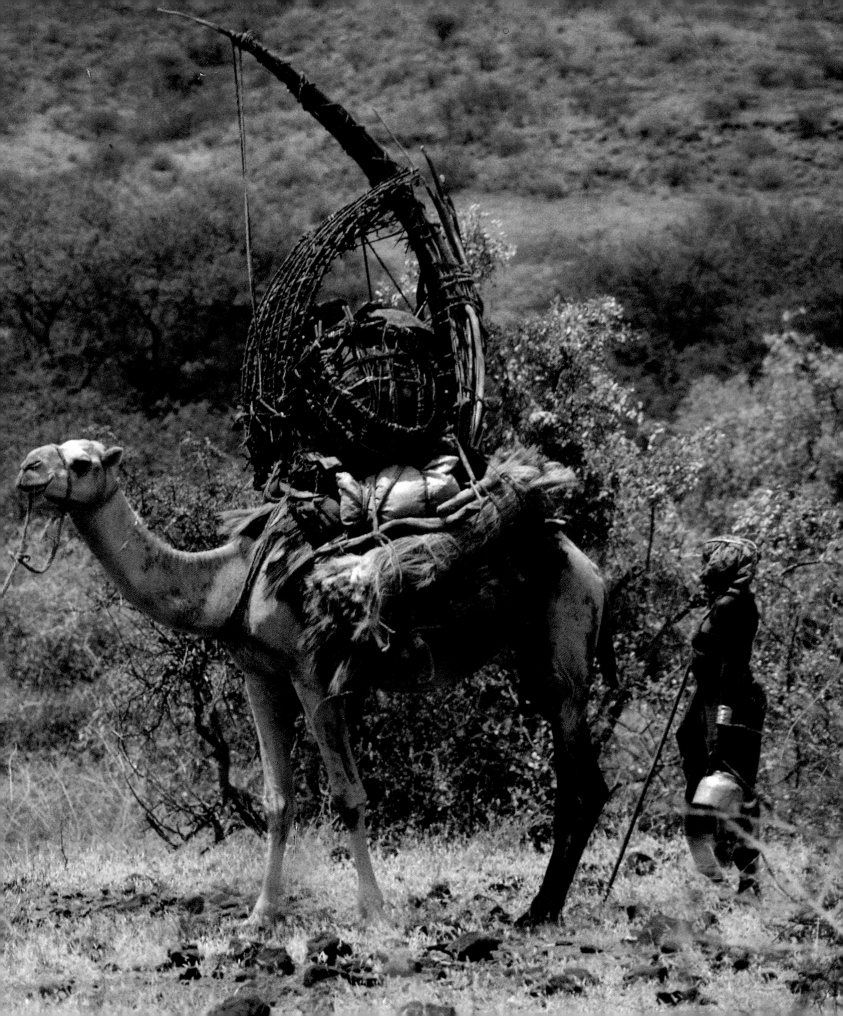

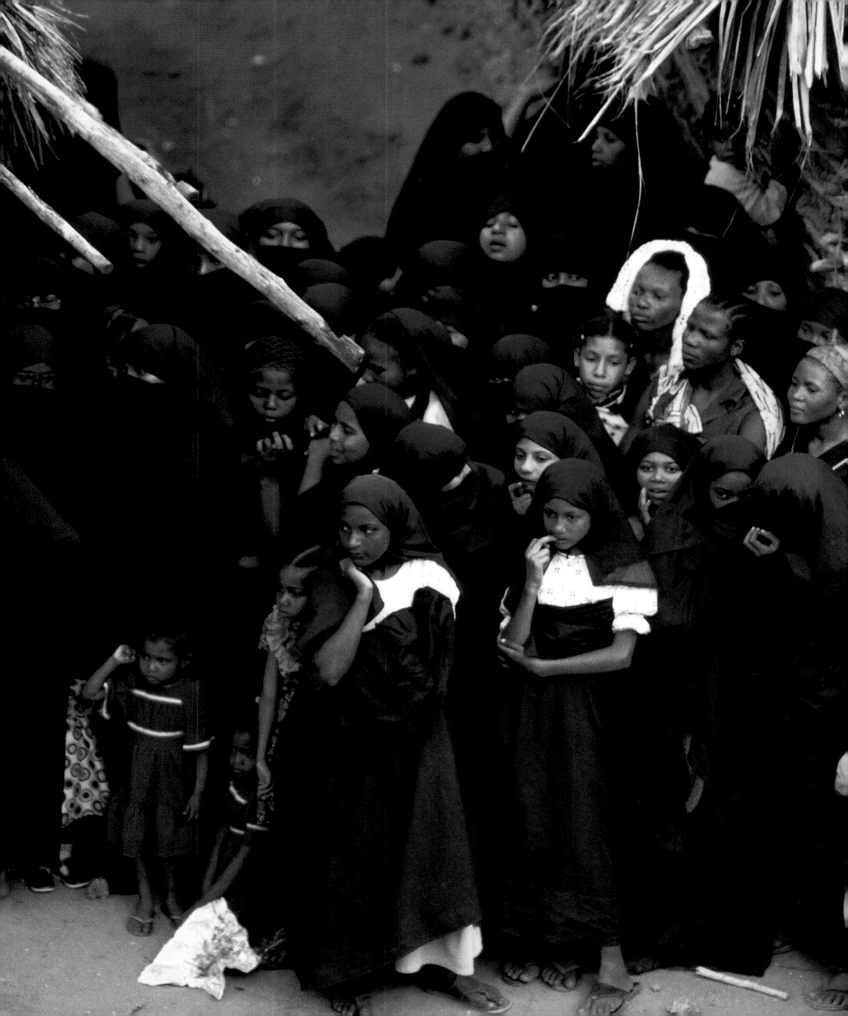

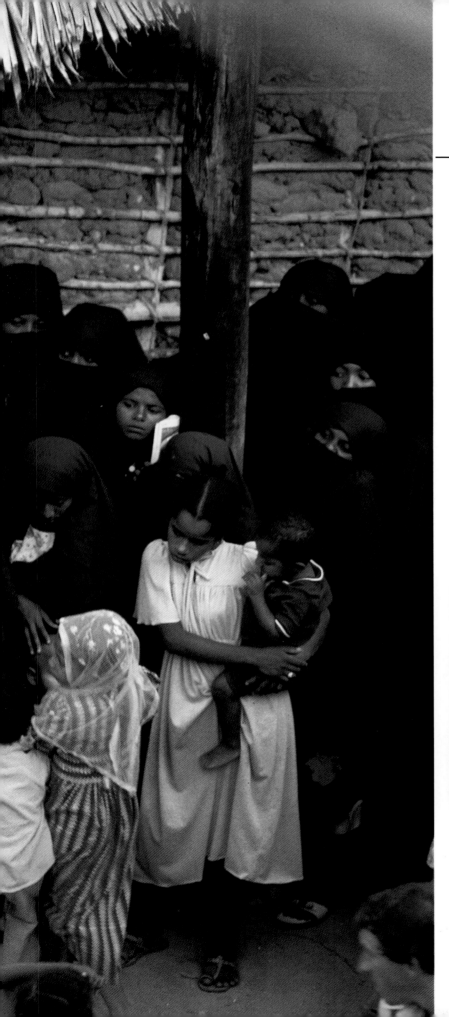

The "Swahilis from the Coast"

56-57 *Arab seafarers were early explorers of the coast of Kenya. Here they founded trading stations, such as the island of Lamu; this photo of some of its inhabitants highlights their Muslim-Arab characteristics. The ethnic blend produced by the integration of Islamic traders and the local Bantu population has resulted in a distinctive physical type: Swahili (meaning in Arab: "belonging to the coast").*

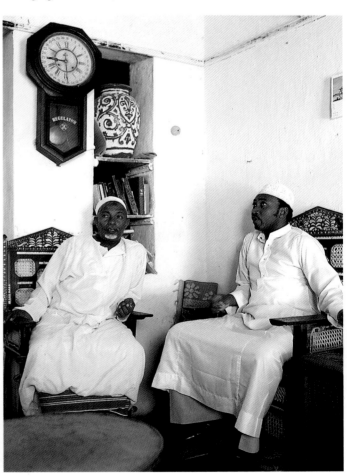

58-59 *There is another side to present-day Kenya: that of business and enterprise. The vast central highlands have been turned into thriving estates where a single cash crop is grown, like the tea plantations at Kericho. In this town there is still an old hotel, the Tea Hotel, where a fire burning in a large stone fireplace takes the chill off the air - Kericho is situated at an altitude of 2,000 metres - while waiting to enjoy a steaming cup of tea with the local farmers.*

57

God's
own snow

60-61 *At the beginning of the Pleistocene, four million years ago, the area that is now central Kenya was shaken by a tremendous eruption, followed by another a million years later. The result of the convulsions was the huge volcano we now call Mount Kenya, rising to a height of 5,199 metres. Over the years closeness to the Equator has turned a desert of lava into a kind of seedbed for the propagation of strange types of high-altitude vegetation.*

62-63 *Bergland Falls are one of the landmarks encountered on the climb to the peak of Mount Kenya. Water from the continuously melting glaciers of the summit feeds numerous streams and rivers which, in the course of millenia, have turned the sterile lava into a rich soil from which lush vegetation has developed amid the masses of basalt rock.*

64-65 *One of the first explorers to ascend the slopes of Mount Kenya, spurred on by his interests as a naturalist, was Count Teleki, after whom this small valley is named. He came across small forests of Senecio Kenyodendron, similar to the ones depicted in the photo: trees that sometimes grow to heights of nearly 9 metres.*

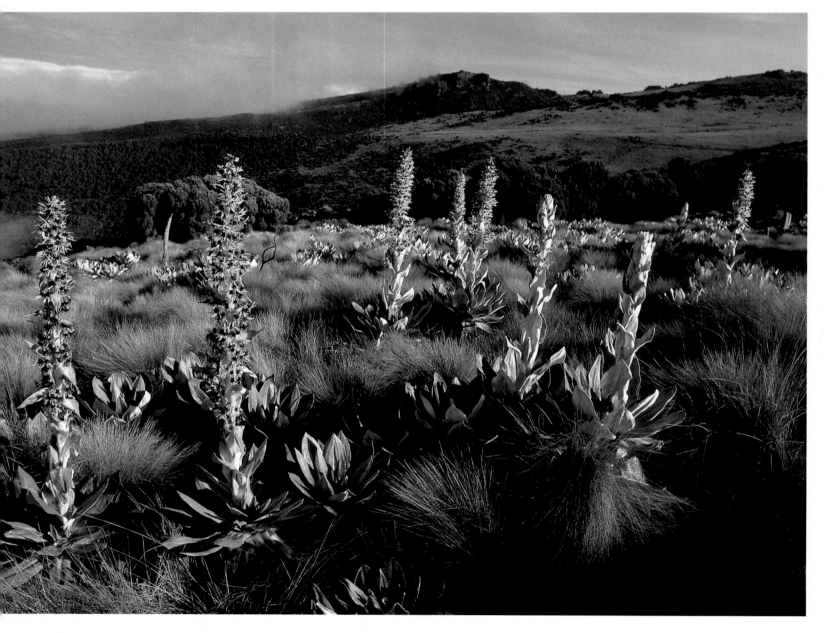

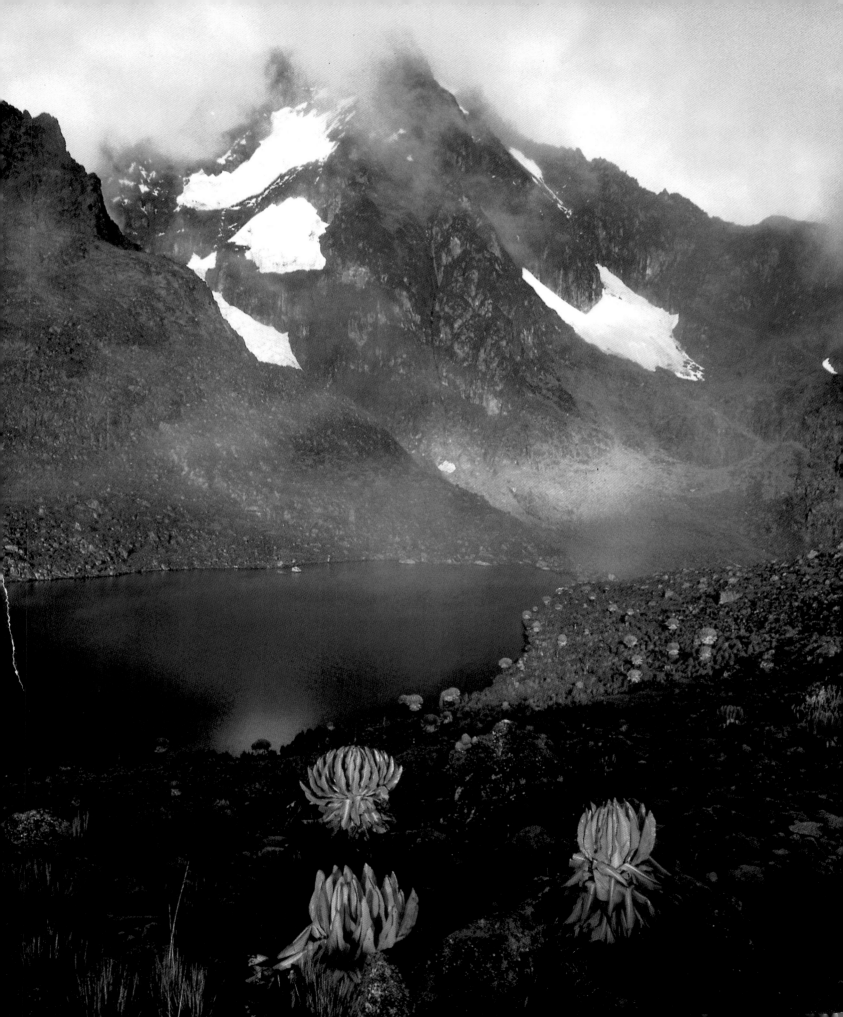

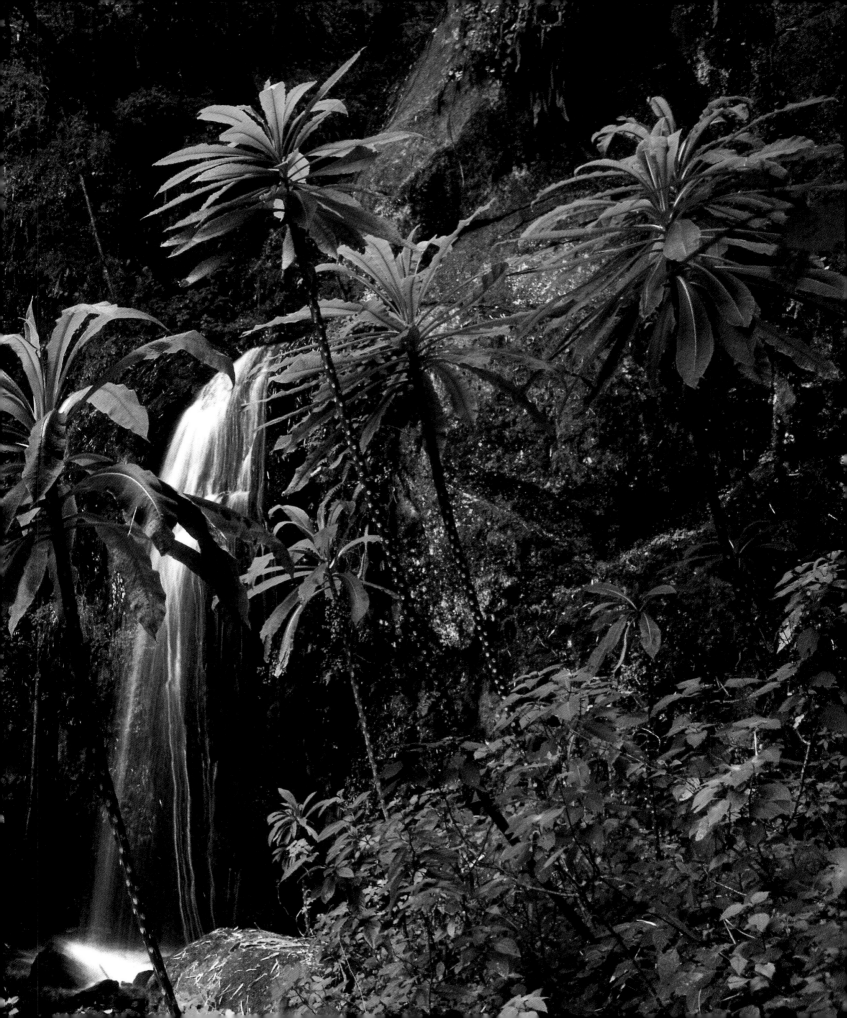

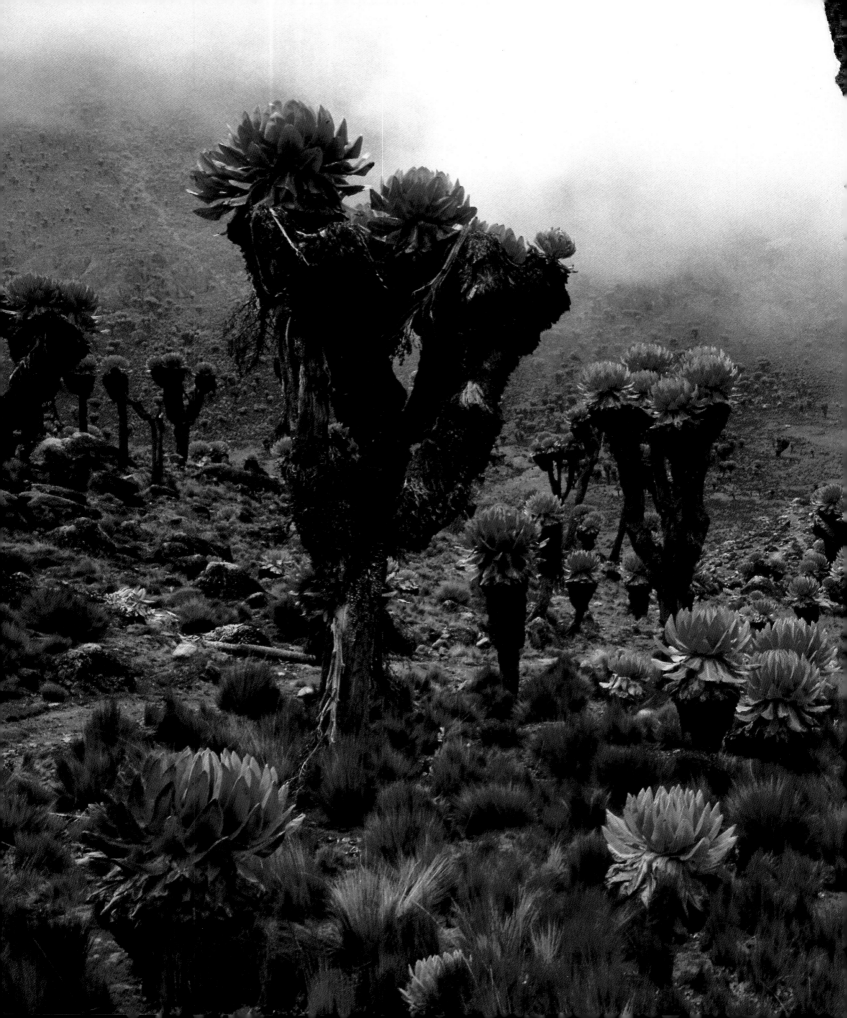

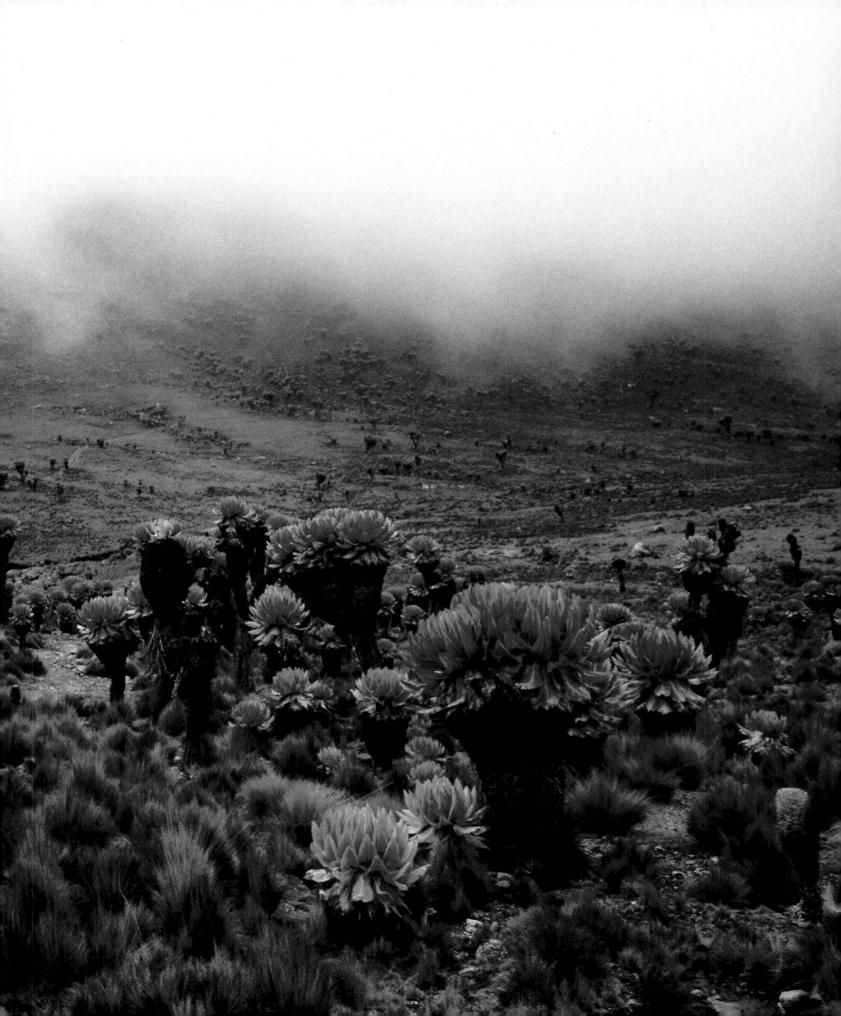

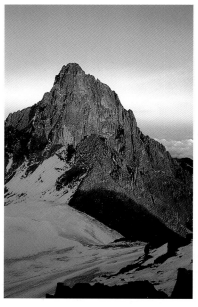

66-67 *In spite of the latitude, Kenya's mountains offer alpine scenery, with perennial glaciers and snows, soaring peaks, wind and cold.*

68-69 *All year round the snow-clad volcanic cone of Kilimanjaro - its ice and snow permanent above 4000 metres - dominates the landscape of southern Kenya from nearby Tanzania.*

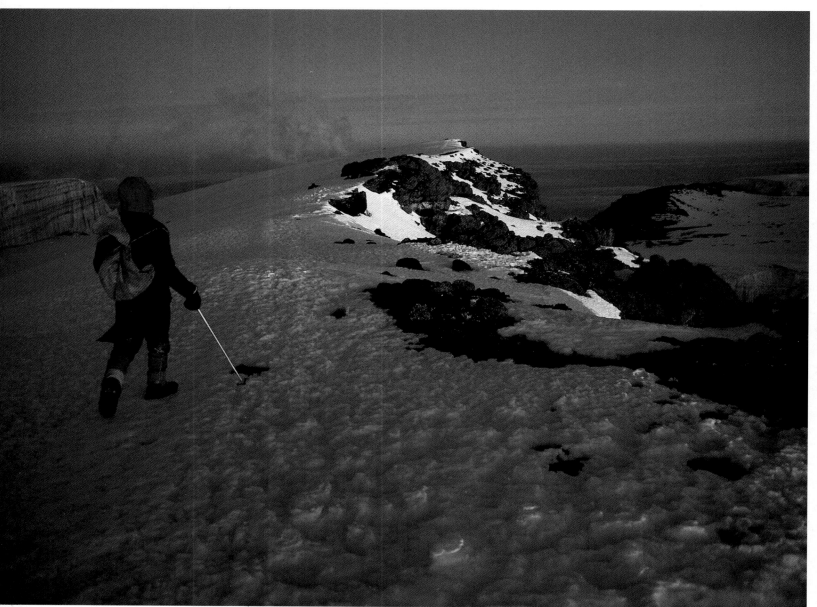

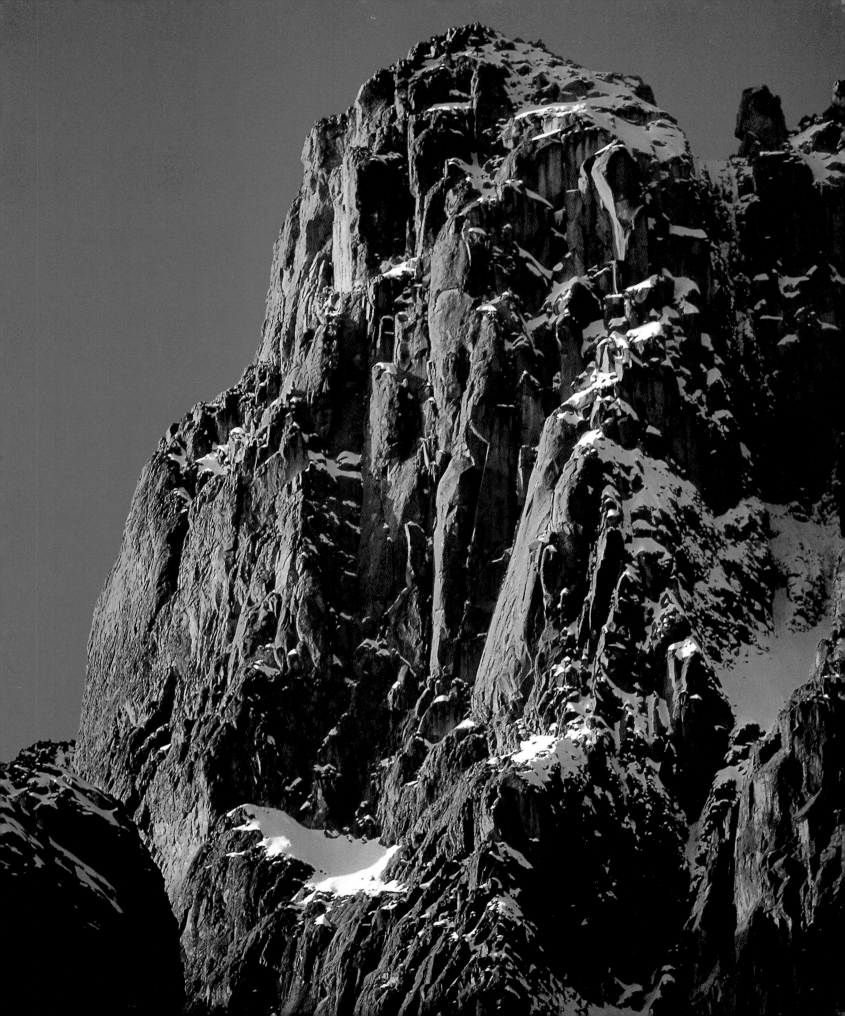

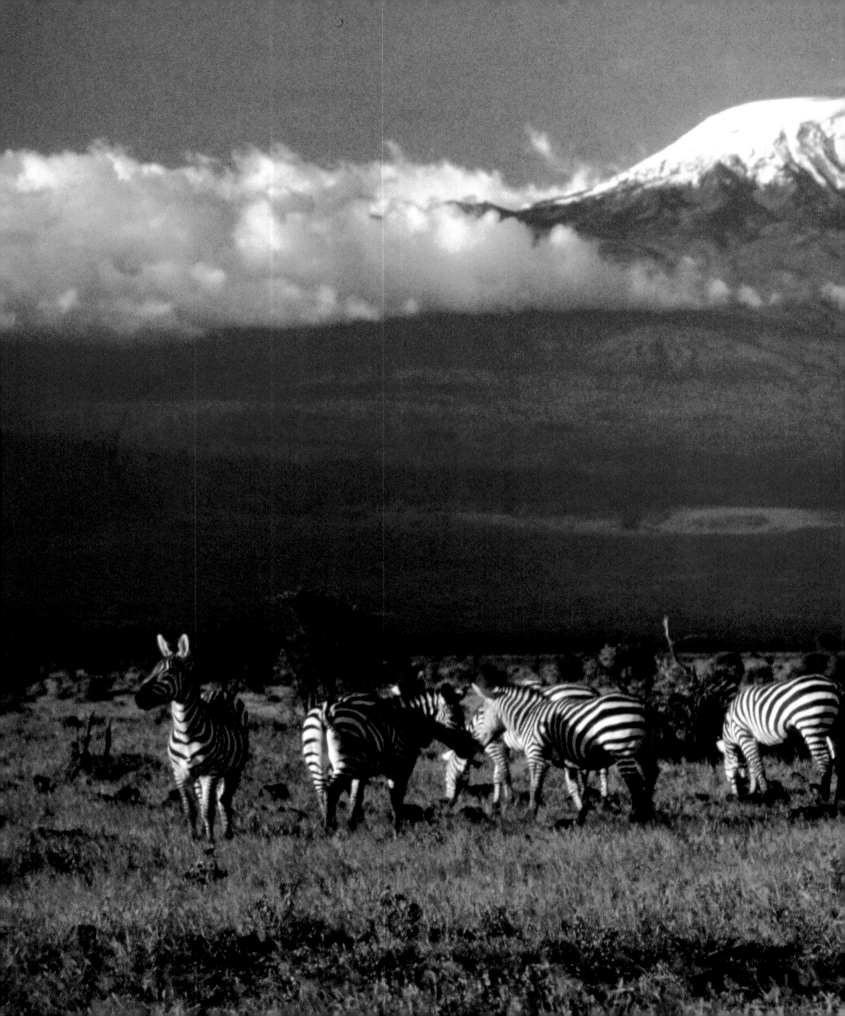

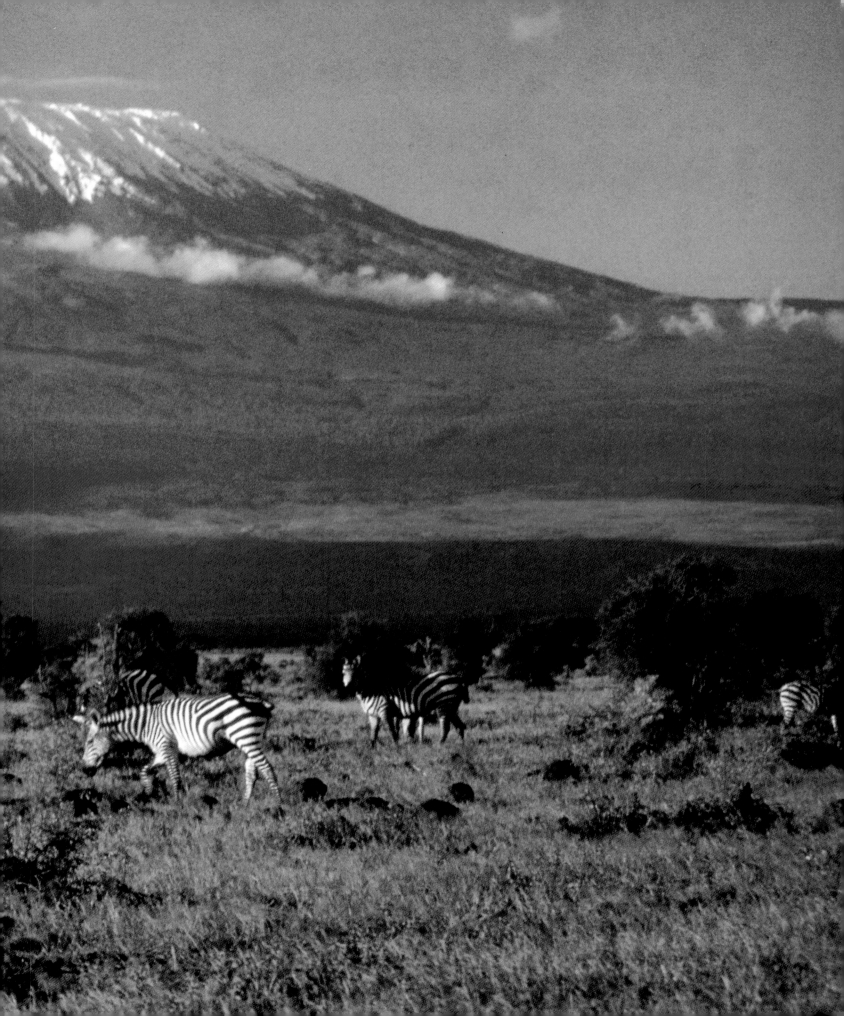

Present-day Kenya

70-71 *Kenya is many things: it may appear untamed and unspoilt, as along the white sands of Watamu (top left); it may don an orderly, touristy air, as on the beach at Nyali, near Mombasa (right); or it may become ultra-modern and chaotic, like Nairobi. Emerging from every view of Kenya, however, is the need to integrate disparate elements - however difficult this task may prove - bringing together palm trees and skyscrapers, European sun-worshippers and Swahili women.*

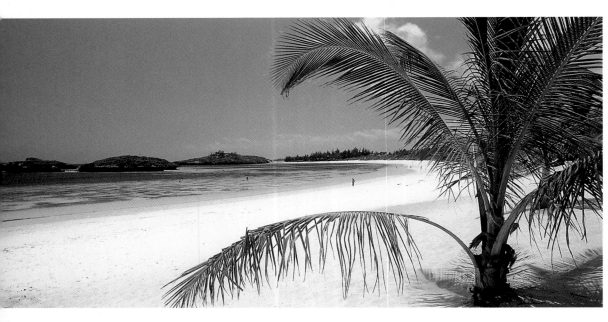

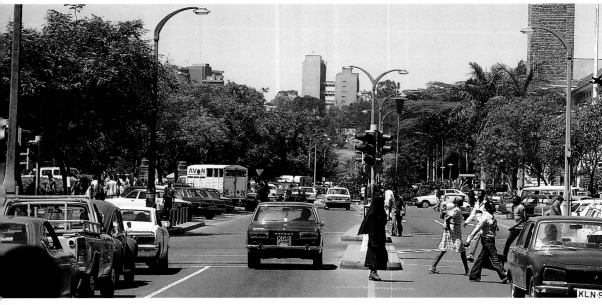

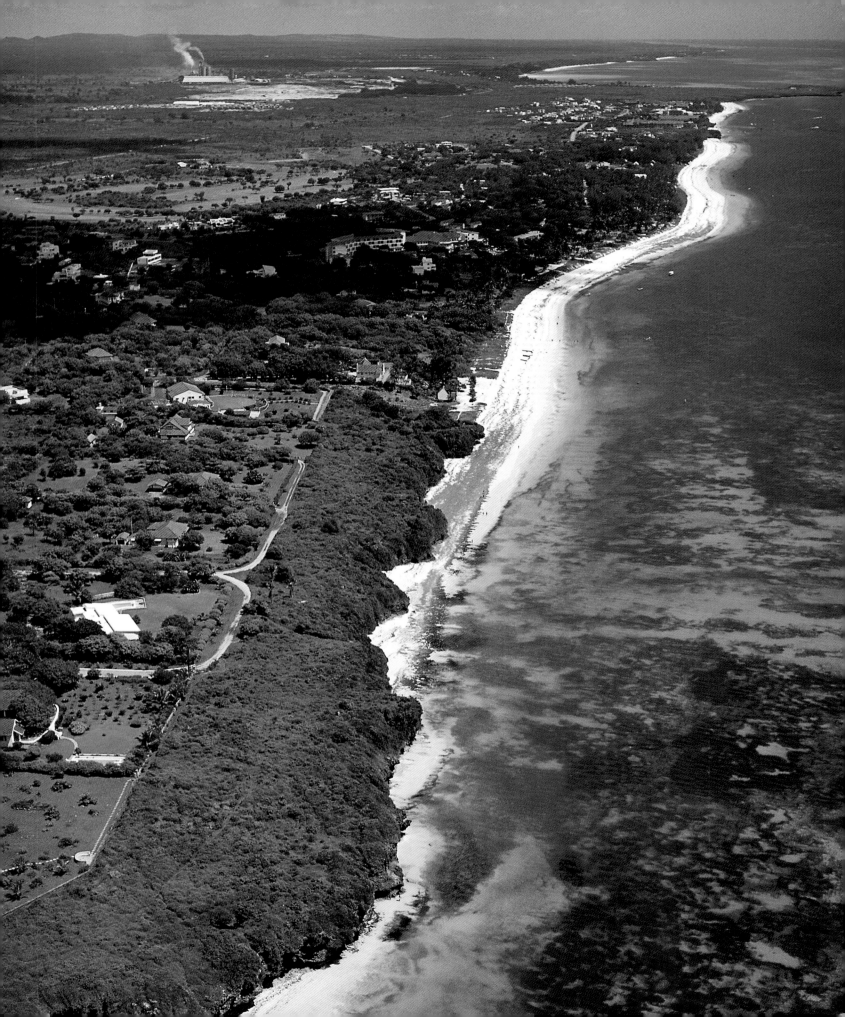

Nairobi, heart of a nation

72-73 *The centre of Nairobi is a mix of Manhattan (top left) and Harlem (bottom left). Kenya's capital began its existence as a railway station and 'halfway house' between Mombasa and Entebbe, in Uganda. Thanks to its strategic position Nairobi has now become the focal point of Eastern Africa, the hub of trade and diplomatic initiatives. Among other things, the*

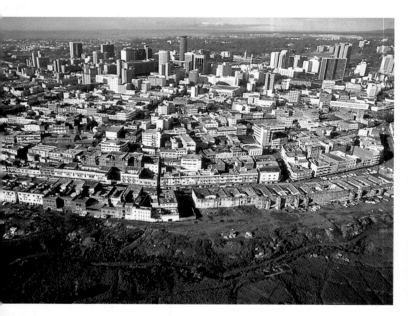

United Nations World Food Programme is based here. And a reminder of the "imperial" role of present-day Nairobi comes from indigenous militiamen who, heads held high, parade down Kenyatta Avenue, the city's main street.

74-75 *Nairobi is famous for its parks and gardens; still tended with the care that became tradition under the British colonialists, they now offer a striking contrast to the US-style modernism rampant in the business and shopping district. Prominent at its centre is the unmistakable outline of the Kenyatta Tower, topped by a revolving restaurant from which diners get the finest view of the city.*

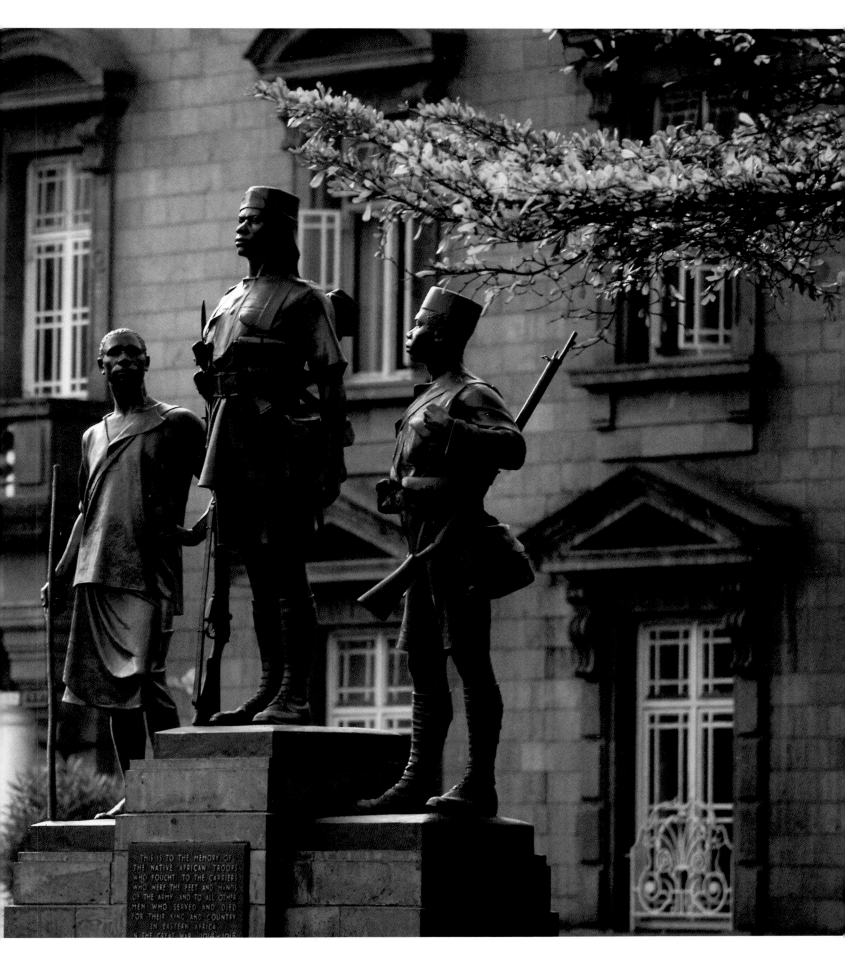

THIS IS TO THE MEMORY OF
THE NATIVE AFRICAN TROOPS
WHO FOUGHT TO THE CARRIERS
WHO WERE THE FEET AND HANDS
OF THE ARMY AND TO ALL OTHER
MEN WHO SERVED AND DIED
FOR THEIR KING AND COUNTRY
IN EASTERN AFRICA
IN THE GREAT WAR 1914 · 1918

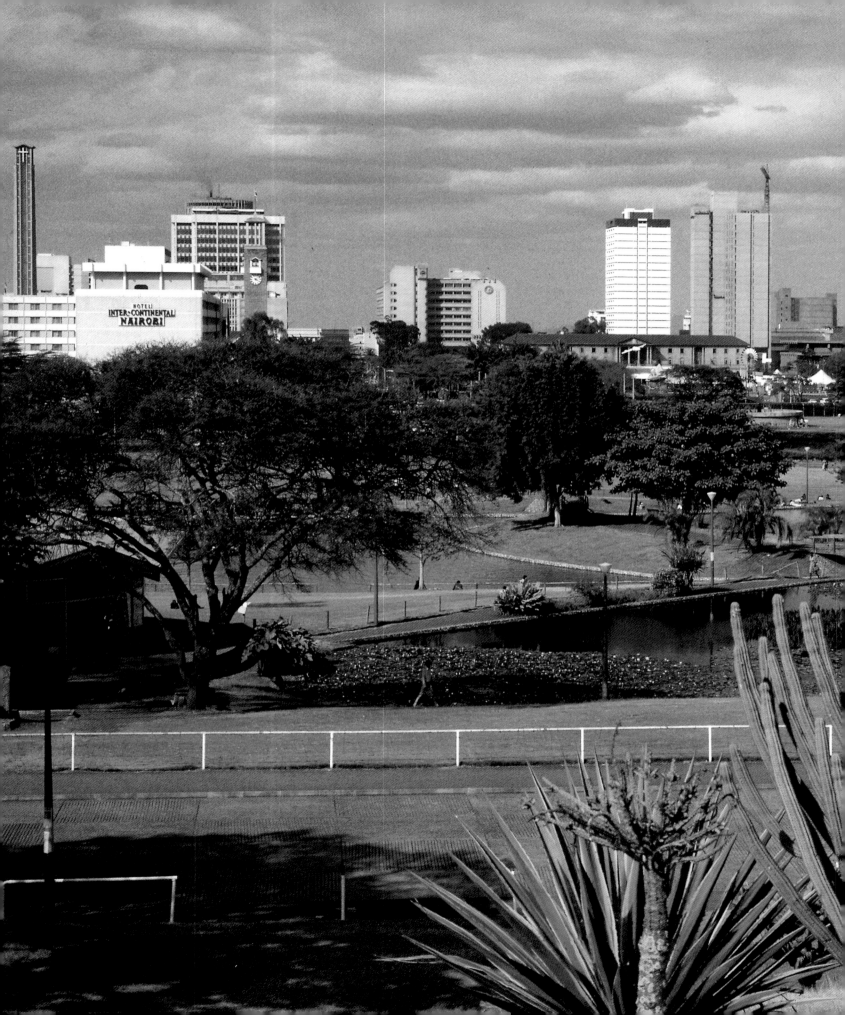

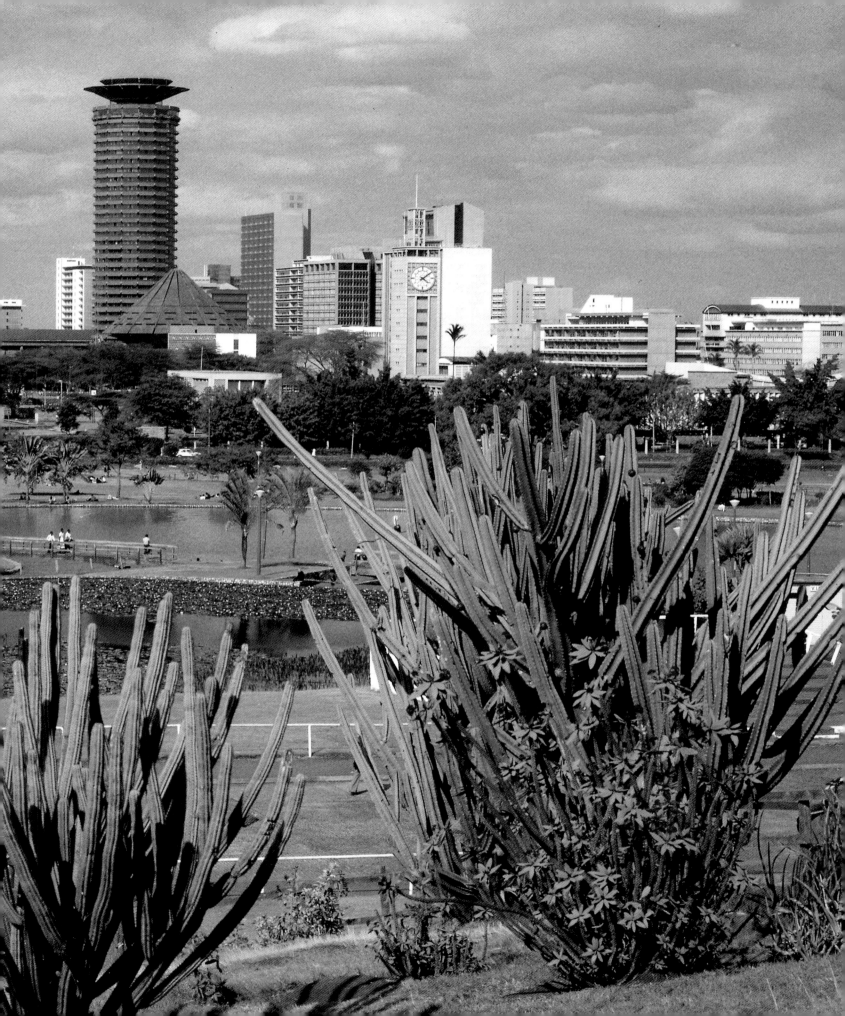

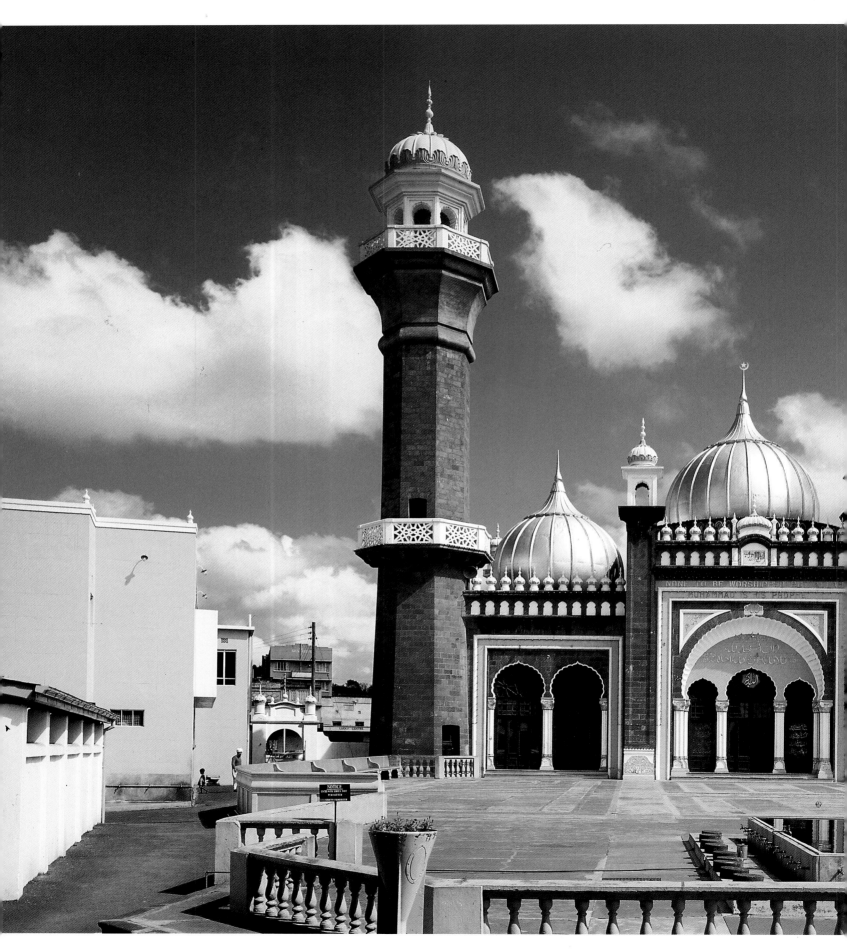

NOTICE
ENTRY WITH SHOES NOT
PERMITTED
STRICTLY PROHIBITED

76 Nairobi is a multi-ethnic city of
many religions. Although the majority
of the population is Christian and
animist, there is a large Muslim
community, of both Arab and
Pakistani origin. The city mosque is an
imposing building beside the national
library left by the British. Nairobi has a
thriving community of traders faithful
to the teachings of Islam.

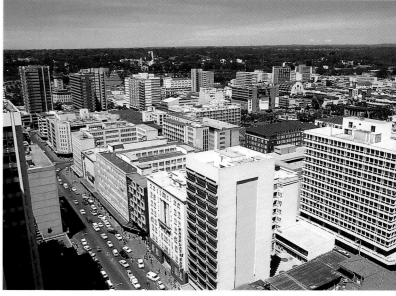

77 The urban layout of Nairobi's
centre is based on a square plan, giving
an impression of order and modernity.
And yet one evening at sunset, no longer
ago than 1962, a lion was seen strolling
down Kenyatta Avenue, in front of the
New Stanley Hotel.

Coastal towns and coral

78 The coastline of the Indian Ocean from Lamu to Mombasa provided mariners with natural harbours and provisioning possibilities that seemed unimaginable after the barren shores of the Red Sea and Somalia. Inhabited by peace-loving peoples, the region was ideal for settlements that eventually became strategic for trade. Fort Jesus was built in Mombasa by the Portuguese at the end of the 16th century to protect trade interests from the attacks of Turkish ships.

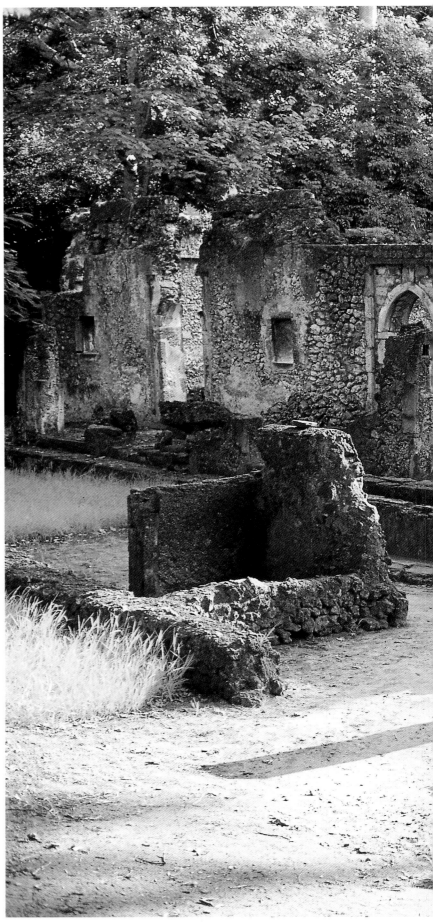

78-79 The town of Gede, south of Malindi, is now uninhabited and in ruins. Along the coastal strip of Kenya many once-important and flourishing towns like Gede were hurriedly abandoned. Two possible reasons are suggested: decline with respect to a neighbouring town or, more probably, depletion of ground water.

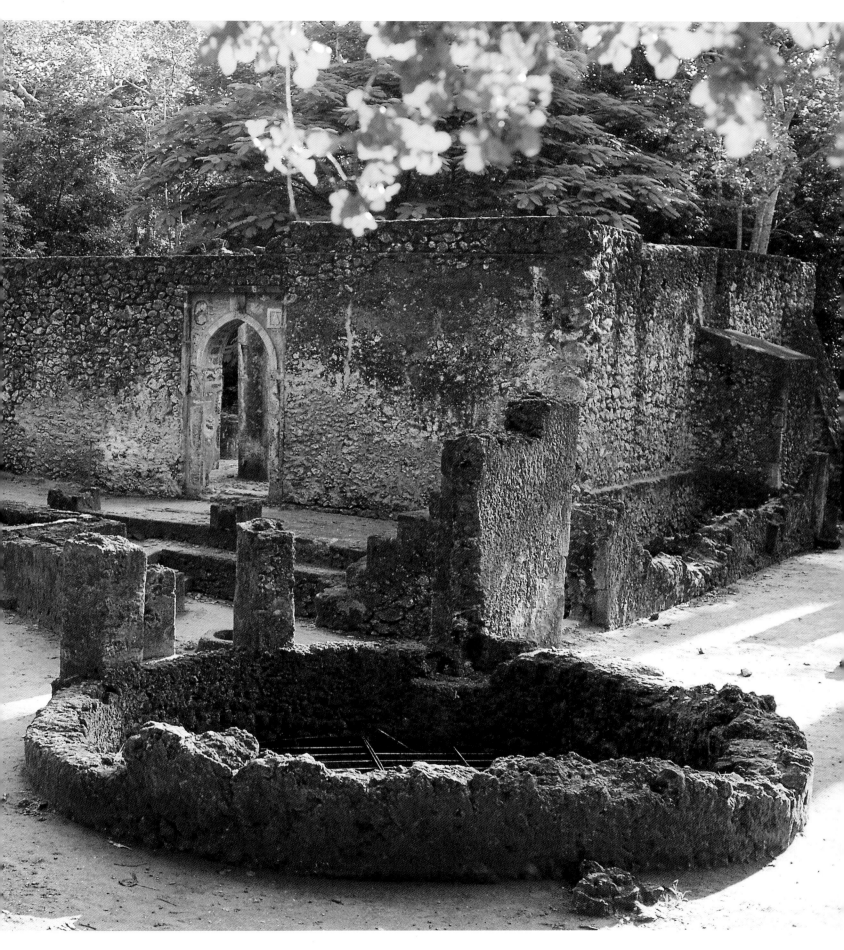

Mombasa,
forms and fragrance of the East

80 *Embellished with huge pairs of
elephant tusks, the main road into
Mombasa is a reminder that we are in
Africa. Visitors to this colourful,
cosmopolitan seaport might otherwise
take the place for Arabia: at the end of
this dual carriageway is an urban maze
riddled with tiny alleyways, where forms
and smells are reminiscent of the East.*

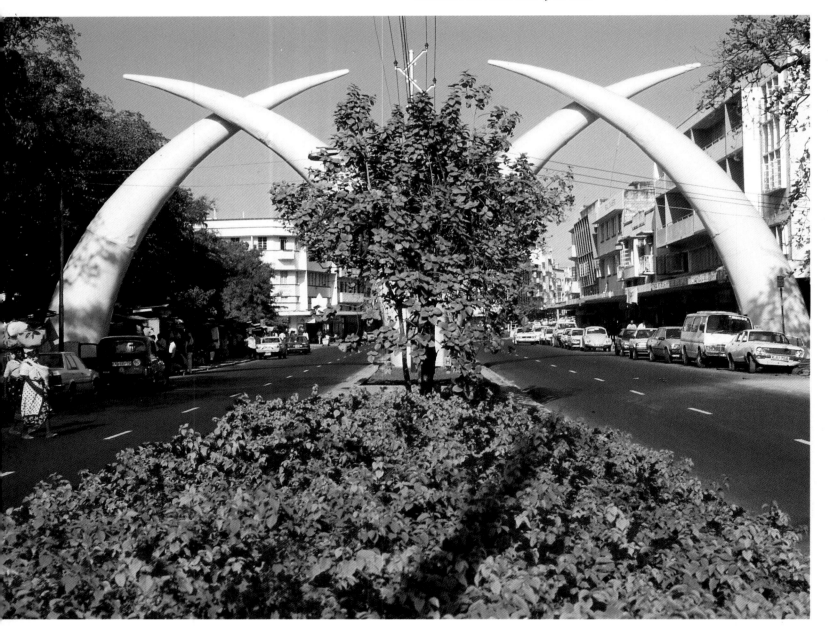

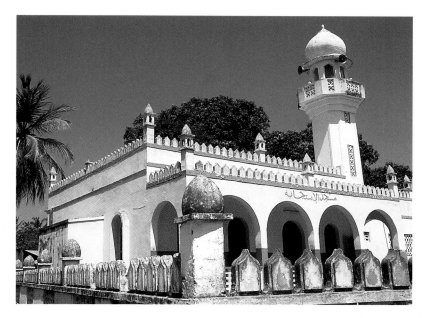

81 *Mombasa is the port where immigrants from India and Pakistan arrived. Apart from the infiltrations by Arab traders much further back in time, the doors of Kenya were opened, via Mombasa, by the British imperialists to subjects from the Indian subcontinent, to provide skilled labour for the railways and lower-grade officials for the colonial civil service. Today the Muslim and Hindu temples are evidence of a well-heeled middle class which, having abandoned positions of authority within the country's administrative structure, now controls trade at various levels.*

A littoral paradise

82-83 *The shores of the Indian Ocean are a paradise on earth. Stretching from Diani Beach (left) to the coral lagoons close to Malindi (right) is a vista of dazzling colours, beaches of incredibly white sand and sea of every shade imaginable. And yet these were* once bleak, desolate places, a mere strip of land between the ocean where traders came and went and the nyika, the mysterious and dangerous hinterland that was the gateway to the Black Continent. Now tourists flock to this part of Kenya.

84-85 *About halfway between the port of Mombasa and the barren littoral of Somalia is the town of Malindi, one of the globe's most celebrated tourist resorts. Looking at the tidy bungalows with de rigueur pools that crowd this coastline, it is hard to imagine that Vasco da Gama set out from these very waters on his voyage to discover the sea route to the Indies. But then Malindi is exceptionally well placed to take advantage of the trade winds which, in certain seasons, blow toward and from Calicut, in India.*

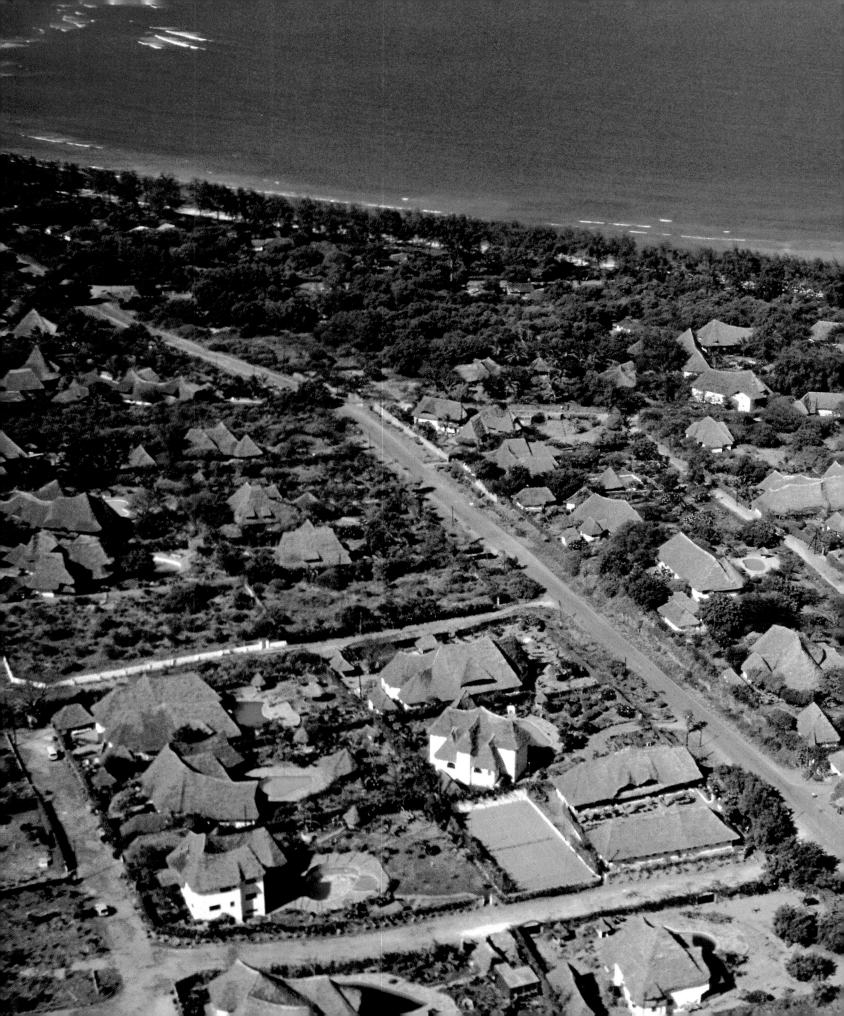

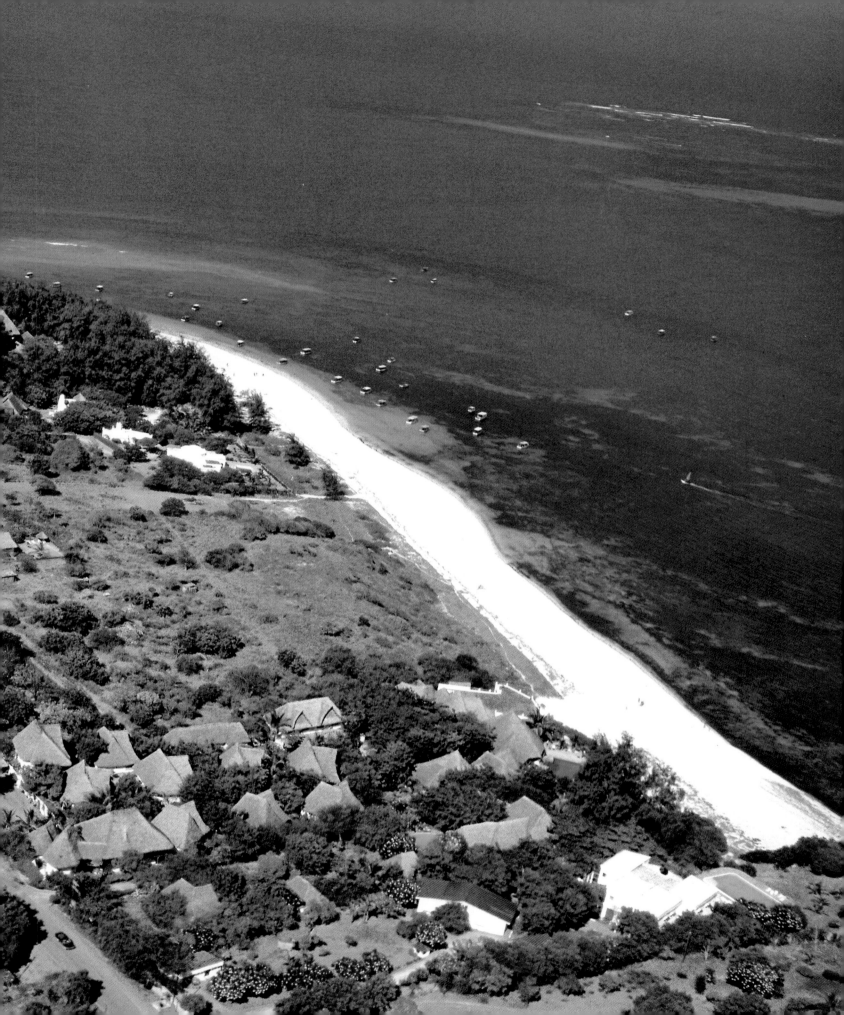

The island-city

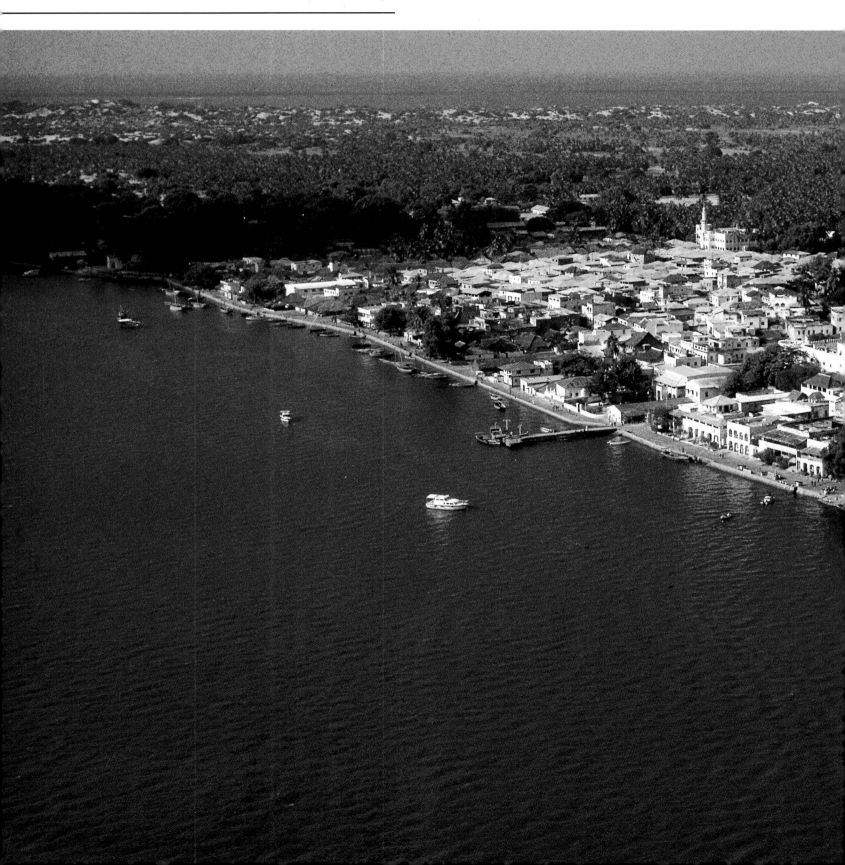

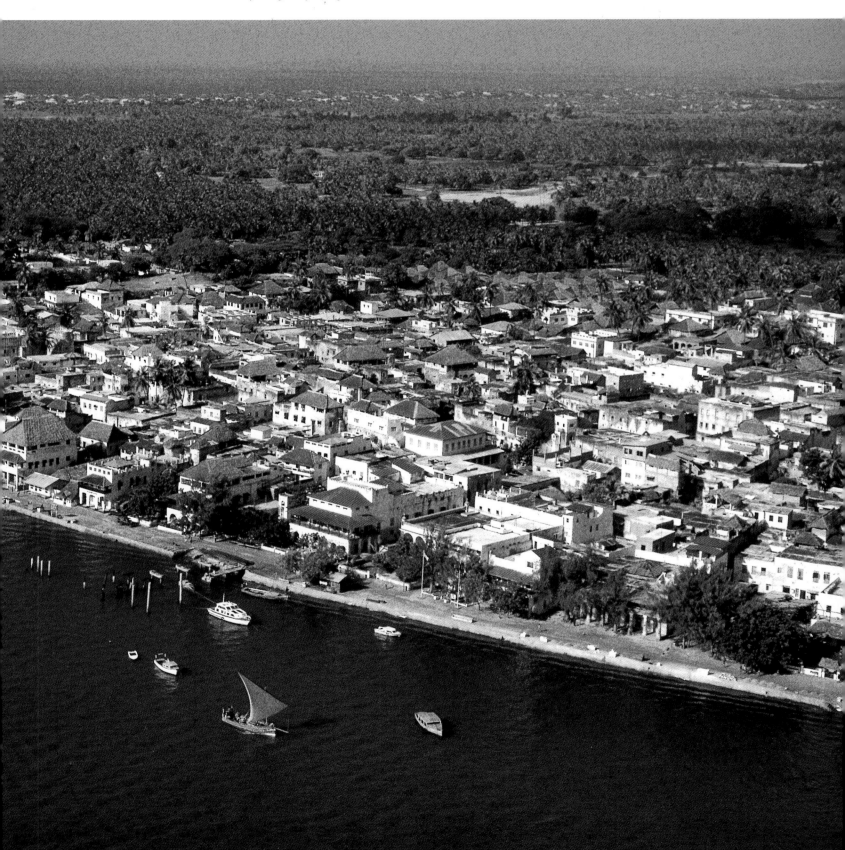

86-87 *The view over the island-city of Lamu, not far from the border with Somalia, has remained unchanged for centuries. The ocean on the horizon looks far away; only a few hundred metres from the mainland, a channel fringed by mangrove forests provides access to the sea. Beyond the waterfront with its recent Indian-style buildings, narrow streets ensure the privacy typical of seaboard towns in Muslim countries. For anyone desirous of understanding relations between Black Africa and the Islamic world a visit to Lamu is a must.*

The Call of the Savanna

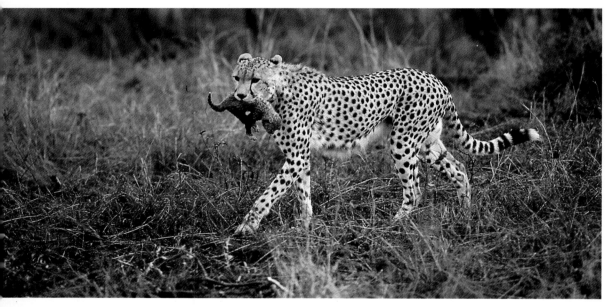

88-89 *With its speed, elegance and beauty, the cheetah (Acinonyx jubatus) is considered the Ferrari of the predators of the savanna. In actual fact its ability as a hunter leaves much to be desired: most of its chases through the grass at breakneck speed come to nothing. And when the cheetah does succeed in making a decent kill, its heart beats so fast (over 200 pulsations a minute) that it has to remain immobile, short of oxygen, for some twenty minutes. At this point other predators (lions, hyenas, jackals) very often strike, snatching away the carcass and leaving the cheetah open- and empty- mouthed.*

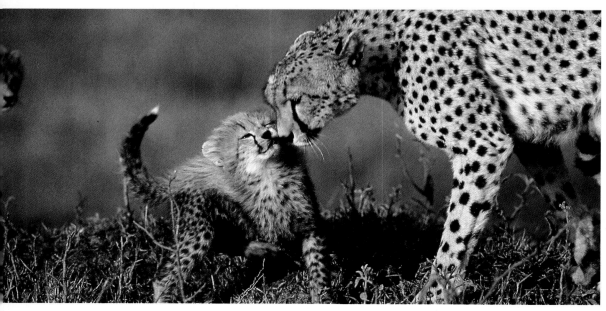

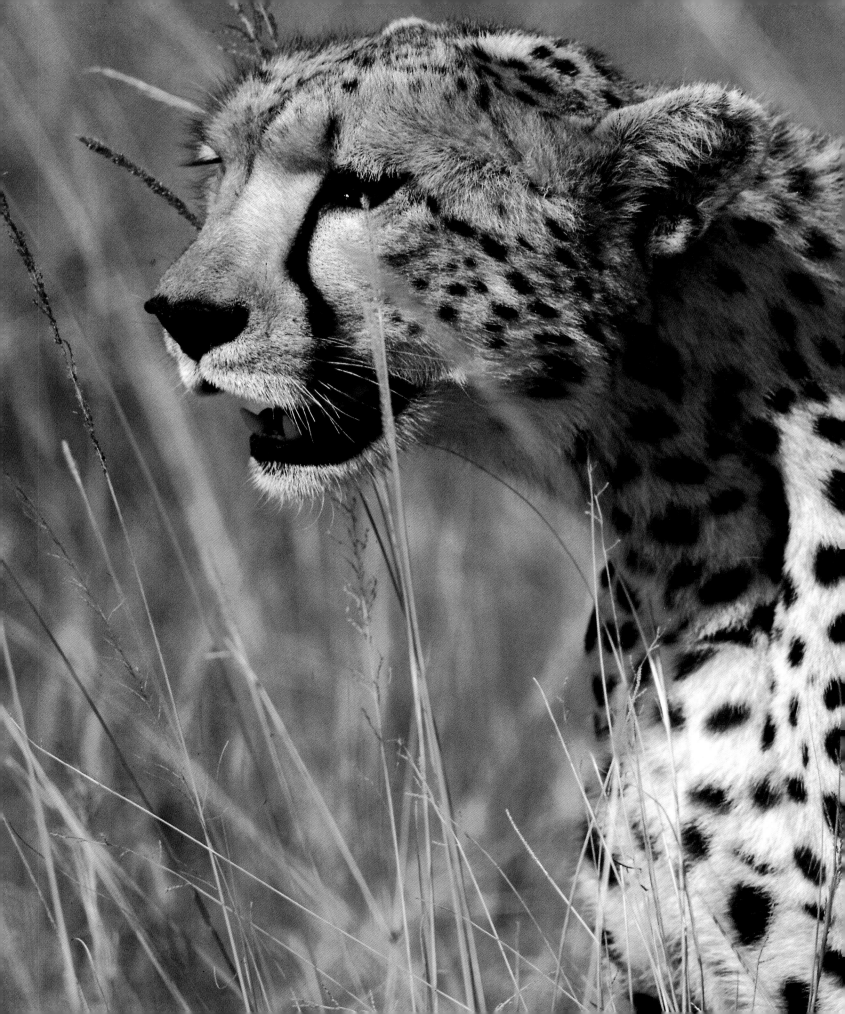

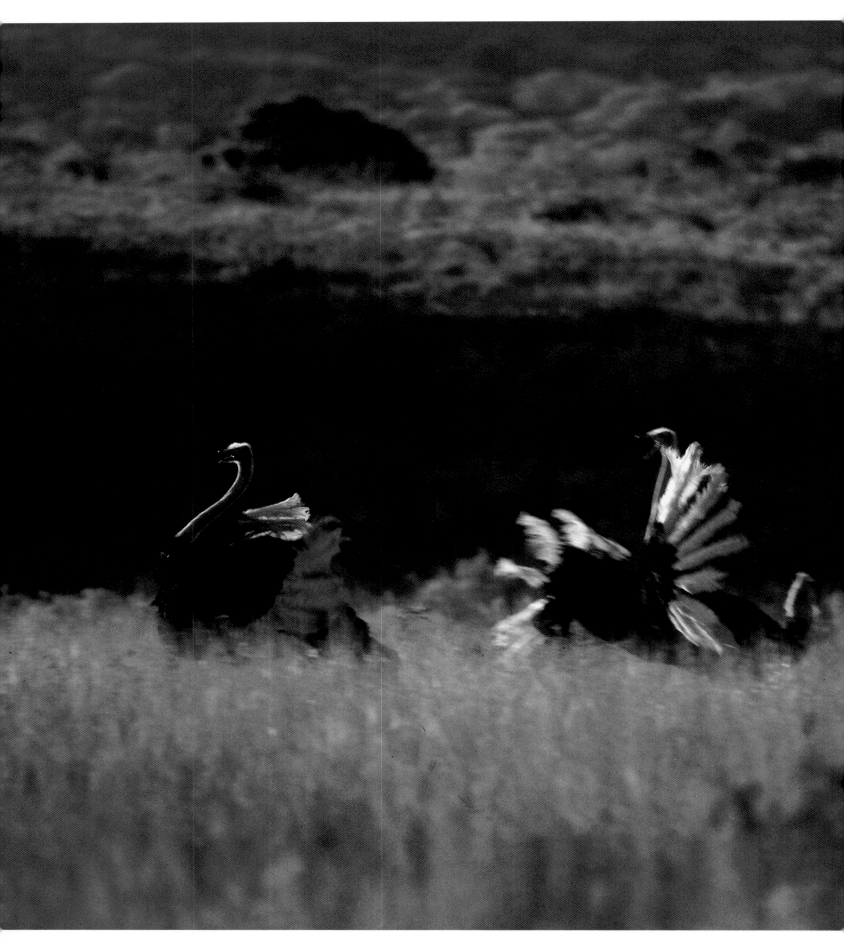

90 *The ostrich* (Struthio camelus) *is one of the most graceful creatures of the savanna. The male has black and white plumage, the female is brown.*

91 *The saddle-bill stork depicted above* (Ephippiorhynchs senegalensis) *stands over 150 centimetres tall. It is not commonly seen in Kenya, which it crosses when migrating. Below is a weaverbird* (Ploceus jacksoni), *recognizable from its golden yellow plumage; typical of*

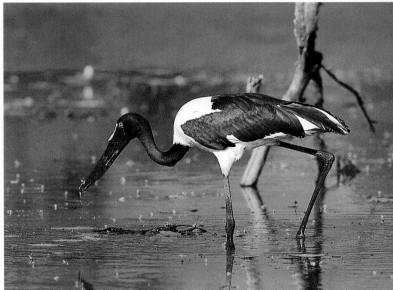

western Kenya, where it lives in crowded colonies. It builds its nest from blades of grass using the technique that earned it its name.

92-93 *Close to the Masai Mara park, on the border with Tanzania, the grassy plains where the Masai live are home to a particular sub-species of giraffe* (Giraffa camelopardalis), *recognizable from its "foliate" markings and called, predictably, the "Masai giraffe". As this picture shows, the giraffes' mission in life seems to be to "trim" the hedges of thorny acacias, since they have a special tongue that they manage to eat the leaves with; their long eye-lashes also serve to protect them against the thorns.*

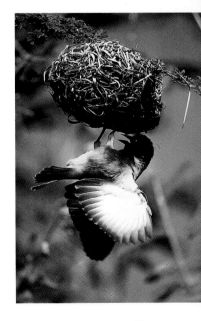

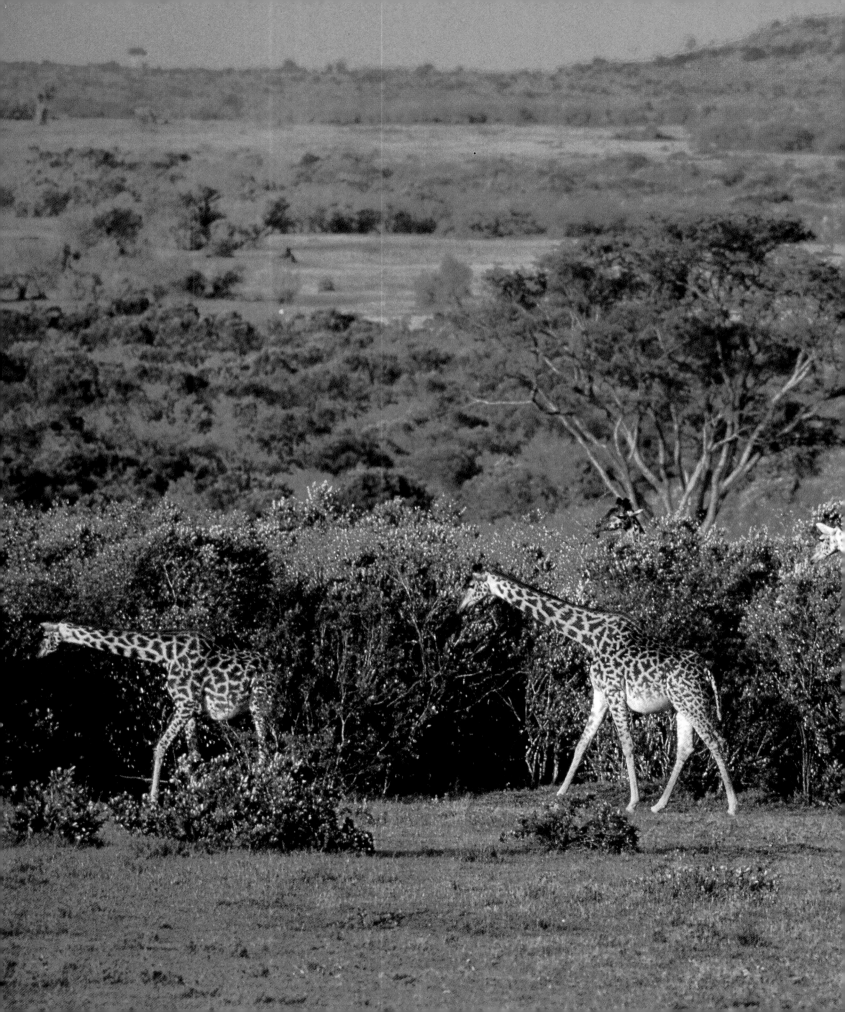

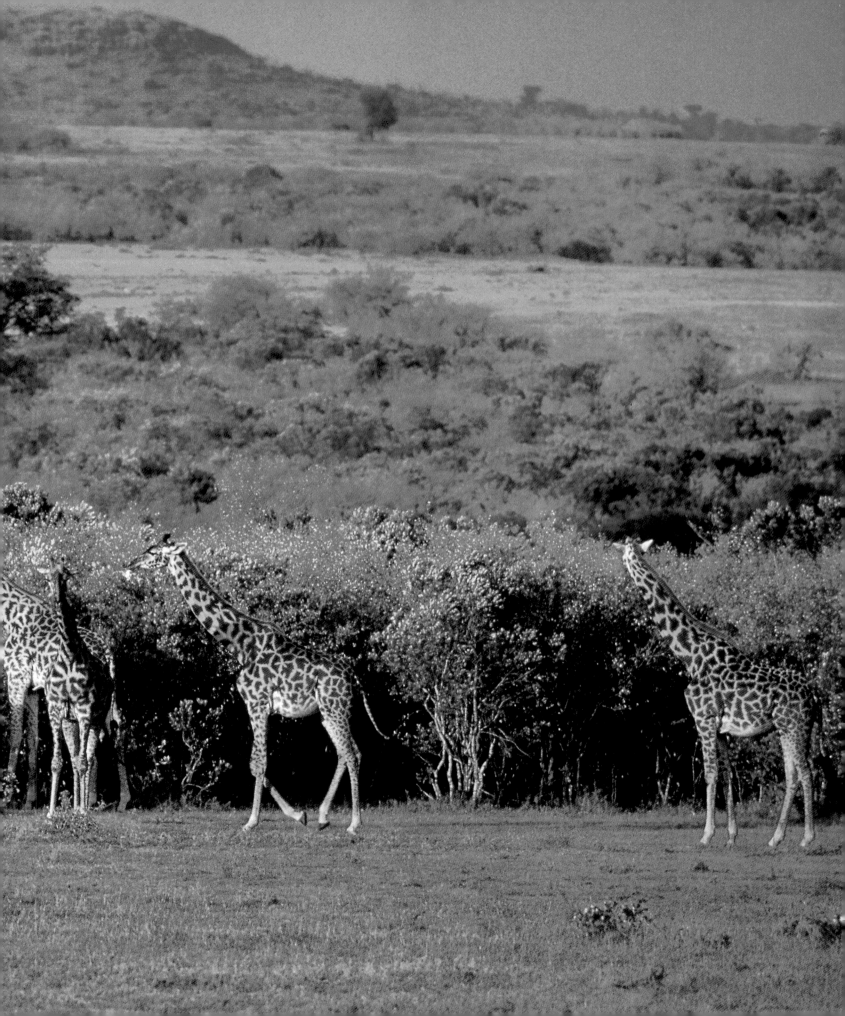

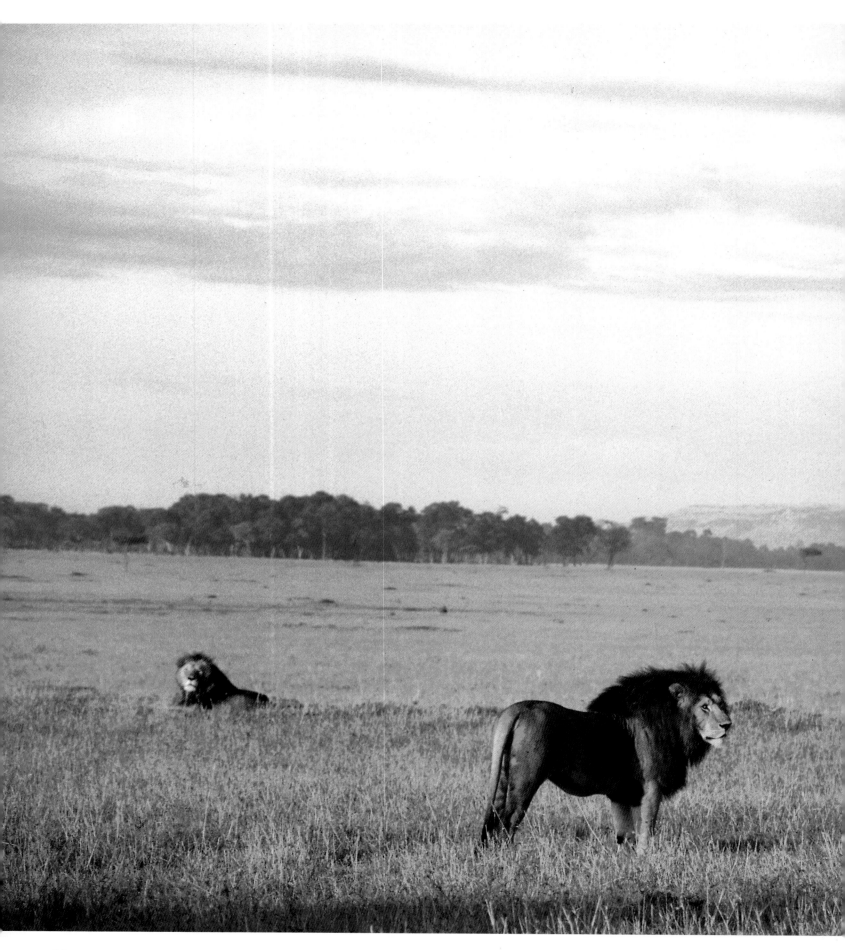

Kings and princes of the grassy deserts

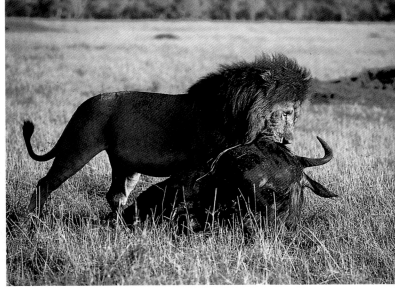

94-95 *To travellers to Africa, the lion* (Panthera leo) *always remains the "king of the jungle" even though it is more often found in the open savanna or in tropical river-forest (in the background in the picture on the left). As everyone knows, the males of the species have the magnificent thick mane. But their reputation of superiority depends more on majestic appearance than substance: in all likelihood, the gnu which the male - top right - is dragging through the grass was killed by a lioness or some other predator.*

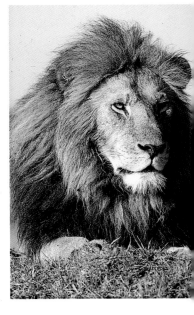

96-97 *In the lion universe it is practically always the females who ensure no member of the family goes hungry. There is no shortage of prey in the savanna (in Masai Mara there are millions of herbivores large enough to satisfy a lion's very healthy appetite). But when lions - either male or female - hunt alone, only in twelve per cent of cases do they manage to make a kill. Results are much better when several hunt together and, because there is less competition among the females, the lionesses manage to feed the whole pride. Often the victim is a topi* (Damaliscus lunatus), *an antelope which can weigh as much as 150 kilograms.*

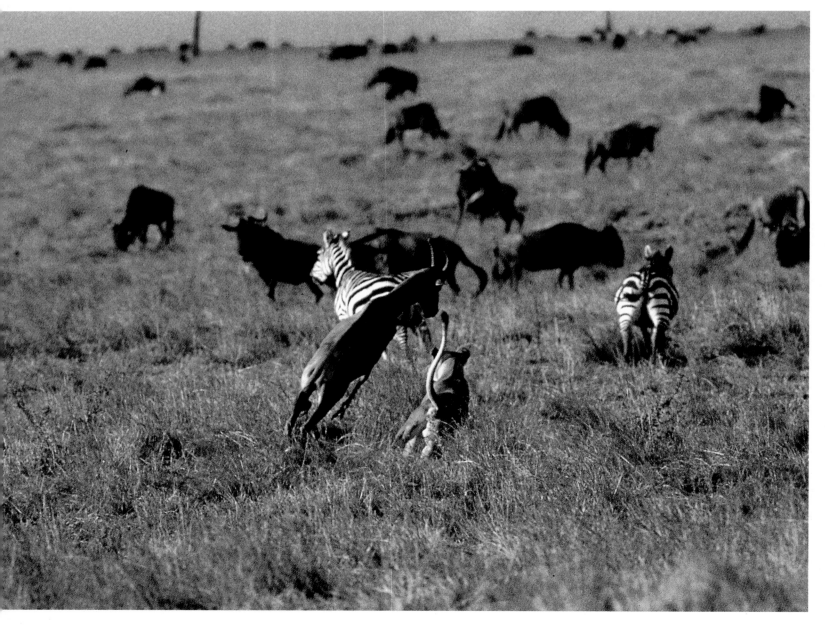

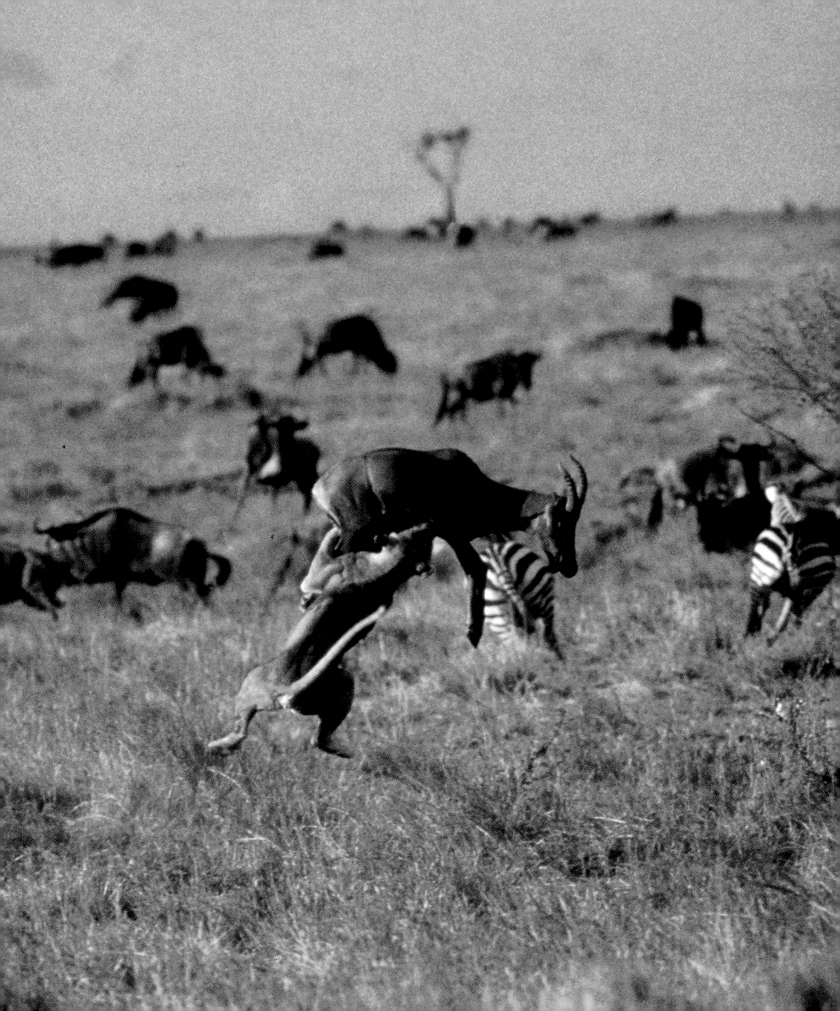

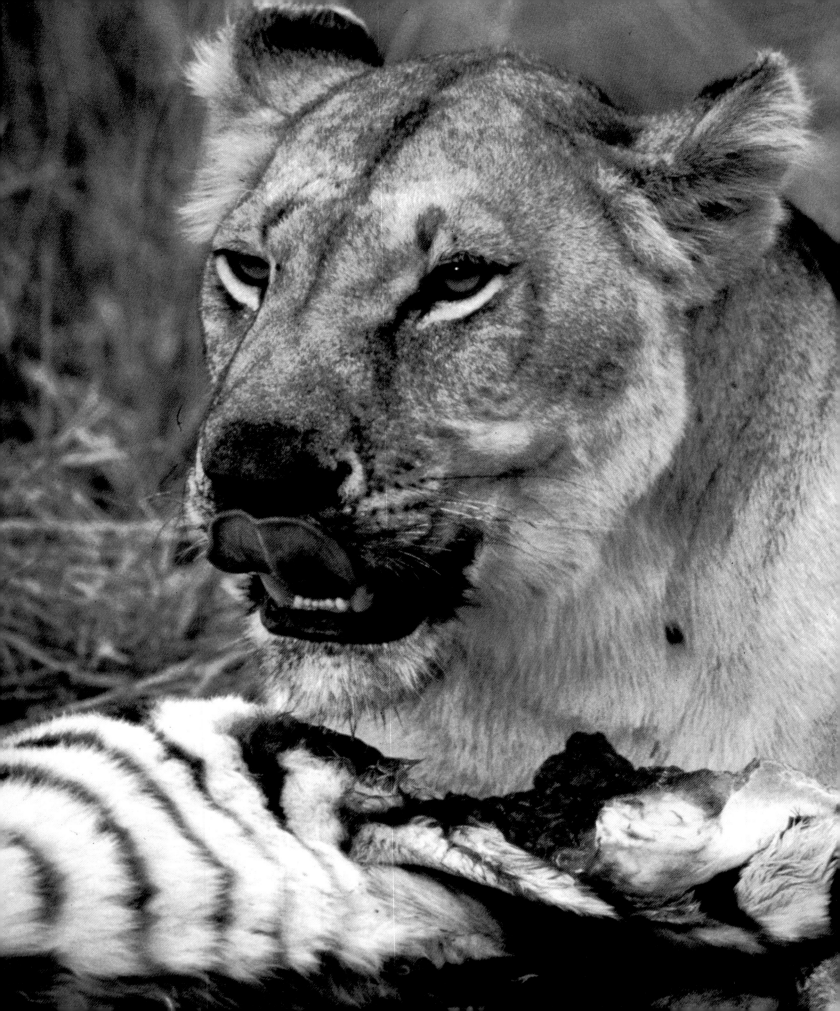

98-99 *Having at last managed to bring down a zebra (on the left), a lioness will determinedly hang on to her kill, even if the intending scavenger is a cub (right). Motherhood is hard for lionesses, since their cubs are constantly at risk from the males. Several studies have shown that when a new male joins the pride (and consequently devours cubs fathered by other males), the lionesses are able to inhibit ovulation for a certain period of time. If the new male proves his worth defending the females of the pride, then another pregnancy - with all the effort and energy demanded by a new litter - might be on the cards.*

100-101 *Spotted hyenas* (Crocuta crocuta) *are efficient predators when they hunt in groups. Using this technique, they have a 70 per cent success rate. Only about half the food they eat is pilfered from the kill of other successful carnivores, and yet these mainly nocturnal hunters have a totally different reputation. It could well be that the sight of a lion devouring ill-gotten gains before the eyes of a group of frustrated hyenas has long led researchers of animal behaviour to reverse their roles, convinced that the hyenas exploited the hunting prowess of the lion, waiting for scraps from the king's table. Often it is instead the lions who, drawn by the characteristic 'laughter' of hyenas after a kill, snatch the carrion from its lawful owner.*

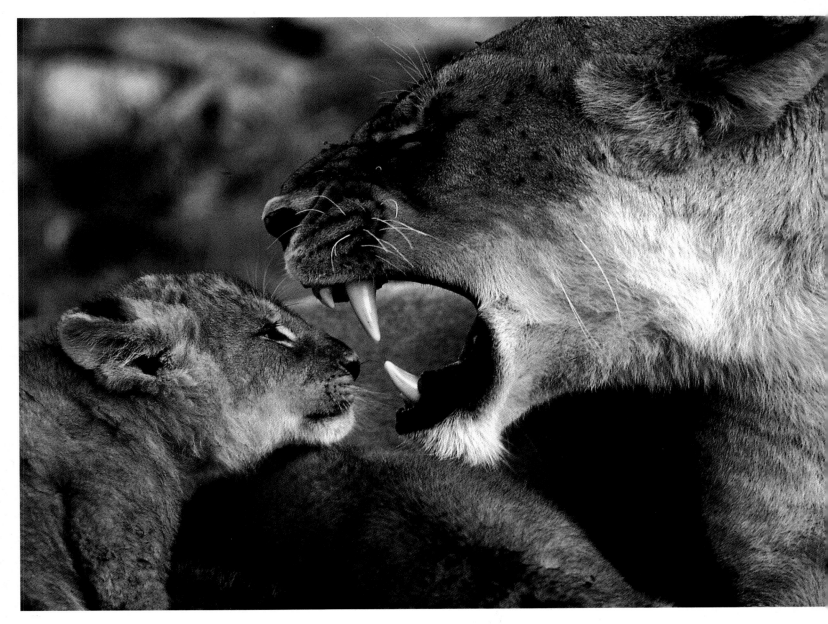

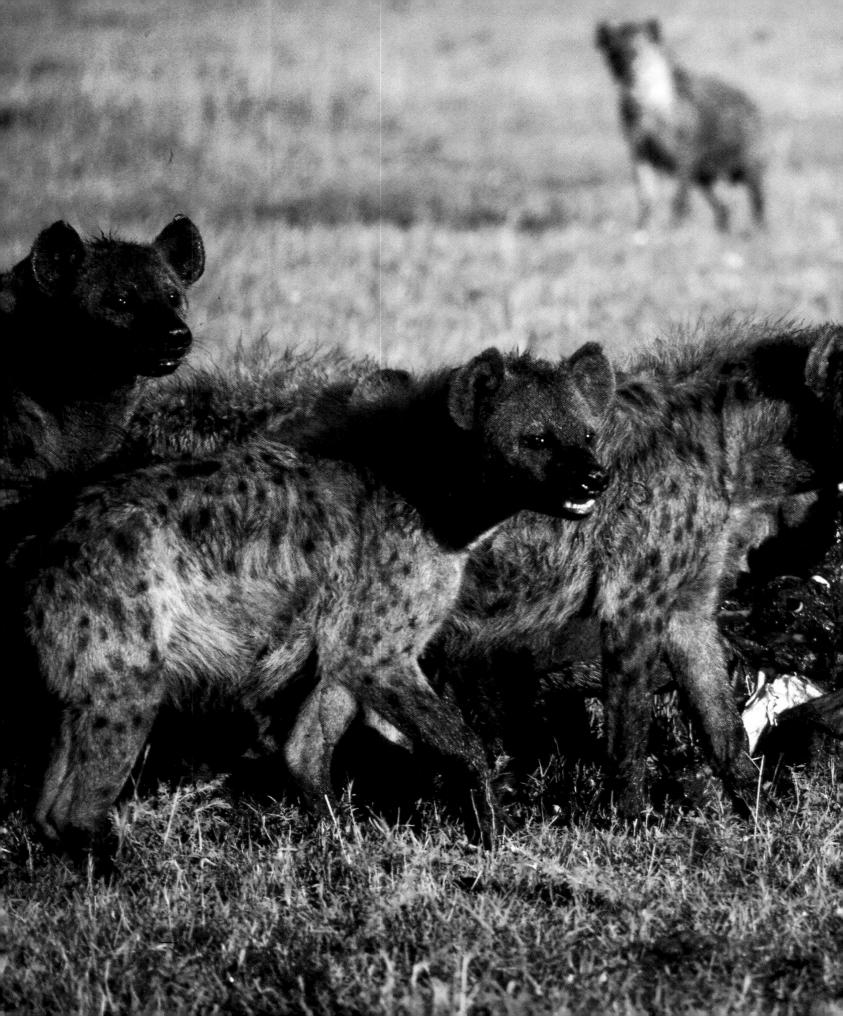

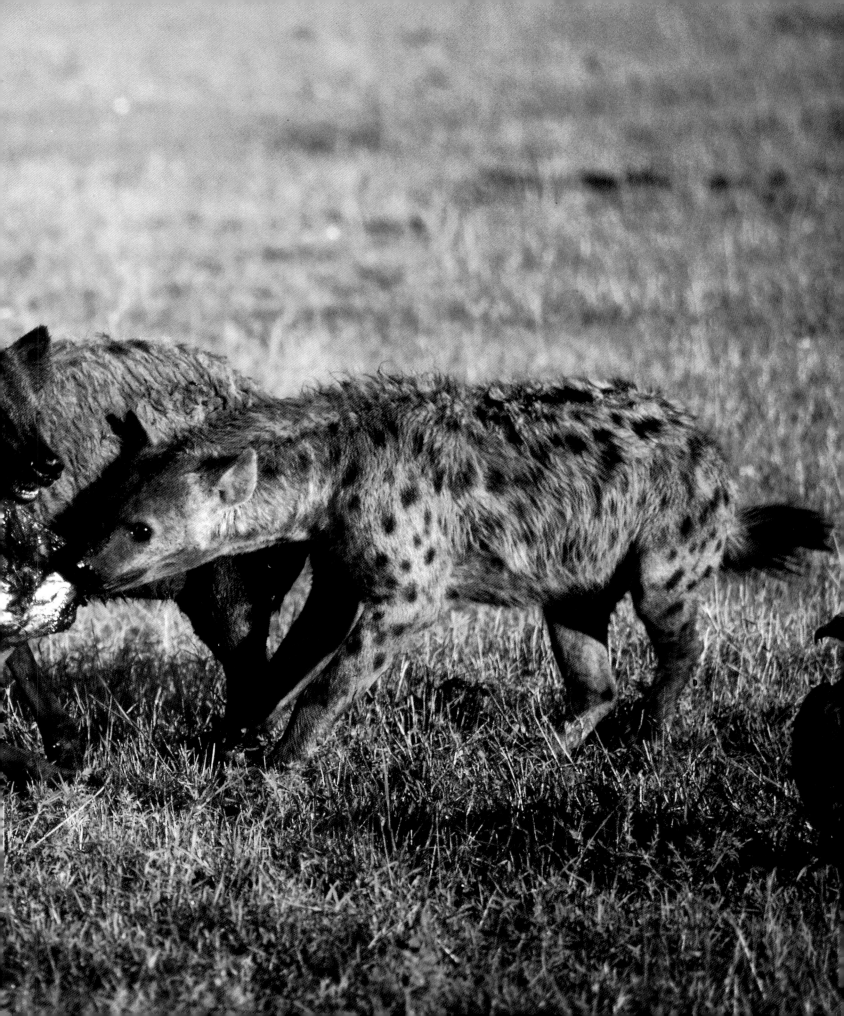

102-103 *The leopard* (Panthera pardus) *is the most elusive hunter of the African savanna. These solitary animals make their home among rocks and thick patches of forest where their spotted coat makes them practically invisible. They eat anything and keep reserve provisions in the tree-tops, in readiness for harder times which - even in the seemingly protein-rich savanna - come surprisingly frequently.*

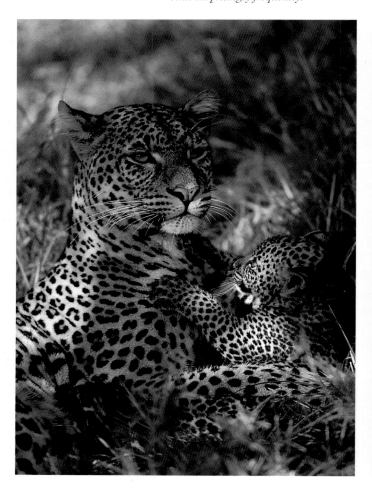

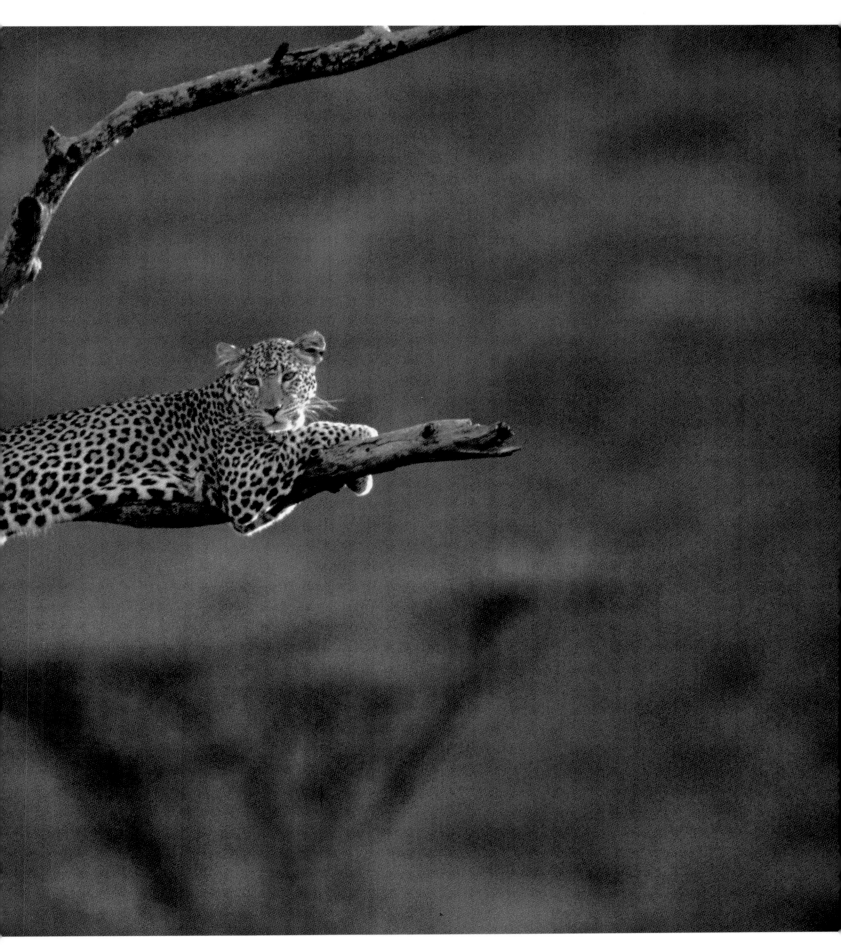

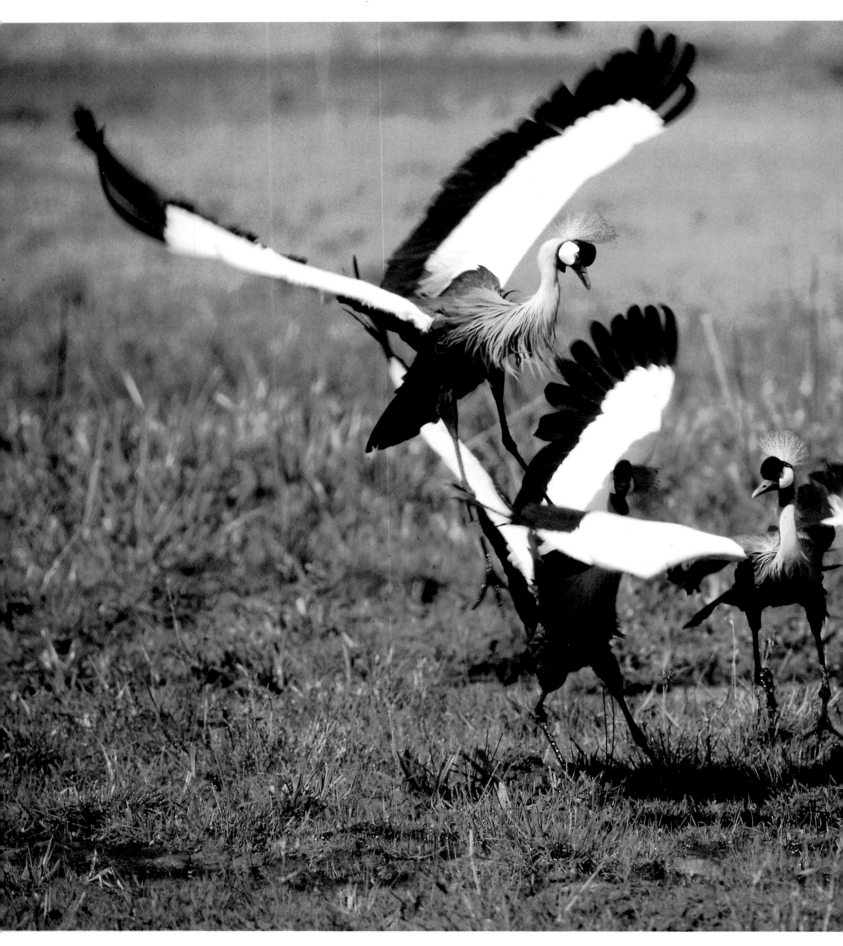

104-105 *The crowned crane* (Balearica regulorum) *may be the symbol of Uganda but it is fairly often encountered in open, wet places all over Kenya. It is an exceptionally beautiful but nasty-natured bird: the love dances it performs to impress a female prior to mating often degenerate into battles between rivals.*

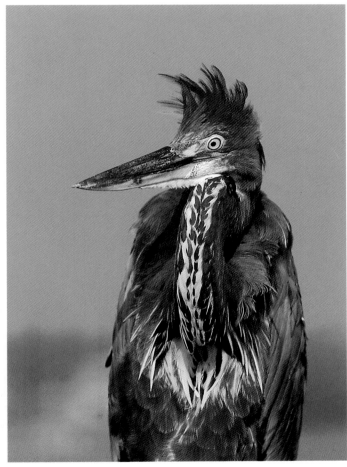

105 *Sometimes standing more than 150 centimetres tall, the goliath heron* (Ardea goliath) *is the very largest of the wetlands birds. It is not only noticeable for its size: its colourful plumage makes it an eyecatching sight in this monochrome setting.*

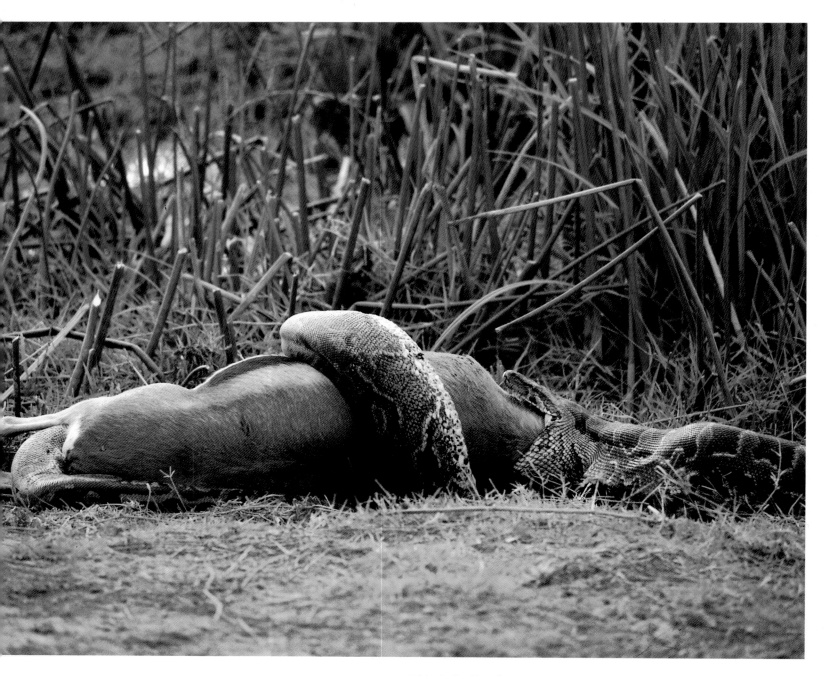

106 Amboseli park may seem to be a
near-desert, a landscape in which few
creatures but gazelles and antelopes can
survive on a diet of short, thin grass, but
in the few wet places, amid the reeds of
seasonal swamps (when and if it rains),
other dramas unfold: a Thompson's
gazelle of no mean size is about to be
devoured by a python, Africa's largest
snake. The python is a kind of dinosaur:
it even has two vestigial rear feet, used
only for mating.

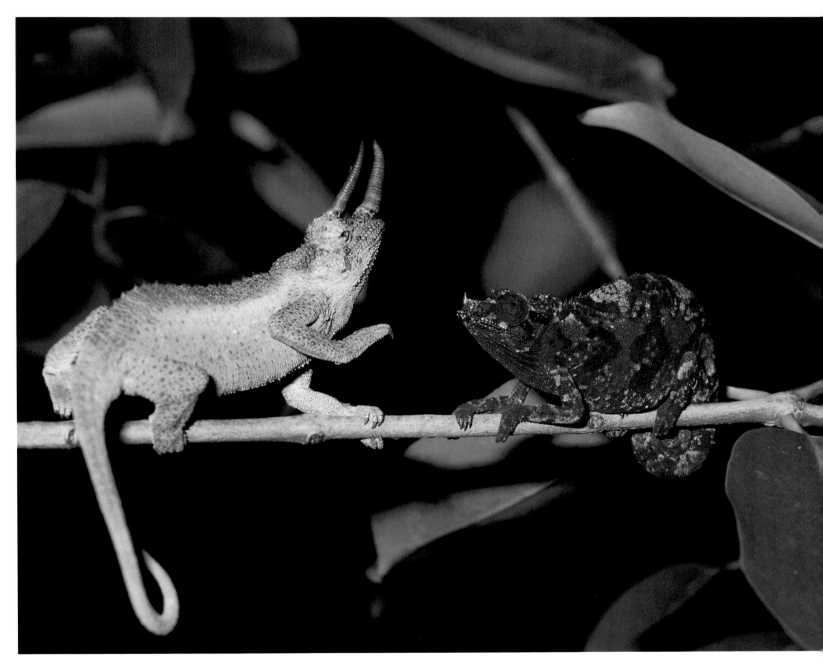

107 *A male chameleon* (Chamaeleo jacksoni) *tries to impress a female by displaying his horns. The camouflage capacity of the chameleon's skin is here made very evident by the different colouring of the two creatures: the male, in the light, is bright green while the female,* *in the shade, is much darker. Determined by a notable chemical capacity to alter skin pigmentation, colour change is an effective strategy for survival. It dates back many millions of years to the age of the dinosaurs, of which these little animals are in certain respects descendants.*

108-109 *Elephants* (Loxodonta africana) *are both the torment and treasure of the savanna. Although very strict laws exist in Kenya, in the space of twenty or thirty years poachers brought the elephant population close to extinction. To protect them, the elephants were 'confined' to the national parks. However, this measure has produced, artificially, an abundance and density of elephants that is unnatural and excessive for the environment of the parks. Even a cute little elephant* (on the left) *will, during its lifetime, munch its way through tons of vegetable matter, not even sparing the bark of trees which it uses to scratch at its parasites. In addition, elephants show little tolerance towards other animals, driving them out of any territory they take over* (right): *here, a baboon gets the worst of their hostile behaviour.*

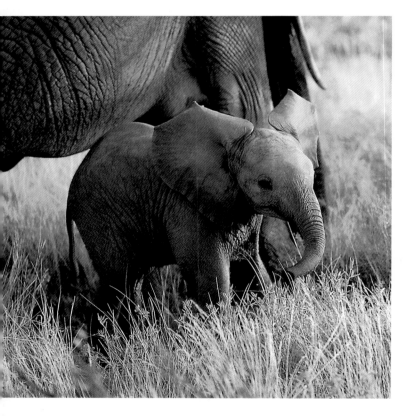

110-111 *The sun sets on Amboseli park and on the delicate equilibrium of its eco-system: buffalo* (on the right) *crop the short grasses and new shoots, while a female elephant leads two young elephants* (left) *to pasture among the bushes and reeds. Out come the insects, drawn by all this activity, only to fall victim to the cattle egret: in return for the favour, these birds busy themselves removing the parasites which live in the folds of the wrinkled skin of buffalo and elephants.*

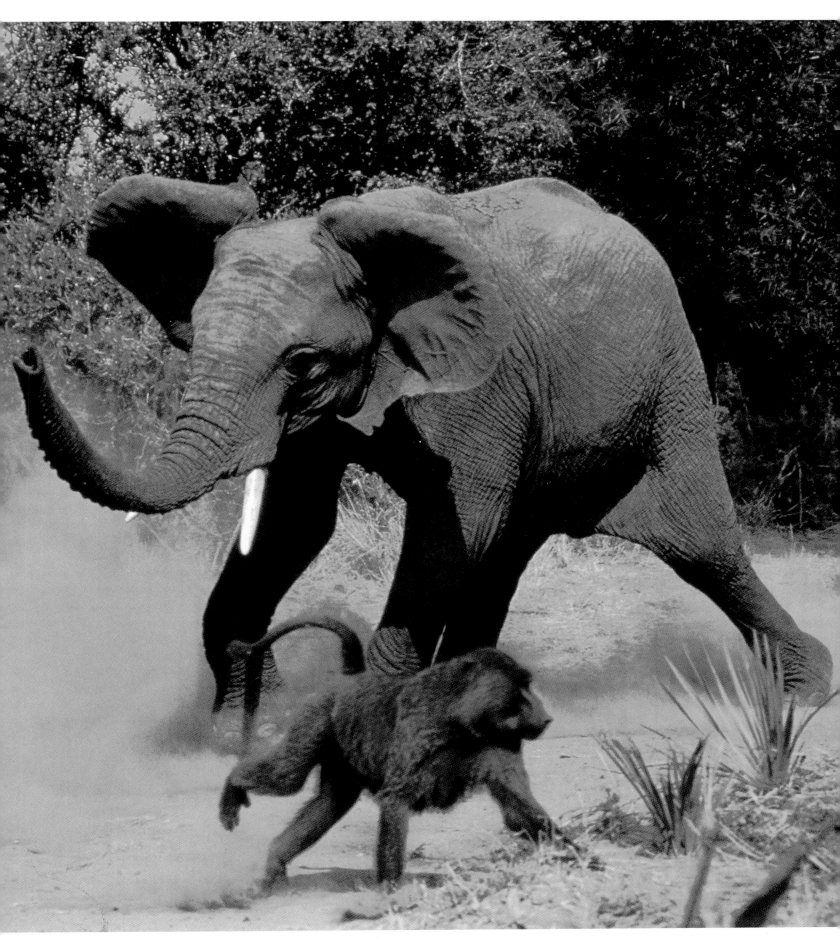

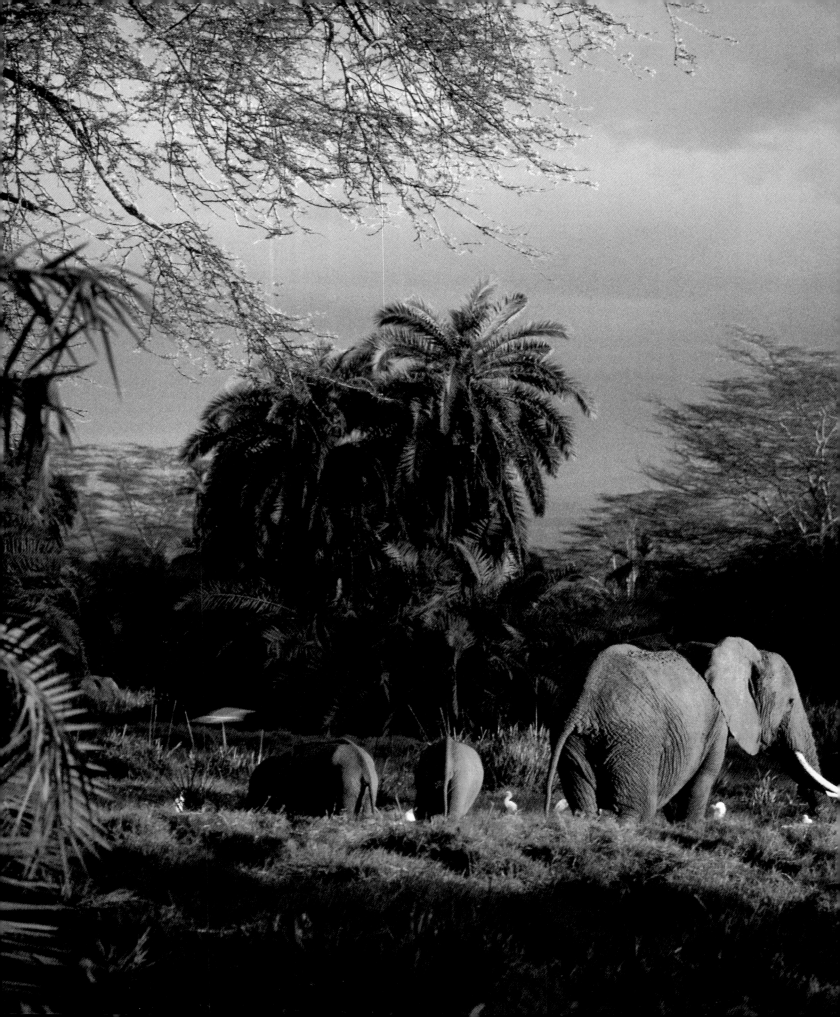

112 *In spite of its cattle-like appearance, the African buffalo* (Syncerus caffer) *is considered the most dangerous creature of the savanna. It weighs around a ton but does not rely solely on its bulk and horns: it is an astute creature, capable of taking an isolated hunter by surprise by imperceptibly circling around it in the long grass, or of cunningly moving this way and that to mislead a group of animals set on attacking it.*

113 *Black rhinoceros* (Diceros bicornis): *the colour distinction between black and white rhinoceros is an arbitrary one: both species are practically the same grey. A major differentiating factor is their size: the black rhino weighs 'only' one and a half tons; the white one* (Ceratotherium simum) *more than twice as much. The white rhinoceros feeds on grass at ground level; the black one gets its nourishment from leaves.*

114-115 *The impala* (Aepyceros melampus) *is one of the most fascinating creatures of the savanna since it combines agility and beauty with considerable strength. Only the males have horns, an adaptation seemingly typical of species that live and feed amid scrub and woodland thickets.*

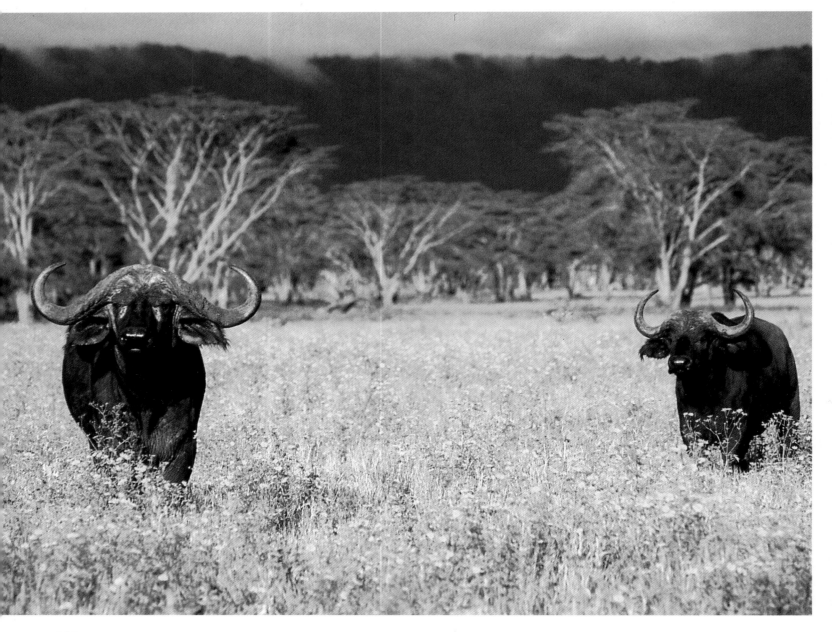

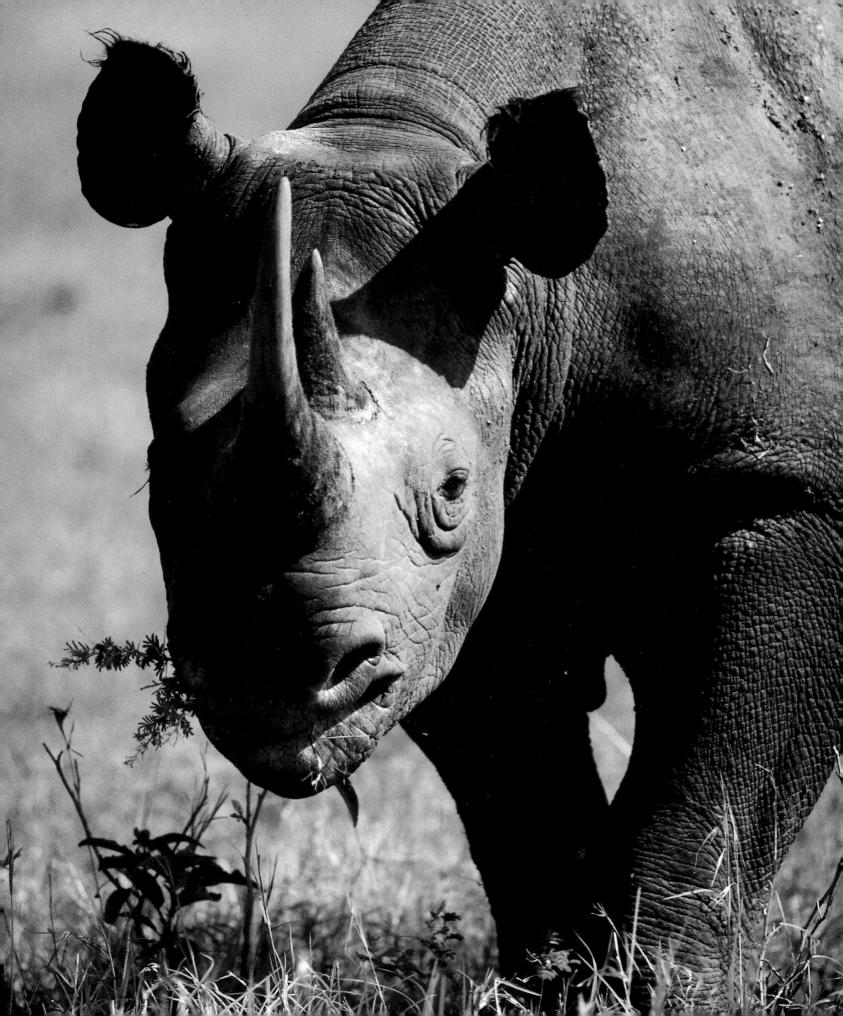

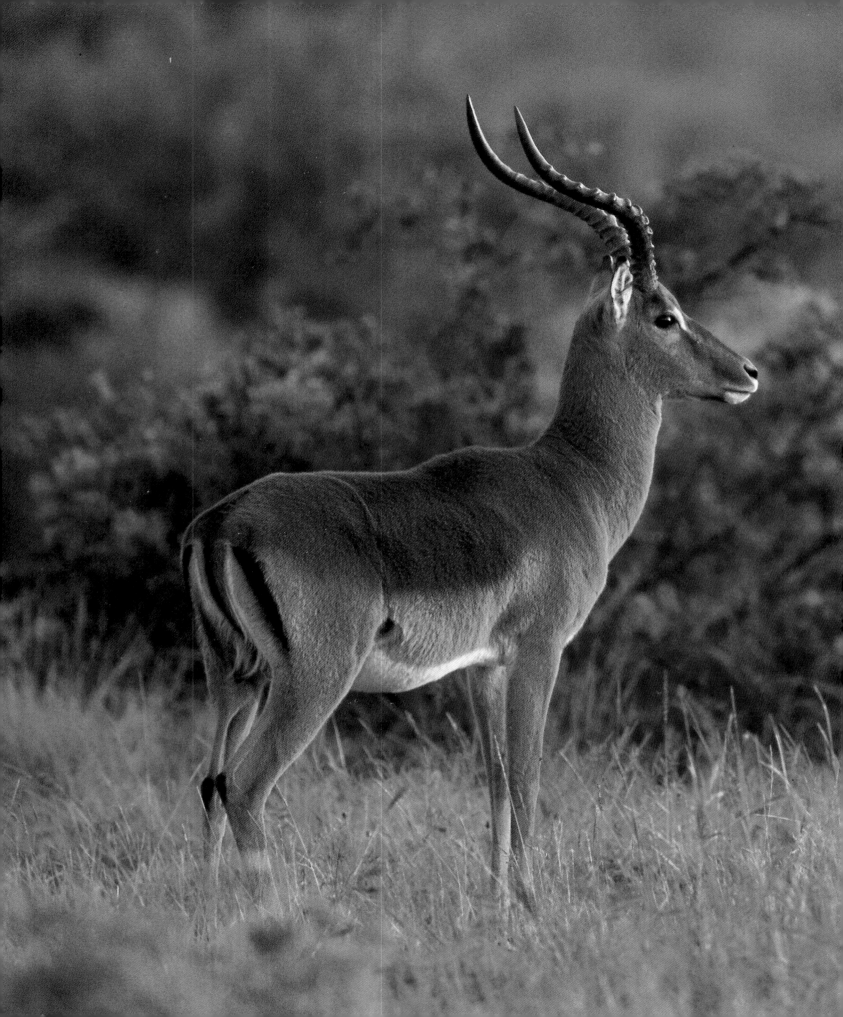

116 right *Apart from man, the baboon* (Papio anubis) *is definitely one of the primates that has most successfully adapted to life in the savanna. To protect themselves against predators, baboons move in troops based on clearly defined social hierarchies, the young males exploring the territory and the dominant males protecting the females, with the young in the centre of the troop.*

116 left *In Kenya, monkeys of the Cercopithecidae family (on the left,* Cerchopithecus aethiops) *are found wherever there are trees and food. They live in large troops, and have a highly developed capacity to communicate.*

117 *In the savanna any creature capable of climbing uses termite mounds to survey the horizon. Thanks to the baboons' curiosity - typical of primates - and their chromatic, binocular vision, they make excellent guards when the rest of the troop is busy eating roots and insects.*

118-119 *The zebras of Kenya (*Equus Quagga Boehmi) *differ from the ones most often found in southern Africa in that their coat is patterned all over with black and white stripes and has no patches of brown. The main function of the stripes is camouflage but biologists think they could also help control temperature (black accumulates heat, white dissipates it).*

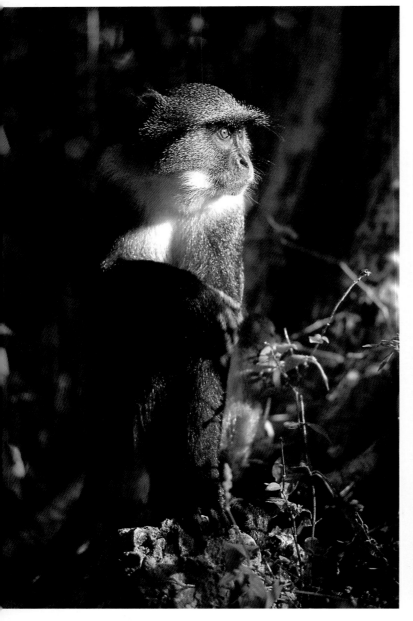

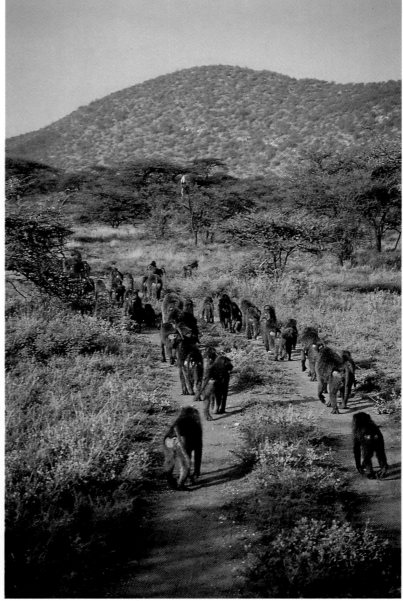

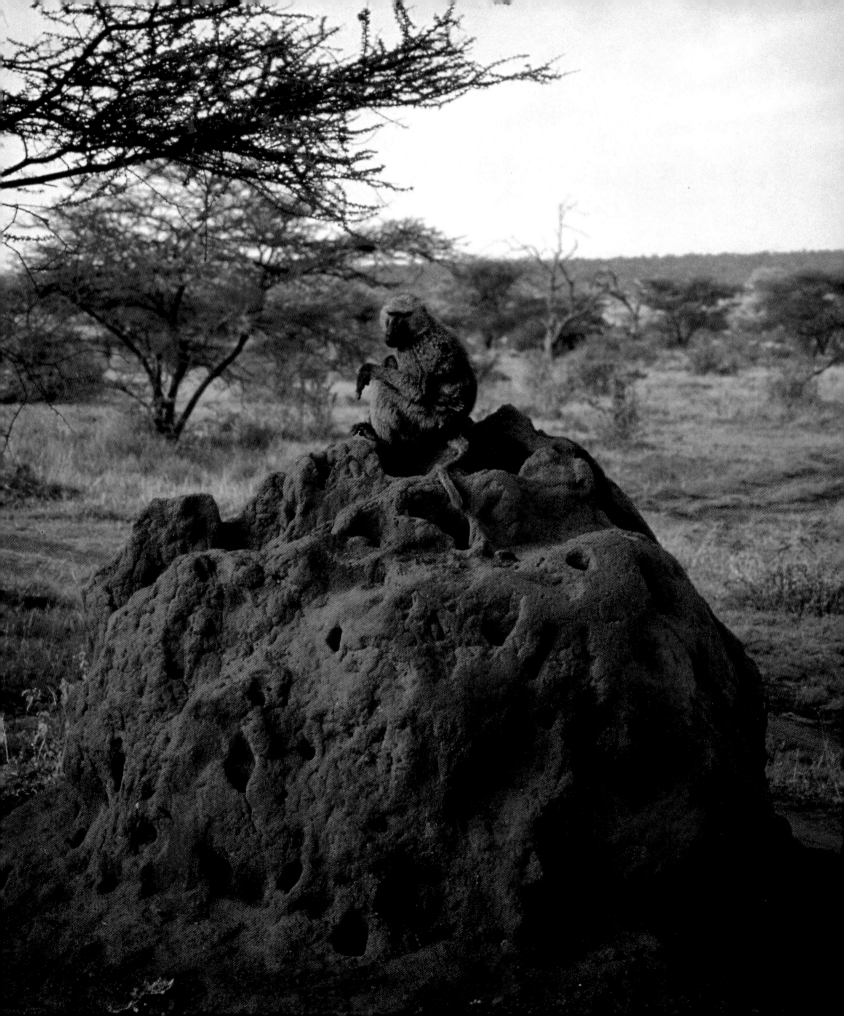

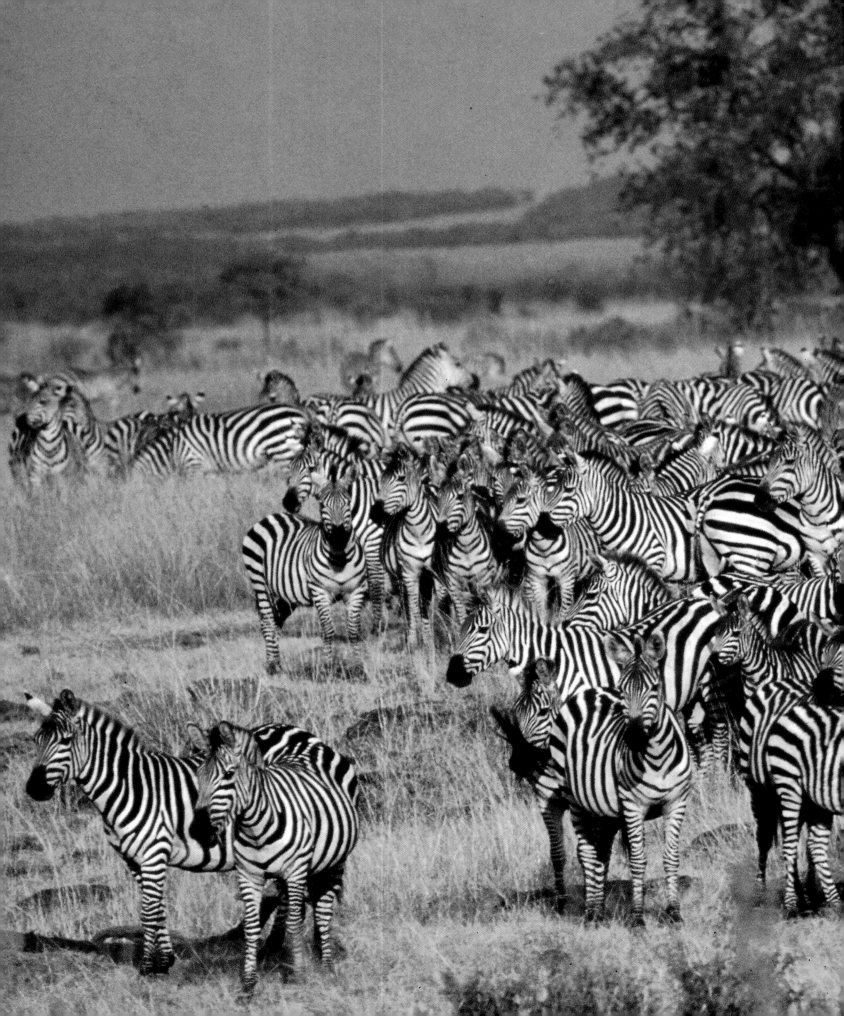

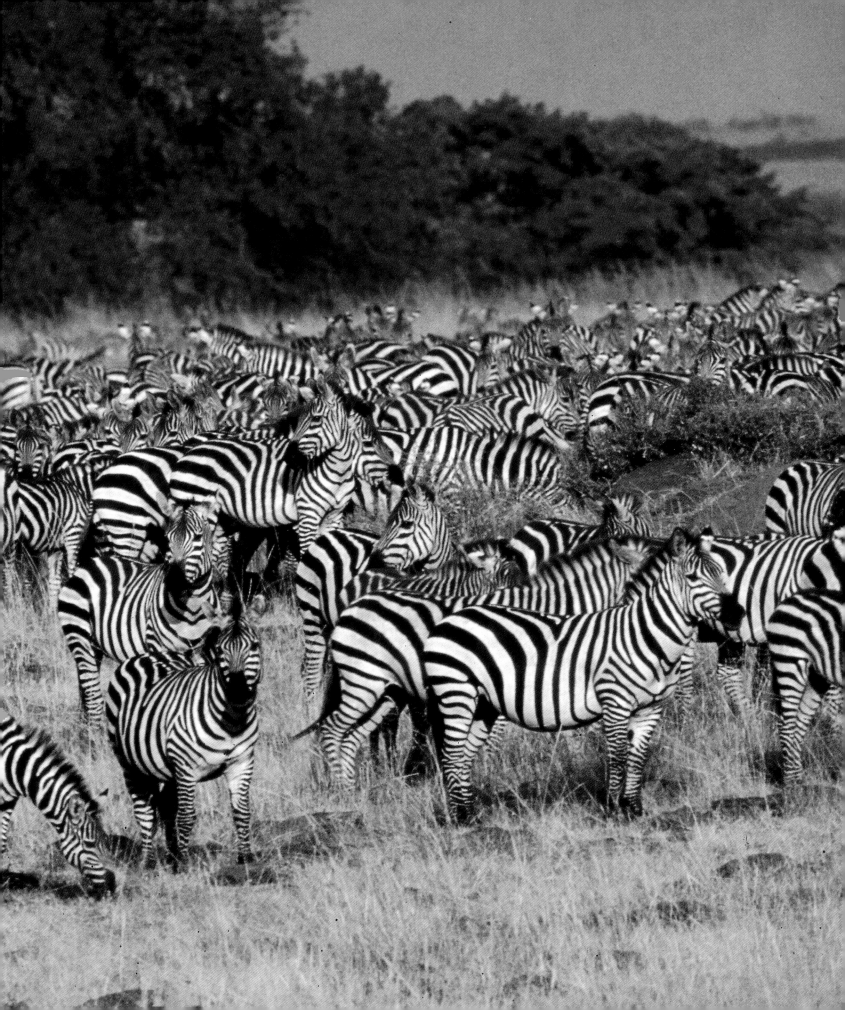

120-121 *The hippopotamus may look like a botched product of Darwinian evolution; in actual fact it is perfectly suited to its natural habitat, water. If a hippo spends too long on dry land, its skin becomes dehydrated and produces a reddish secretion, which is why people often say that hippos "sweat blood" (on the left). By day the hippopotamus is forced to remain submerged to protect itself from the rays of the sun; at night it wanders on the shore, feeding on grass which it tears up with its sturdy teeth, of an ivory by no means inferior to that of the elephant. Although a seemingly inoffensive herbivore, the hippo has a strong sense of territory and defends the area where it grazes and reproduces from intruders. It is not uncommon to see crocodiles cut in two by its teeth. The hippopotamus is also responsible for the highest number of incidents involving African animals and men.*

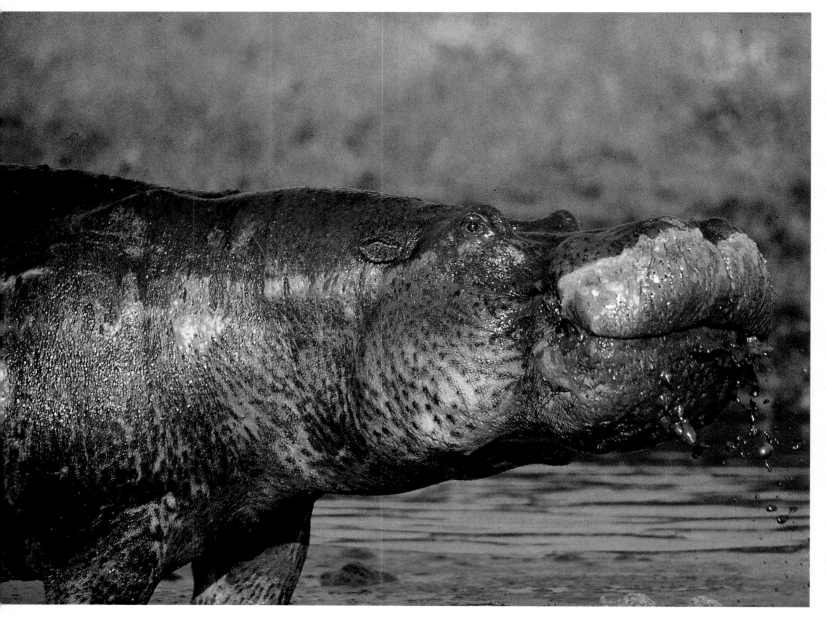

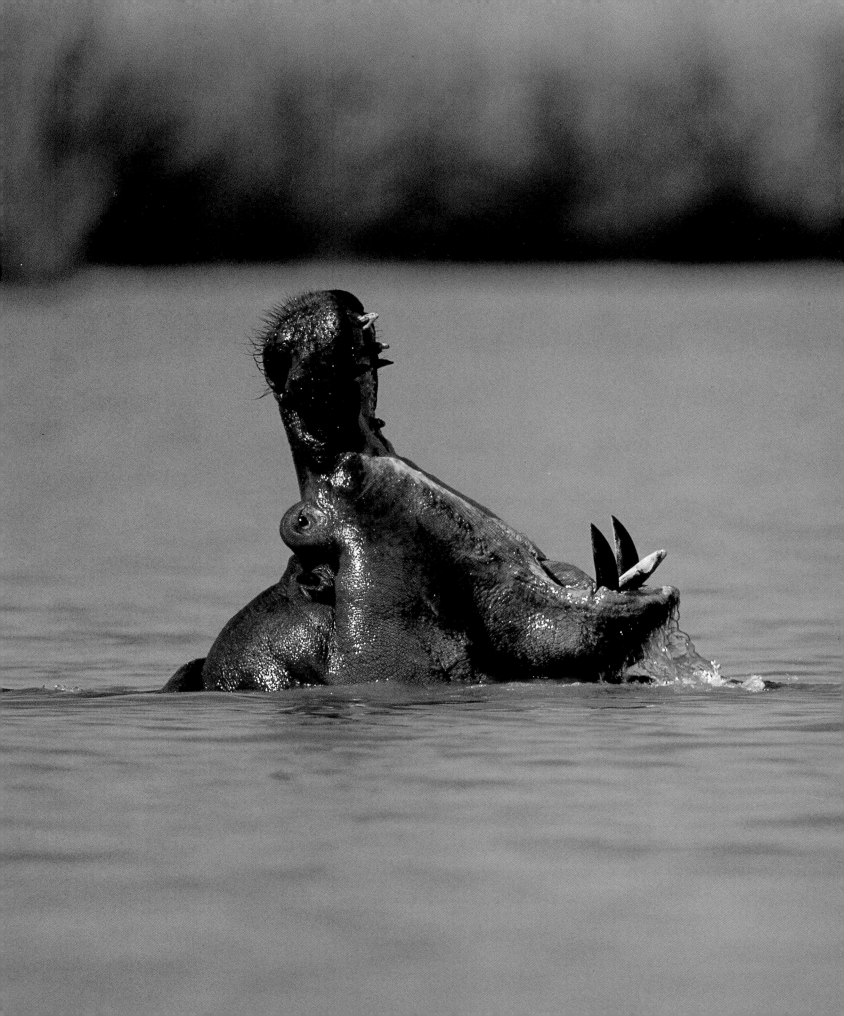

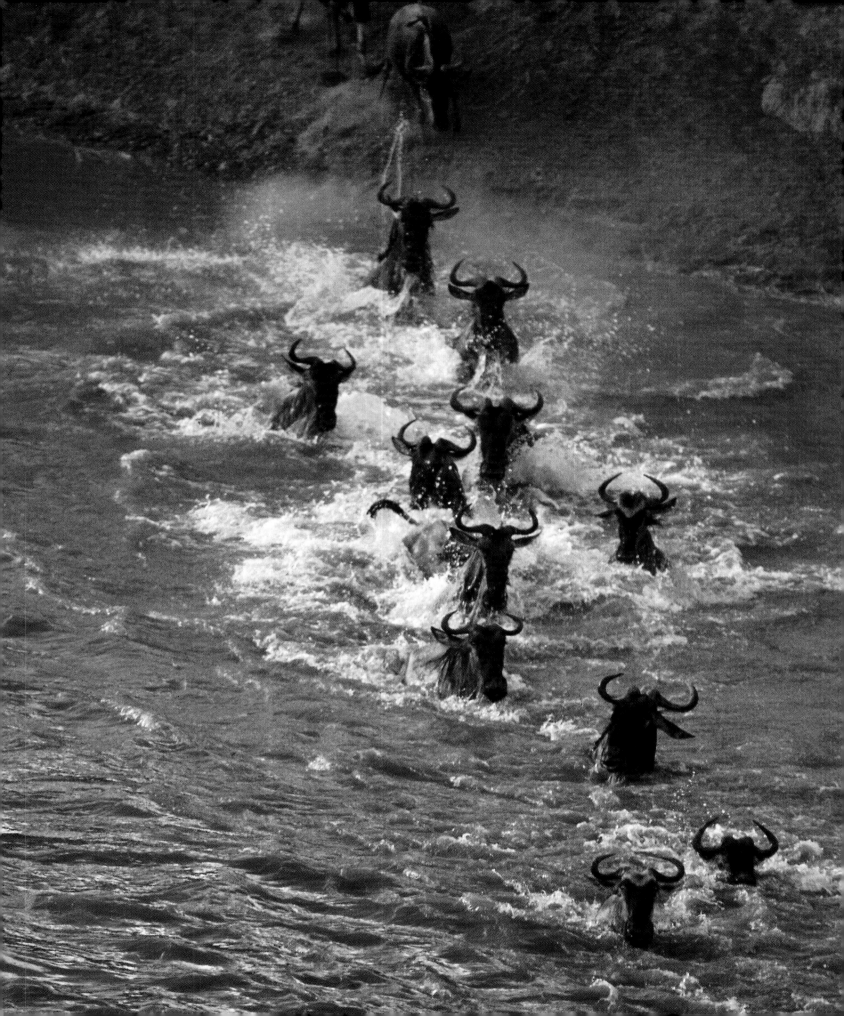

122-123 *The wildebeest or gnu* (Connochaetes taurinus) *lives in herds of hundreds of thousands. It is considered the clown of the savanna because of the way in which the males indulge in weird 'dances' of ungainly movements accompanied by strange grunts (hence their name: the sound they make is like a nasal "gnugnu"). The gnu looks as though it was put together with the leftovers of evolution: the head of an ox on the body of a horse, complete with tail and mane. On the borders of the Masai Mara, at the beginning of the rainy season, huge herds of gnu start on a migratory trek that takes them north from the short-grass plains in Serengeti, Tanzania, where grazing is now exhausted. But across their path is the Mara River in flood. Every year thousands of gnu are drowned or crushed to death in their desperate attempt to get to the other side of the muddy waters.*
The migration is awaited like manna by thousands of predators - lions, crocodiles, hyenas, vultures: after the huge herds of gnu have plunged across the Mara, there will be fatter bellies all around.

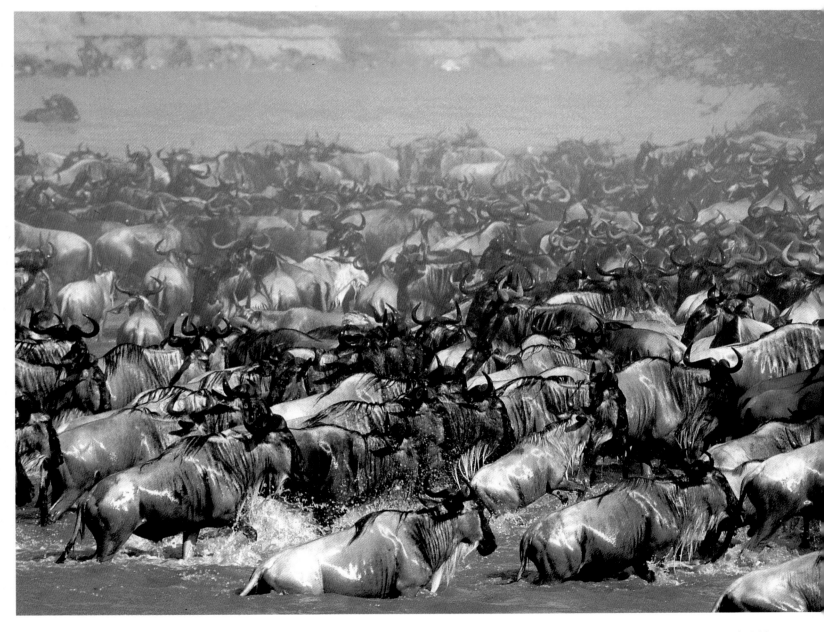

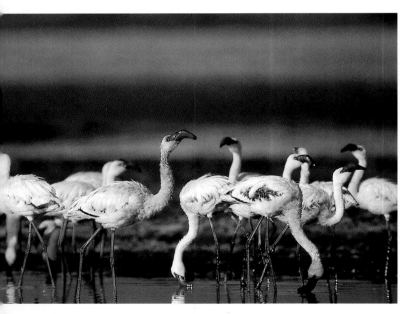

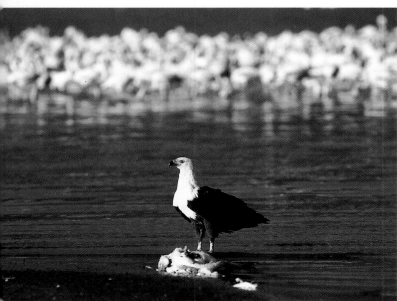

124 top and 125 *The characteristic pink colour of flamingoes* (Phoeniconaias minor) *comes from a chemical compound contained in the algae they feed on (which means that, if flamingoes' plumage is nearly white, they are not getting the right food). Since the minute plants that nourish and sustain them depend on the alkalinity of the water, flamingoes are in their element in the volcanic lakes of the Great Rift Valley; on occasions the microscopic algae that abound in these lakes turn their surface a bright jade green* (right).

124 bottom *The feeding strategy of the fish eagle is simple but cunning: it takes up position close to a flock of flamingoes and waits for the noise made by the thousands of birds to disturb the fish and 'push' them its direction.*

126-127 *Lesser flamingoes live in flocks containing several million birds. In Lake Bogoria* (in the photo) *as in Lakes Nakuru and Baringo (in this same area), flamingoes find abundant nourishment; they nest and breed in the barren salt pans of Lake Natron, in Tanzania.*

128 *As the sun goes down, a family of elephants lingers on the shores of a lake; stretching away on the far horizon are the vast plateaux lands of Kenya.*

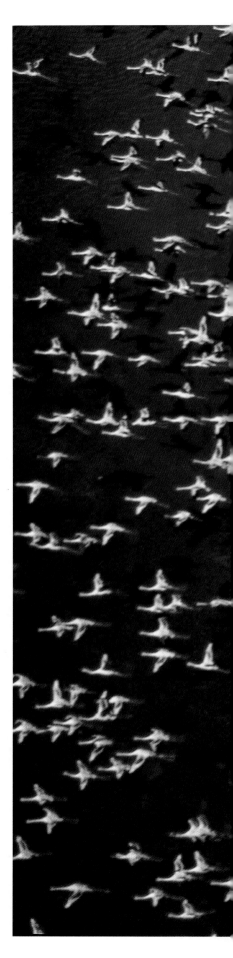

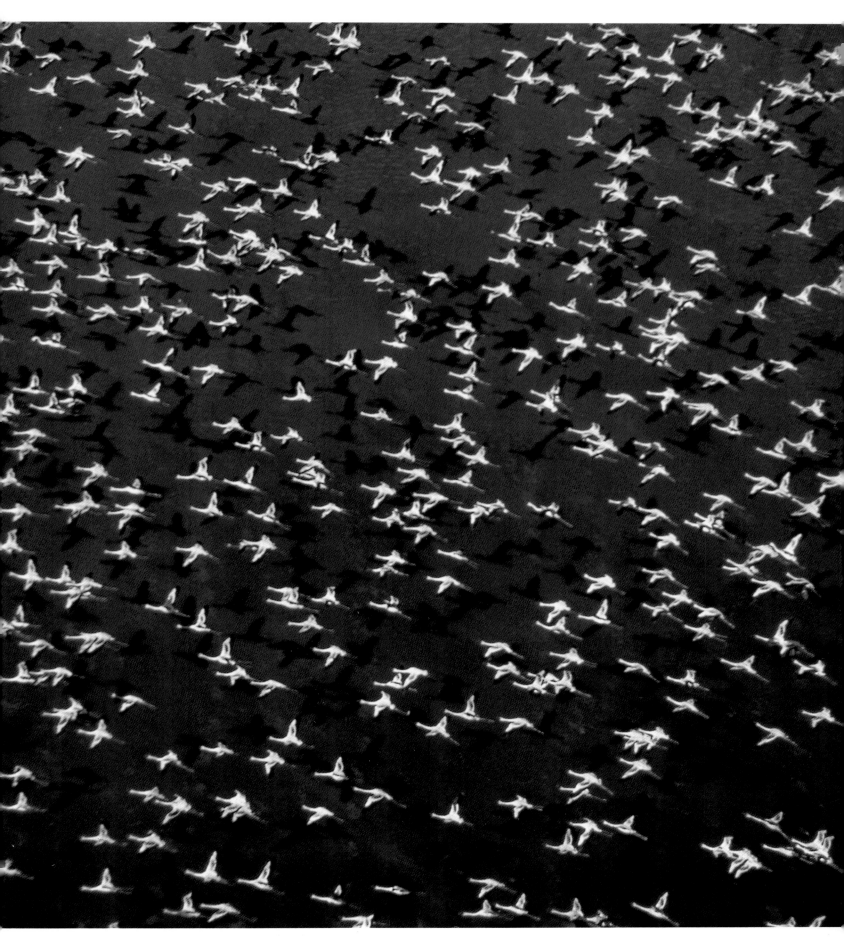

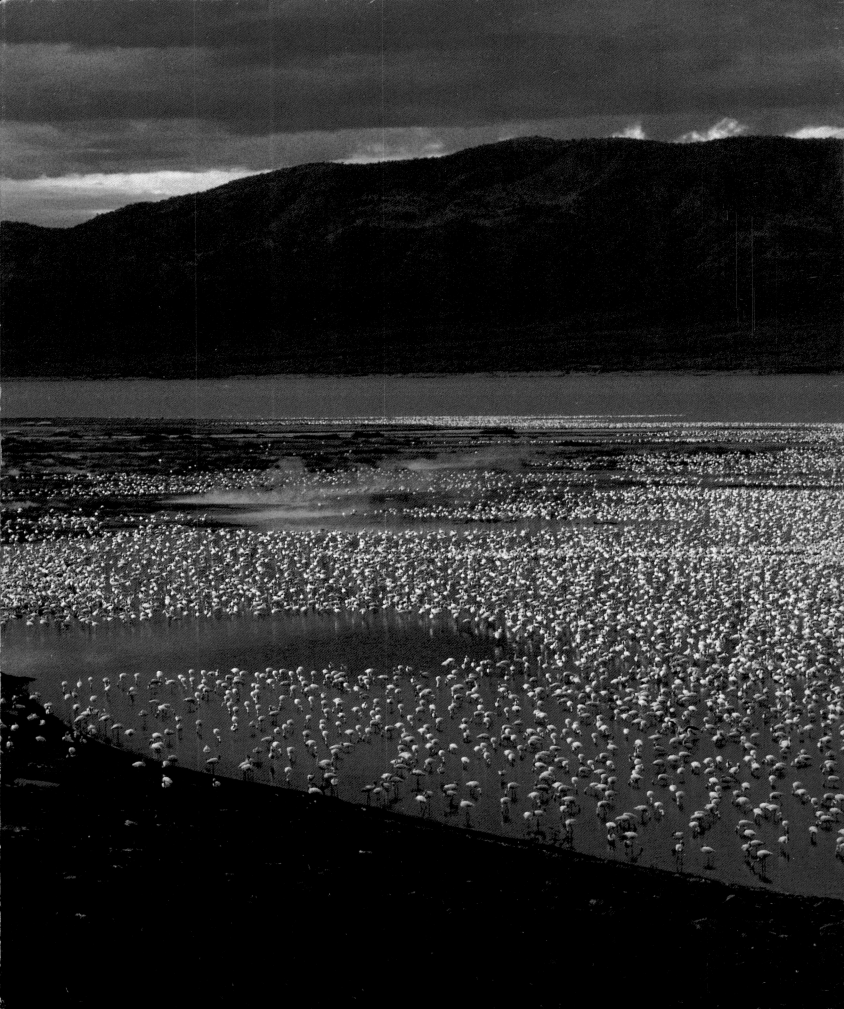

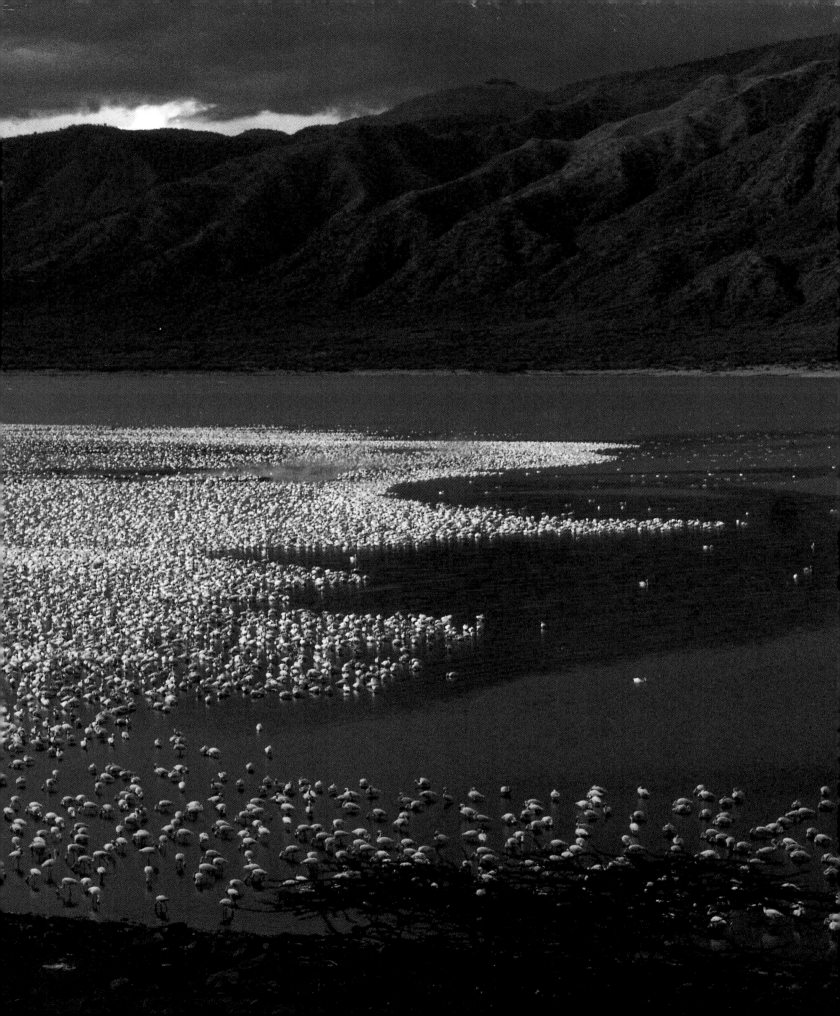

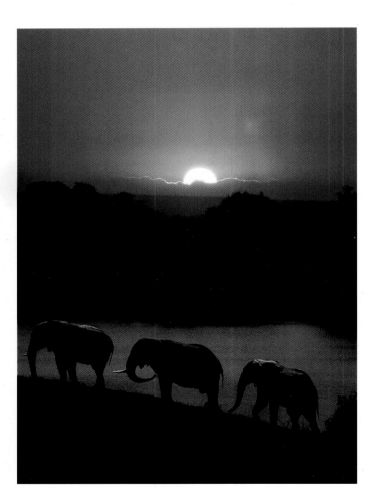